The Book of
Horror
The Anatomy of Fear in Film

The Book of Horror

The Anatomy of Fear in Film

F

FRANCES
LINCOLN

Matt Glasby

Illustrations by Barney Bodoano

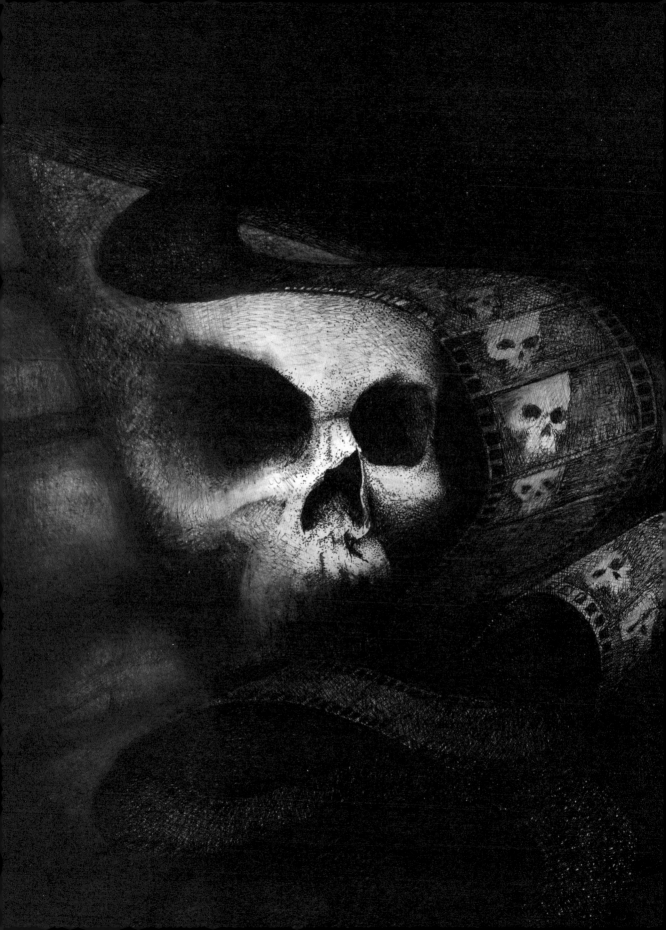

Introduction

'Horror has never really gone out of fashion because being scared never has.'

'Horror,' said legendary director John Carpenter, 'is a reaction; it's not a genre.' While it is unwise to argue with the master, perhaps it is more accurate to say that horror is a genre unlike any other – except comedy – because it *depends* upon a reaction.

Whether they deal with monsters, murderers or creeping madness, horror films are trying to scare us. As Professor Darryl Jones notes in *Sleeping With the Lights On*, even the word 'horror', derived from the Latin *horrere*, signifies an involuntary response: to cause our hair to stand on end, to make us tremble or shudder.

This is why what constitutes a horror film is an issue of style not subject matter. Despite centring on a supernatural being, *Casper* is clearly not a horror film; yet *Annabelle* – about a toy doll – most certainly is. Equally, though they contain horrifying moments, the likes of *Jaws*, *Alien* and *The Silence of the Lambs* do not qualify because scaring us is not their primary objective. A recent *Time Out* compilation of the 100 Best Horror Movies included the war film *Come and See*, the TV drama *Threads* and sci-fi efforts *The Fly* and *The Thing* – which just goes to show how blurred the lines are and, more importantly, how few horror films succeed in frightening us.

With blockbusters such as *It* breaking box office records, and 'elevated' horrors by Jennifer Kent (*The Babadook*), Jordan Peele (*Get Out*, *US*) and Robert Eggers (*The Witch*, *The Lighthouse*) winning critical plaudits, the genre has never been more popular. But horror has never really gone out of fashion because being scared never has. From silent-era classics such as Georges Méliès's *The House of the Devil* (1896), perhaps the first ever horror film, to tech-savvy twenty-first-century efforts like *Death of a Vlogger* (2020), our fears remain the same, even if the ability to show them on-screen evolves at pace.

Viewed today, the Universal monster movies of the 1930s or Val Lewton's RKO B-movies of the 1940s are marvels of inference and innovation, but no longer actively frightening. For this reason, *The Book of Horror* concentrates on films from the post-war era. It is not a history, or a hagiography, but a sincere attempt to collate the scariest movies ever made and examine how they work.

> **'Ultimately the final list contains films that are actually, tangibly scary, and remain so after multiple viewings.'**

Despite being a horror critic for nearly two decades and an obsessive fan for three, deciding on the final selection proved a daunting task. Hundreds of classic and contemporary movies were surveyed, alongside obscurities from Iceland, Indonesia and beyond, suggested by friends, colleagues and filmmakers.

Faced with seventy-five years of material to choose from, it became necessary to apply some ground rules. To be considered, entries had to be proper horror films – so no TV movies, sci-fi or thrillers – and still readily, legally, available. Although the book goes back as far as 1945's *Dead of Night*, Alfred Hitchcock's 1960 classic *Psycho* is the first movie discussed in detail, because it represents a watershed moment for the genre. After *Psycho*, nothing was off-limits in the pursuit of a good scare: no subject too transgressive, no special effect too extreme, no narrative twist too shocking. This practice continued throughout the Video Nasty era of the 1980s to the present day: the decapitation of Charlie (Milly Shapiro) in Ari Aster's recent *Hereditary* being a harrowing example.

There was also a strict no doubles policy. Only the very best sequels (such as *[Rec]²*) have been included, and in the rare cases that an original film and its remake are both eligible, as with *Ju-On: The Grudge*, the more effective was chosen. Franchise horrors such as *A Nightmare on Elm Street* and *Friday the 13th* largely did not make the grade, because familiarity has dulled their edges. Readers will also notice the absence of great, genre-straddling auteurs such as David Cronenberg, Brian De Palma and David Lynch. Ultimately the final list contains films that are actually, tangibly scary, and remain so after multiple viewings. If that disqualifies such masterpieces as *Videodrome*, *Carrie* and *Mulholland Drive*, so be it.

What frightens us is, of course, subjective, but even subjective responses contain patterns worth unpicking. Tricks such as exaggerated lighting and non-linear editing are common in all forms of cinema, so instead a unique system was devised to examine seven specific techniques, or scare tactics, that horror films rely on to work their dark magic.

Scare Tactics

Throughout the book, each of the seven scare tactics is represented by its own bespoke symbol. So, for example, when you see a ticking clock like this ●, it means Dread. The symbols appear in the text to show that a particular scare tactic is relevant to a particular scene or aspect of the film. They are also used in a summary infographic to illustrate how much each film uses each scare tactic overall. A second infographic charts the intensity and timings of the film's most frightening moments. The seven scare tactics can be broken down like this . . .

1 DEAD SPACE

This refers to two related aspects of cinematography: negative space and positive space. Negative space is when there is too much room around the subject of a shot. It makes us feel unsettled, like something might jump out at any moment. The expanse of curtain behind Marion Crane (Janet Leigh) in *Psycho*'s shower scene is perhaps the ultimate example. Negative space also lets us glimpse something that the characters do not, such as the masked face appearing out of the darkness in *The Strangers*. Positive space is when there is too little room around the subject of a shot. It allows threats to intrude suddenly into the frame, such as when Mrs Ganush (Lorna Raver) is revealed lying behind Christine (Alison Lohman) in *Drag Me to Hell*. Found-footage films such as *The Blair Witch Project* are particularly adept at manipulating dead space because the panicky camera movements switch from shaky wide shots (negative space) to extreme close-ups (positive space) without warning. *Lake Mungo*, meanwhile, makes more sophisticated use of it by having a ghost haunt the edges of family photographs and videos.

2 THE SUBLIMINAL

This refers to visual and aural cues that we do not necessarily notice. Most films use sound to influence us – for example, constant low-frequency rumbles can be physically upsetting, especially in the cinema. But horror films often go further, deploying hard-to-pinpoint sound effects such as buzzing insects (in *The Exorcist*) or the white

noise of a slaughterhouse (in *The Texas Chain Saw Massacre*) to stimulate an involuntary fear response. It may be far from subtle, but Goblin's extraordinary score for *Suspiria* features heavy breathing and chanting to evoke an undercurrent of pervasive evil. When it comes to subliminal visual cues, William Friedkin was a pioneer, inserting flashes of a demon's face into *The Exorcist* to suggest that the film itself was possessed. No wonder traumatised viewers responded by fainting, crying and worse.

3 THE UNEXPECTED

This refers to the many ways horror films seek to surprise us, from jump scares to plot twists. Used by everyone from Val Lewton to James Wan, jump scares are a good way to shock the audience, and when done well – for example, the last gasp of car-crash victim Benigna (Montserrat Carulla) in *The Orphanage* – they increase our overall anxiety levels. On a subtler register, narrative about-turns such as the killing of Charlie in *Hereditary* break an unspoken pact with the audience, suggesting that the world of the film is random, unhinged and not to be trusted, making us fear what comes next.

4 THE GROTESQUE

This refers to corporeal horrors, from creature effects to broken bodies. Human beings are hardwired to find blood and wounds alarming, because they remind us that the flesh is weak, and that eventually we will die. Though far from politically correct, horror villains are often diseased (as in *[Rec]*) or disfigured (as in *Baskin*), which sends signals to our brains that something is awry. Equally, watching people in pain (as in *Martyrs*) brings back memories of our own suffering and makes us feel vulnerable. Our sense of disgust is just as powerful, and easily triggered by the sight of bodily fluids, insects or alien physiognomies – anything from which we naturally flinch. This is put to good use in *The Descent*, where the wet, eyeless faces of the 'crawlers' inspire both fear and revulsion.

5 DREAD

This refers to the feeling of foreboding when we know something terrifying is on the way. It is also perhaps the horror film's major currency. As Roger Clarke notes in *A Natural History of Ghosts*, 'So much of the ghost story is the anticipation.' Dread takes many forms. Sometimes it is there in the title: like the way *The Texas Chain Saw Massacre* makes us fear the massacre we are assuredly about to see. It could be in the backstory, as in *The Haunting*, where we wait for history to repeat itself; or in warnings contained within the narrative, such as when Danny (Danny Lloyd) is told to stay out of room 237 in *The Shining*. *Ring* actually offers a seven-day countdown during which to anticipate its worst horrors. On a technical level, dread can

be harnessed by recurring motifs such as the thudding sound that prefigures *The Entity's* assaults; the long, slow pans that make us fear what will be revealed in *It Follows*; and the point-of-view shots in *Halloween* that suggest the camera is stalking its prey.

6 THE UNCANNY

This refers to the sense that something is not quite right, and is perhaps the hardest scare tactic to pin down. The uncanny has its roots in Freud's 1919 essay *Das Unheimliche*, and refers to the unsettling feeling of experiencing something strangely familiar or familiarly strange, like the imagery of a nightmare. As Professor Jones writes, the uncanny arises from 'uncertainty over whether what we are seeing is alive or dead, organic or mechanical, material or supernatural', as well as the juxtaposition between the mundane and the weird. Examples include: Mrs Kersh (Joan Gregson) dancing naked behind Bev (Jessica Chastain) in *It Chapter Two*; *Banshee Chapter's* blank-faced human hosts; and the strange, jerky movements of Sadako (Rie Ino'o) in *Ring*. The way *Hereditary* moves from miniature scale models to actual rooms without cutting is deeply uncanny, because it makes the real look fake, and vice-versa.

7 THE UNSTOPPABLE

This refers to the sense that the traumas we are experiencing will never end. Most horror films feature narratives that spiral out of control and then refuse to resolve themselves, but some take it to another level. *The Texas Chain Saw Massacre* makes its heroine, Sally (Marilyn Burns), jump through a window – twice – only to end up back in the same unceasing nightmare. At the climax of *Halloween*, Michael Myers is revealed to be an unkillable boogeyman who is still out there somewhere, watching, waiting. And in *Ju-On: The Grudge* the curse threatens to continue outwards forever. A similar effect is achieved by *The Exorcist's* repetitive score, which keeps looping back to the beginning. By refusing to give viewers catharsis, horror films offer no release from the emotions they stir up. Perhaps the most extreme example is the pivotal scene in *Ring* where Sadako climbs through the TV to claim her next victim, because it makes the screen itself a site of danger, so even in our own homes we are still vulnerable – no matter that the movie is over.

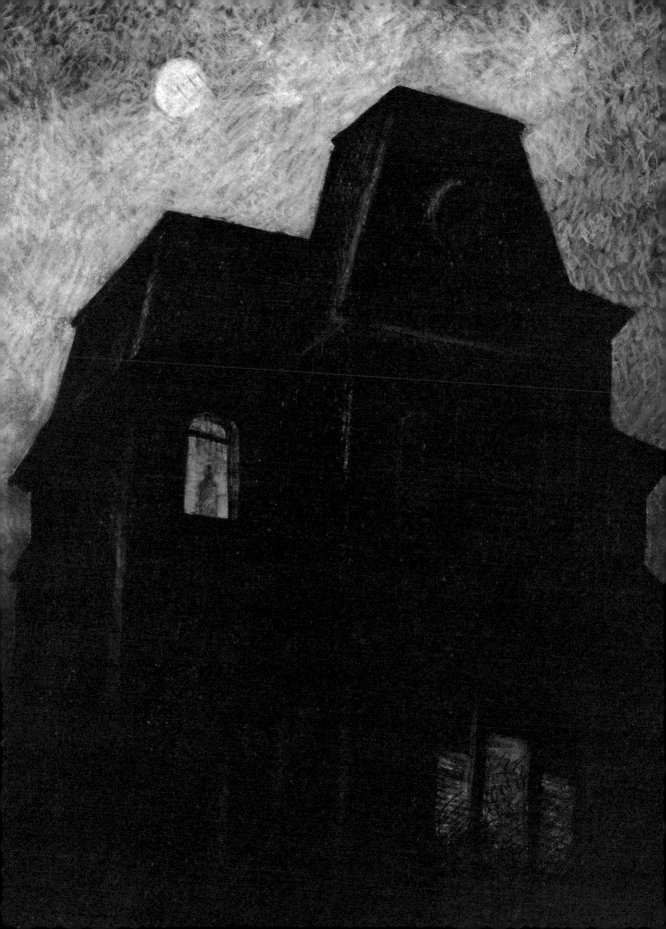

Psycho

Mommie dearest

RELEASED 1960

DIRECTOR ALFRED HITCHCOCK

SCREENPLAY JOSEPH STEFANO,
ROBERT BLOCH (NOVEL)

STARRING ANTHONY PERKINS, JANET
LEIGH, VERA MILES, JOHN GAVIN,
MARTIN BALSAM

COUNTRY USA

SUBGENRE PSYCHOLOGICAL THRILLER

When *Psycho* hit cinemas in September 1960, it changed the perception of horror forever. Whereas before, the genre relied upon gothic fantasies taking place in faraway, feudal neverwheres; now, the dangers felt real and raw, and the monster could be anyone, even that nice man next door.

Written in the same period and place that Wisconsin murderer/grave-robber Ed Gein committed his crimes, Robert Bloch's 1959 novel centred on Norman Bates, a middle-aged motel owner with a split personality, who dressed as his dead mother to commit murder. Crucially, Joseph Stefano's script made Norman (Anthony Perkins) young, vulnerable and charming. It also shifted the focus of the first 40 minutes to his victim, Marion Crane (Janet Leigh), so that her sudden demise would be all the more shocking.

When it came to Norman's transvestism, Hitchcock knew he was on risky ground with the censors, so he shot the film cheaply, in black and white, with his *Alfred Hitchcock Presents* TV crew. Yet what excited him was not just the air of sexual transgression, but the mechanics of surprise. 'The thing that appealed to me and made me decide to do the picture was the suddenness of the murder in the shower, coming, as it were out of the blue,' he said, quoted in Peter Ackroyd's 2015 biography. While modern viewers might have been alerted to Marion's truncated screen-time by a tell-tale credit reading 'and Janet Leigh', 1960s audiences were completely unprepared.

Arriving at the 47-minute mark, the shower scene is among the most fêted in movie history. It even earned its own documentary: 2017's *78/52*, named after the number of shots and cuts in the sequence. But its real legacy is not Hitchcock's startling, staccato editing, but the fact it made horror cinema *unsafe*.

The film begins like a regular thriller. In Phoenix, Arizona, respectable, relatable Marion longs to marry her lover, Sam Loomis (John Gavin), so she steals $40,000 from work that she was meant to deposit in the bank and sets off to join him in California. A clever bit of shorthand shows the money on her bed, then her suitcase packed, the fateful

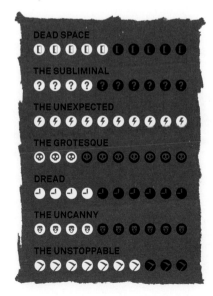

DEAD SPACE

THE SUBLIMINAL

THE UNEXPECTED

THE GROTESQUE

DREAD

THE UNCANNY

THE UNSTOPPABLE

decision already made. Eagle-eyed viewers will spot her shower curtain hanging innocently in the background ◓. On the road, she is stopped by a traffic cop (Mort Mills) who tells her she should sleep in a motel 'just to be safe'. Then she trades in her car, all the while trying to quieten the chattering voices of her conscience – a subtle echo of Norman's mental illness.

With the rain pouring down, Marion heeds the cop's advice and pulls into the Bates Motel. She finds nobody at the front desk, but in the Californian gothic-style house behind she can just make out the silhouette of a woman walking past the upstairs window ◓. While the chilling reality of what we are seeing – that it is Norman, dressed as his mother, unaware he has an audience; that he must do this *all the time* – will not land until later, it is a smart piece of misdirection. We want to know who the woman is, what will happen to Marion and the money, but we have not been primed for the slaughter to follow. '*Psycho* has a very interesting construction and that game with the audience was fascinating,' said Hitchcock in an interview with the French director François Truffaut. 'I was directing the viewers. You might say I was playing them like an organ.'

The scenes that follow, as Marion and Norman bond over milk and sandwiches in his parlour, are beautifully written and performed, with plenty of ominous asides ◓. Surrounded by stuffed birds – Norman, we learn, is a keen taxidermist, and the bird imagery is

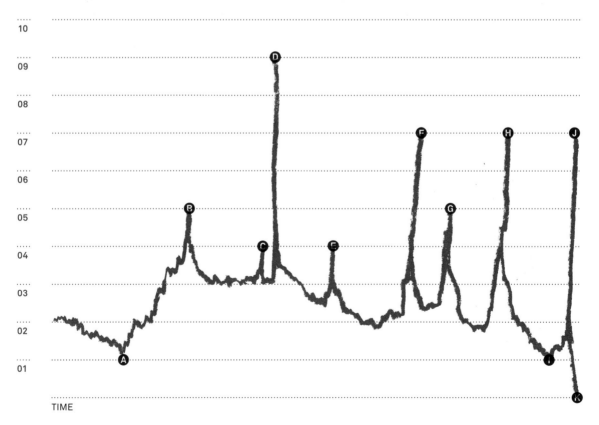

SCARE RATING

TIME

'We all go a little mad sometimes. Haven't you?'
— Norman Bates

echoed elsewhere (in the names Crane and Phoenix, plus the candy corn he pecks at) – they talk of being stuck in traps of their own making. We hear Mrs Bates telling Norman off from the house, and he explains that, 'She's as harmless as one of those stuffed birds,' but 'isn't quite herself today.' Soon he's recalling how his father died, then his stepfather, and that 'a son is a poor substitute for a lover', a phrase with clearly incestuous undertones. And yet, thanks to Perkins, Norman remains oddly endearing, stuttering and oversharing in the presence of a beautiful woman. By the end of their chat, Marion has resolved to return to Phoenix and give back the money. But as she undresses in her room, Norman takes a painting off the wall – *Susanna and the Elders* by Frans van Mieris, which depicts a scene of Biblical voyeurism – and watches through a peephole. The shot of an eye staring, entranced, at something off-screen is a quintessential Hitchcock image, with the audience watching the watcher, and guilty by association.

Having worked out her sums on a scrap of paper, Marion disposes of the evidence in the bathroom – supposedly the first time a flushing toilet was ever shown on-screen – then gets into the shower. That the camera dawdles on her might be put down to the director's much-reported lechery (he was later accused of sexual assault by *The Birds* star Tippi Hedren), but there are also point-of-view shots of the cleansing water to encourage viewer identification with Marion. After a series of quick, tense cuts 🕐, we settle on an image with an unusual amount of dead space ⓘ behind her. It is here the outline of a figure – Mrs Bates? – appears, entering the room, pulling back the curtain and raining knife blows on poor Marion, as Bernard Herrman's strings shriek in shock. In mere seconds, we watch her bleeding, falling, dying on the bathroom floor, the sudden violence of the attack ⚡ underscored by jagged edits. As Hitchcock himself said, quoted in Ackroyd: 'All the excitement of the killing was done by the cutting.'

But the real terror comes from the sense of relentlessness ⏩. Not only does the attack feel endless because it takes place in a series of starkly stretched moments, the contract with the audience has been broken forever. Once the thriller has made the acquaintance of horror – albeit briefly – there is no way back. Having killed off his star, Hitchcock can do anything to us, and we have no choice but to watch.

Although film history tends to disagree, the rest of *Psycho* is somewhat pedestrian, with boring leads – Sam and Lila Crane (Vera Miles), Marion's sister – and just a few moments of pulse-quickening virtuosity to be found.

The murder of Arbogast (Martin Balsam), a private detective hired to find Marion, provides a terrific jump scare ⚡. Alone in the Bates house, he climbs the stairs in several deliberately paced shots while the door to Mrs Bates's bedroom inches open above. As the tension

TIMELINE

- Ⓐ **15 MINS** MEDDLING COP
- Ⓑ **28 MINS** MOTHER
- Ⓒ **45 MINS** PEEPING NORM
- Ⓓ **47 MINS** RI-RI-RI!
- Ⓔ **58 MINS** SINKING FEELING
- Ⓕ **77 MINS** ARBOGAST GOES DOWN
- Ⓖ **86 MINS** MOTHER OBJECTS
- Ⓗ **102 MINS** CELLAR DWELLER
- Ⓘ **105 MINS** ANNOYING SHRINK
- Ⓙ **108 MINS** 'WOULDN'T HARM A FLY'
- Ⓚ **109 MINS** ENDS

crests, Mrs Bates/Norman strides out of the room and stabs him in the face, while the violins scream. He flails downstairs – a terrible optical effect – and Mrs Bates/Norman finishes the job with a flurry of knife blows.

The next comes at the climax, when Lila explores the house and finds Mrs Bates sitting, facing the wall, in the fruit cellar. Because Stefano and Hitchcock have kept the film's secret so well, using different actors for her voice and high angles to pretend she is alive but infirm, we are still expecting to meet a murderer. Instead, Lila touches her shoulder, and what reels around is a hollow-eyed skeleton ☺. The second shock ⚡ comes when Norman bursts in wearing a dress and wig, with a raised knife and a gleeful grin on his face. He is stopped by Sam, but the scene ends on Mrs Bates, a swinging lightbulb animating her desiccated features ☠.

Hitchcock worked hard to avoid spoilers, so this double-whammy must have floored original audiences. Perhaps, then, they needed the following scene: a dreadful monologue by police psychiatrist Dr Richman (Simon Oakland), wherein he explains Norman's pathology to Lila and Sam in painstaking, buzz-killing detail. In truth, such pedantry is the preserve of the thriller. Horror does not need to be explained, it just is – as shown by the final scene.

A policeman interrupts asking if he can take Norman a blanket. We follow him down the hall to the holding cell, where we hear Mrs Bates say, 'Thank you.' What follows is uncanny in the extreme ☠. As we close in on Norman, alone in his cell, Mrs Bates's voice dominates the soundtrack as she has her son, protesting her innocence. A fly lands on Norman's hand, he looks down, then up at us. 'They'll see,' Mrs Bates begins, purring. 'They'll see and they'll know and they'll say, "Why, she wouldn't even harm a fly."' When Norman smiles, it is overlaid for the faintest second with the image of his mother's skull ❷. The inference is clear: in the battle between horror and thriller, there can only be one winner.

Further viewing

PEEPING TOM 1960
Considered so scandalous upon release that it ruined the career of the mighty British director Michael Powell, *Peeping Tom* helped *Psycho* usher in horror's new era. Shot in primary, porno-flick hues, it tells the story of Mark Lewis (Carl Boehm), a London photographer and murderer who films his victims' terror as they realise their fates. It has much to say about cinema's voyeuristic pleasures/pitfalls, and its extraordinary point-of-view shots 🕐 no doubt helped inspire the slasher genre. But it is as a study of child abuse that the film is most effective. Mark's father (Powell himself) subjects the boy (Powell's son Columba) to all kinds of cruelties then films them, from dropping a lizard on his bed while he is sleeping to making him say goodbye to his dead mother in her coffin. 'Don't be silly, there's nothing to be afraid of,' Powell senior chides at the climax. 'Hold my hand daddy, I love you,' is the boy's bone-chilling 😨 response.

THE HOUSE WITH LAUGHING WINDOWS 1976
When it comes to the *giallo*, a lurid (its name translates as 'yellow') Italian thriller that proliferated in the 1970s, the title is less a plot descriptor than a promise of perversity to follow. And Pupi Avati's sedate effort delivers with an added frisson of unease. Art restorer Stefano (Lino Capolicchio) is sent to a remote marshland village to work on a church fresco by Legnani, a 'painter of the agonies' who caught syphilis, went mad and died. Here, he meets all manner of cranks and obsessives, each with a Legnani secret to spill – we even hear his voice on tape, making eerily ecstatic pronouncements 😀 over scenes of torture and murder 😵. Billeted in a creepy old house, Stefano experiences a barrage of spooky distractions as he slowly learns the truth. Owing a big debt to *Psycho*, the final reveal is so demented it will stay burned into your brain.

SLEEP TIGHT 2011
Peppy on the surface, deeply, slyly sinister underneath, Jaume Balagueró's psychological thriller features the kind of audience manipulation of which Hitchcock would be proud. Lonely César (Luis Tosar) is the concierge of an upscale Barcelonan apartment block. When we see him waking at dawn to leave Clara (Marta Etura) in bed, we presume they are having an affair. At the front desk, the residents harangue or ignore him, and he confides his woes to his elderly mother, who is near-catatonic in hospital. But César isn't the put-upon victim he first appears, and his privileged position is ripe for abuse. In the first of many escalating reveals, we see him hiding under Clara's bed 🛏 as she dances around her flat in her underwear, waiting for her to fall asleep so he can strike. What is so upsetting is not that this everyday boogeyman wants Clara, but that he wants to destroy her, and will go to any lengths ➤ to do so.

The Innocents

The (re)turn of the screw

RELEASED 1961

DIRECTOR JACK CLAYTON

SCREENPLAY WILLIAM ARCHIBALD,
TRUMAN CAPOTE, JOHN MORTIMER,
HENRY JAMES (NOVELLA)

STARRING DEBORAH KERR, MEGS
JENKINS, MARTIN STEPHENS, PAMELA
FRANKLIN, MICHAEL REDGRAVE

COUNTRY USA

SUBGENRE GHOST STORY

'We must pretend we didn't hear it, that's what Mrs Grose says,' insists young Flora (Pamela Franklin). 'Pretend?' asks Miss Giddens (Deborah Kerr), her new governess. 'Then we won't imagine things,' says Flora. 'Sometimes one can't help . . .', begins Miss Giddens, 'imagining things.'

The tension between the real and the imaginary – what adults cannot know and what children must not – is where Jack Clayton's classic ghost story draws its power. Based on Henry James's 1898 novella *The Turn of the Screw*, adapted by William Archibald from his 1950 play, then punched up by Truman Capote, it is a film of still waters, with plenty going on, undisclosed, beneath the surface.

The set-up is simple. In Victorian-era England, prim Miss Giddens accepts a job looking after orphans Flora and Miles (Martin Stephens) at a country pile owned by their distant uncle (Michael Redgrave) and run by the housekeeper Mrs Grose (Megs Jenkins). But the former staff members – valet Peter Quint (Peter Wyngarde) and governess Miss Jessel (Clytie Jessop) – lived out a violent love story there, and the repressed Miss Giddens begins to sense their presence in the children's strange behaviour, and around the house itself.

'My original interest in the story was in the fact that one could tell it from a completely different point of view,' said Clayton, quoted in Neil Sinyard's 2000 biography. 'That evil was alive in the mind of the governess and, in fact, she more or less creates the situation . . . through almost Freudian hallucinations.' In other words, is Miss Giddens haunted by ghosts of the past, or of the imagination?

Quiet dread 🕐 is the foundation of most films like this, and something *The Innocents* excels at. Before the 20th Century Fox logo even appears, we hear the creepy lament 'O Willow Waly', which will recur at moments of supernatural suggestion throughout. Next we see Miss Giddens praying and sobbing, anticipating dark happenings to come and hinting that she might be less stable than she appears.

There's a subtle piece of foreshadowing when she meets Flora in the grounds of the house. While a sing-song voice calls her name,

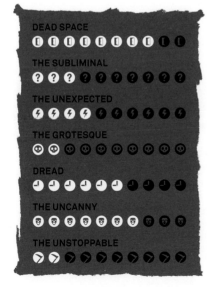

DEAD SPACE

THE SUBLIMINAL

THE UNEXPECTED

THE GROTESQUE

DREAD

THE UNCANNY

THE UNSTOPPABLE

> 'I know I saw him, a man or something that once was a man, peering in through the window, looking for someone.'
> — Miss Giddens

the child appears first as a white dress reflected in the lake. Later, when we learn what really happened here, it will feel like we have always known. Either way, whether they reveal the living or the dead, reflective surfaces are not to be trusted in the film.

Upon entering the house and touching a vase of roses, Miss Giddens announces, 'I never imagined it would be so beautiful.' On the word 'imagined', however, the petals fall off. 'That keeps happening,' says Mrs Grose. Clearly, nature – soon to be associated with the brutal, bestial Peter Quint – is not to be trusted either. Later, in an rare example of the grotesque ☺, Miss Giddens watches a beetle crawl out of the mouth of a cherub statue, a visual metaphor for how the children have been corrupted by the not-so-dearly departed.

Haunted house films rely on the manipulation of dead space ❶, and Clayton and cinematographer Freddie Francis (later the director of *Dr Terror's House of Horrors*, among others) prove themselves to be masters, shooting in deep-focus Cinemascope, with the edges of the frame painted black to create a sense of enveloping darkness.

It is ironic, then, that Miss Giddens first 'sees' Peter Quint in daylight at the top of a tower, with the sun in her eyes creating as much dead space as darkness would. Tellingly, as Flora hums 'O Willow Waly', Miss Giddens drops the flowers she is holding in the water fountain.

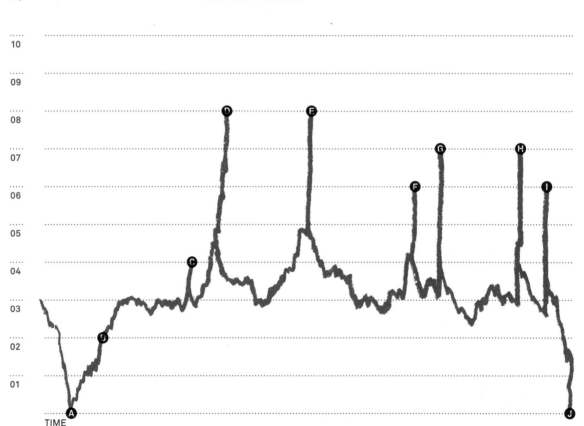

SCARE RATING

TIME

Further viewing

DEAD OF NIGHT 1945
Steeped in déjà vu and dream logic, Basil Dearden's wraparound story for this portmanteau film concerns architect Walter Craig (Mervyn Johns), who arrives at a country house party feeling he has been there before. One by one the guests recount tales of the supernatural, which vary in quality from the throwaway (Charles Crichton's 'The Golfer's Story') to the downright disturbing (Robert Hamer's 'The Haunted Mirror'). It is the director's second tale, 'The Ventriloquist's Dummy', that packs the biggest punch, as Michael Redgrave's fragile showman is taken over by Hugo Fitch, his possessed doll. The final freakout, in which the nightmarish narrative comes full circle and Hugo creaks into life, is unsettling 👹 in the extreme.

LET'S SCARE JESSICA TO DEATH 1971
Ignore the seemingly spoilerific title: nothing is certain in John Hancock's debut – a strange, spiralling tale of psycho-sexual anxieties in the free-love era. Fresh out of hospital, Jessica (Zohra Lampert), her boyfriend Duncan (Barton Heyman) and his friend Woody (the marvellously moustachioed Kevin O'Connor) head to rural Connecticut, where they meet and befriend a squatter (Mariclare Costello) living in the farmhouse they have bought, ignoring warnings from the locals ('Damn hippies!') about the property's violent history 🕐. Whether experiencing frightening visions or battling intrusive thoughts, Lampert is excellent as the close-to-the-edge Jessica. Meanwhile, the synthesiser-scored scenes of a spooky woman in white rising from the waters 👹 are both odd and oddly chilling.

I AM THE PRETTY THING THAT LIVES IN THE HOUSE 2016
Written/directed by Oz Perkins, son of Anthony, I Am the Pretty Thing posits the idea that houses that have seen death 'can only be borrowed' from their ghosts. Lily (Ruth Wilson) is a live-in nurse employed to look after Mrs Blum (Paula Prentiss), a horror writer with dementia. But Polly (Lucy Boynton), the tragic figure that inspired Blum's book The Lady in the Walls, still walks the empty rooms at night. At first, Perkins favours subtly building unease 🕐 over outright horror, making use of the big, black expanses 🔲 behind Lily to suggest Polly's presence. There is also a great jump scare ⚡ where we see a spectral image reflected in Lily's iris. But mostly this is a film of literary touches, such as the description of a ghost's memories as 'faces on the wrong side of wet windows, smeared by rain'.

TIMELINE

- **Ⓐ 5 MINS** JOB INTERVIEW
- **Ⓑ 12 MINS** TO THE MANOR BORN
- **Ⓒ 28 MINS** BLINDED BY THE SUN
- **Ⓓ 35 MINS** HE'S BEHIND YOU
- **Ⓔ 50 MINS** LADY BY THE LAKE
- **Ⓕ 69 MINS** STATUE!
- **Ⓖ 75 MINS** LADY IN THE LAKE
- **Ⓗ 90 MINS** GREENHOUSE EFFECT
- **Ⓘ 94 MINS** A KISS BEFORE DYING
- **Ⓙ 100 MINS** ENDS

But it is his next appearance that provides the film's first big scare, after 35 ominous minutes. During an ill-fated game of hide-and-seek, Miss Giddens conceals herself behind a curtain when, as 'O Willow Waly' plays from a music box, Quint appears through the black glass at her back. It is a startling moment, not just because of his alarming appearance but because he seems to come from out of the ether 🔲, retreating before anyone else sees him.

Though the film has one out-and-out jump scare ⚡ – when Miss Giddens, beset by ghostly voices, is shocked by a hideous mask in the candlelit dark – it makes more effective use of the uncanny 👹. While the children play by the lake, Miss Giddens sees a female figure dressed in black, standing in the reeds. The shot is so eerie because of the figure's stillness, the bucolic backdrop, and the fact that she should not be there at all. Before Miss Jessel (we presume) appears, Clayton shows Miss Giddens looking in that direction first, as if she might have conjured the tragic governess herself.

While jump scares dissipate when we realise what we have seen, melancholy moments like these retain their power, because the film never explains whether they are 'real' or 'false'. Clayton clearly relished the ambiguity, but the film's subtle magic rubbed off on him too – during the shoot he saw Miss Jessel standing at the bottom of his own garden, a true ghost of the imagination.

The Haunting

Residence evil

RELEASED 1963

DIRECTOR ROBERT WISE

SCREENPLAY NELSON GIDDING,
SHIRLEY JACKSON (NOVEL)

STARRING JULIE HARRIS, CLAIRE
BLOOM, RICHARD JOHNSON,
RUSS TAMBLYN, FAY COMPTON

COUNTRY USA

SUBGENRE GHOST STORY

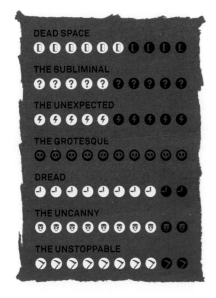

DEAD SPACE

THE SUBLIMINAL

THE UNEXPECTED

THE GROTESQUE

DREAD

THE UNCANNY

THE UNSTOPPABLE

Adapted from Shirley Jackson's 1959 novel *The Haunting of Hill House*, perhaps the apex of the genre, Robert Wise's 1963 masterpiece begins with an altered version of Jackson's legendary opening lines. 'Hill House had stood for ninety years and might stand for ninety more,' intones Dr John Markway (Richard Johnson). 'Silence lay steadily against the wood and stone of Hill House, and whatever walked there walked alone.'

By the time we hear those words again, subtly changed and spoken by a ghost, we will have experienced one of the most distinctive buildings committed to celluloid. Indeed, Hill House, an empty Massachusetts mansion, is less an 'undiscovered country' as Markway puts it, than a malevolent beast intent on consuming its inhabitants. 'Can't you feel it?' asks fragile spinster Eleanor Lance (Julie Harris). 'It's alive, watching, waiting.'

We first meet Dr Markway proposing an experiment to Hill House's elderly owners, who – wisely – live elsewhere. His plan? That he and a few carefully chosen guests will conduct a supernatural investigation to see what they find. 'Maybe only a few loose floorboards,' he says, 'maybe a key to a whole new world!' It proves to be the latter for Eleanor, or Nell, who has been invited because she experienced poltergeist activity as a child. A carer whose elderly mother has just died, she is keen to escape the stifling atmosphere of her sister's house, and the anxious swirl of her thoughts, which we hear in voiceover. At the house she soon bonds with Theo (Claire Bloom), a psychic and – even rarer in 1960s cinema – a lesbian. Boorish playboy Luke Bloom (Russ Tamblyn), who stands to inherit the house, ghosts and all, rounds out the party.

Wise was the director of *West Side Story*, among other prestige pictures, and an unlikely candidate to make a horror film, but he was clearly open to the possibilities. 'I was reading one of the very scary passages – hackles were going up and down my neck – when [screenwriter] Nelson Gidding burst through the door to ask me a question,' he told writer Frank Thompson. 'I literally jumped about three feet out of my chair. I said, "If it can do that to me sitting and reading, it ought to be something I want to make a picture out of."'

'It was an evil house from the beginning, a house that was born bad.'
— Dr John Markway

From that opening narration onwards, *The Haunting* is front-loaded with dread ◷. In the first few minutes, we see four of the house's previous inhabitants – all women – meeting grisly fates. Hugh Crain, who built the house, drowns off-screen. His first wife (Pamela Buckley) dies on the approach to the house when her carriage crashes into a tree. Crain's second wife (Freda Knorr) sees something at the top of the stairs and falls to her death. His daughter Abigail, who changes from a young girl (Janet Mansell) to an old woman (Amy Dalby) in a series of unsettling dissolves ◷, dies calling for her helper (Rosemary Dorken). The latter inherits the house, but hangs herself from the top of the spiral staircase in the library years later.

In the modern day, the house is looked after by the fabulously grim Mrs Dudley (Rosalie Crutchley) and her husband (Valentine Dyall), who offer warnings so stark as to be almost comical. 'You'll be sorry I ever opened the gate,' Mr Dudley chides Nell. Mrs Dudley's doomy proclamations make her sound like she could be one of Hill House's ghosts, trapped forever in the same loop. 'We couldn't hear you. In the night,' she starts. 'No one could. No one lives any nearer than town. No one will come any nearer than that. ◷'

Though set in America, the film was made in Britain, with Elliott Scott's ominously ornate interiors constructed at MGM-British Studios in Borehamwood, Hertfordshire. Wise and his

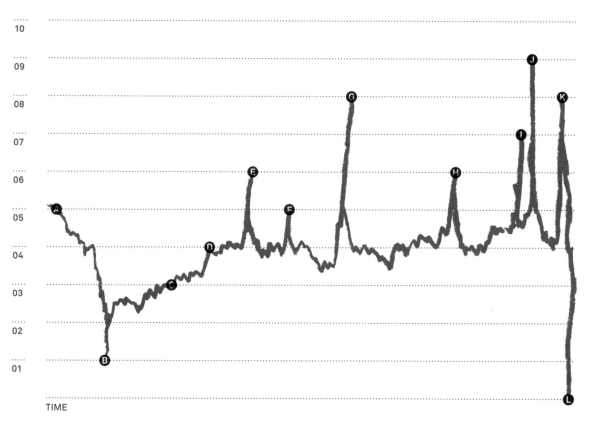

SCARE RATING

10

09

08

07

06

05

04

03

02

01

TIME

cinematographer Davis Boulton decided to shoot in Panavision, using an untested wide-angle lens which ran the risk of distortion. 'That's exactly what I need,' said Wise, quoted in Sergio Leemann's book. 'I want the house to look almost alive.' And it does – uncannily so 🖤. Nell says she feels 'like a small creature being swallowed whole by a monster', and we often see ceilings (another rarity in 1960s cinema) spreading above her like a closing maw. But the house isn't just alive, it's 'diseased', 'deranged', 'leprous'. Even its geography is wrong. As Markway notes, the doors are off-centre, the layouts confusing, and Wise uses rapid cuts and Dutch (that is, tilted) camera angles to disorient the viewer too. A wonderful early shot of Nell bending to pick her up her case is, in fact, a reflection in a polished floor, a foreshadowing 🕐 of her fate: being subsumed into the house.

Initially, Gidding imagined that the character was in the throes of a nervous breakdown – the house, her hospital; Markway, her doctor – but Jackson rejected the idea. Instead, Nell's agitation and aching to belong make her easy prey. At one point, the characters find the words 'help Eleanor Come Home' scrawled across a wall. But is it a plea for Nell to return to her family, or an instruction to make her a resident of Hill House on a more permanent basis? The bizarre capitalisation suggests the latter.

'Oh, this house!
You have to watch
it every minute.'
— Eleanor Lance

Although it never reveals its ghosts, Hill House's assaults feel unending ⟩. At night, Nell and Theo hear a booming in the corridor outside their room, which builds until it seems as if someone is 'knocking on the door with a cannonball'. The camera pans around the room, nervously, catching the pair in an old patinated mirror, then showing them cowering from a high angle: their unseen assailant's point of view. When the door moves, Wise zooms in lightning fast on the handle, which turns with dreadful purpose ●. In a later attack, the door actually bulges inward, its adornments, seen from below, making it look like a throttled human face ●. As a special effect it proved especially economical. 'All I had was a strong prop man on the other side who would push it and move it,' Wise told *American Cinematographer*. 'That's all it was and it scared the hell out of everybody.'

Before the shoot, sound editor Allan Sones and his crew decamped to a seventeenth-century manor house to record its creaks and groans, resulting in a soundtrack that terrified studio technicians. For the scenes in which the characters hear noises off-camera, a 'pre-score' of voices – laughing, crying, screaming – was created to be played during shooting. It remains in the finished film.

You can see the effect on Julie Harris in what is perhaps *The Haunting*'s scariest moment. Lying in bed listening to the lunatic voices outside – or are they in her head? – Nell sees a face in the wallpaper pattern and feels Theo gripping her hand. When the light snaps on, Wise whip-pans across the space, to show Theo in bed on the other side of the room ●. 'Whose hand was I holding?' asks Nell, terrified.

Throughout the film Wise moves the camera as if it is an agent of the house ●. After Abigail's helper hangs herself, it comes racing down the spiral stairs like a fleeing spirit. When Nell looks up at the tower muttering, 'That's where she did it!', it swoops down towards her like a bird of prey, or a plummeting body. As Nell, in chaos, leaves the others to give herself over to the house, it is canted one second, craning the next; seasick and swinging like her see-sawing mood. And without us ever seeing a single, tangible ghost.

Wise learned the art of less-is-more from *Cat People* producer Val Lewton, his mentor. 'Lewton's favourite theme was the greatest thing that people had was fear of the unknown,' he told *The Times*. '"What's that in the shadows back there? That noise?" That's what he played on. So when I did *The Haunting*, it was a kind of a tribute to him. I have had so many people say to me about *The Haunting* that it is "the scariest film I have ever seen". But I didn't show anything. It was just suggestions. There is nothing in it.'

The film ends, as it began, with Jackson's chilling prose. 'Silence lies steadily against the wood and stone of Hill House,' says Nell, who, having driven her car into a tree like the first Mrs Crain, will be staying forever. 'And we who walk here, walk alone.'

Further viewing

THE CHANGELING 1981
After losing his wife and daughter in an accident, composer John Russell (George C. Scott) leaves New York for wintry Seattle, looking for somewhere to 'lock myself in and pound away on the piano'. With the – debatable – help of local historian Claire Norman (Trish Van Devere), he moves into a Victorian mansion with a past that is all too keen to reveal itself. Right from the start, director Peter Medak frames Russell from above, in the dark turns of staircase, as if someone is watching 🕐. Soon an unquiet spirit is manifesting itself in strange, reverberating sounds, a bouncing ball that belonged to Russell's daughter and, in the film's most chilling sequence, the automatic writing of a medium who scrawls, 'Help, help, help!' Rick Wilkins' score moves from melancholy piano to spooky children's choir ❓, and the camera becomes a spectral presence, floating through the empty rooms like a lonely ghost 👻.

THE WOMAN IN BLACK 2012
Directed by James Watkins (*Eden Lake*) for the rejuvenated Hammer, this is the second screen adaptation of Susan Hill's 1983 novel. In 1910, London lawyer Arthur Kipps (a suitably Dickensian-looking Daniel Radcliffe) is dispatched to remote Crythin Gifford to recover documents left by Alice Drablow, the deceased owner of Eel Marsh House. Shunned by the locals, Kipps crosses the eerie Nine Lives Causeway to the Drablow residence, a creaky, cobwebby place that screams 'haunted'. It does not disappoint. The woman in black appears with increasing regularity: standing behind him in the inky darkness 🚪, peering out the window ⚡, or floating across the room to lay a shadowy hand on his shoulder 🕐. The nursery, meanwhile, is full of creepy Victorian toys 👻 that spring to life at unnerving moments. Combining a striking gothic sensibility with the constant scares of a ghost train 🔄, this is strong beer for Harry Potter fans.

THE CONJURING 2013
Adhering to the formula laid down by *Insidious*, this canny franchise starter from director James Wan throws every supernatural trope at the screen to see what sticks. In 1971 real-life paranormal investigators Ed and Lorraine Warren (Patrick Wilson and Vera Farmiga) are called to a haunted house in Rhode Island, where the Perron family find themselves overwhelmed by unexplained phenomena. One daughter (Mackenzie Foy) sleepwalks, another (Kyla Deaver) has an invisible friend who only appears in a music box mirror 🚪, and the spooky basement was boarded up by previous residents. When staging his scares, Wan favours sadistically drawn out build-ups 🕐 that shock with a sudden reveal ⚡. Standout examples include a game of hide-and-clap which sees mum (Lily Tomlinson, who played Nell in *The Haunting* remake) tracking her daughter through the house only to realise that something else is providing the claps, and a snarling witch-demon appearing on top of a wardrobe ⚡.

Don't Look Now

Death in Venice

RELEASED 1973

DIRECTOR NICOLAS ROEG

SCREENPLAY ALLAN SCOTT, CHRIS BRYANT, DAPHNE DU MAURIER (SHORT STORY)

STARRING JULIE CHRISTIE, DONALD SUTHERLAND, HILARY MASON, CLELIA MATANIA, MASSIMO SERATO

COUNTRY UK

SUBGENRE SUPERNATURAL

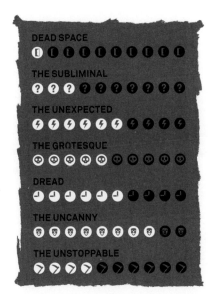

DEAD SPACE

THE SUBLIMINAL

THE UNEXPECTED

THE GROTESQUE

DREAD

THE UNCANNY

THE UNSTOPPABLE

Based on a 1971 short story by Daphne du Maurier (*The Birds*) and adapted by Alan Scott and Chris Bryant, *Don't Look Now* seems to be a simple story of death foretold. But in the hands of Nicolas Roeg, a master of allusive, non-linear editing, it becomes something more profound: a meditation on how grief breaks down the barriers between past, present and future.

Perhaps it is best thought of as a beautiful mosaic. Each carefully crafted piece contains the same repeated motifs – water, glass, the colour red, the idea of seeing/not seeing – yet it is not until they are all assembled that the awful inevitability of the pattern finally becomes apparent.

Affluent couple John (Donald Sutherland) and Laura (Julie Christie) Baxter lose their daughter Christine (Sharon Williams) in a drowning accident, then retreat to Venice to recover, only for disaster to follow them, as if pre-ordained. The opening scene – a lazy Sunday afternoon that quickly, inexorably bleeds into tragedy – is full of anxious augurs ◖.

At their country home, John is examining a series of slides while Laura looks up the answer to one of Christine's questions in a book called, aptly, *The Fragile Geometry of Space*. Christine and her brother Johnny (Nicholas Salter) are playing happily outside; the latter getting short shrift (as he will throughout the film), the former wearing an iconic red mac. But it is the fragile geometry of time – not space – that is being tested here.

John, we will learn, is psychic, and a series of images – rain on the garden pond, broken glass, sunshine through a hotel window, a red smear (or is it a figure?) on a slide depicting the interior of a Venice church – seems to alert him to Christine's coming death. When it happens, it is horrific, with John emerging from the water clutching her red-wrapped body, and groaning in wordless agony.

Next, the narrative shifts forward some months. In an empty, wintry Venice, a city also sinking in the water, John is working on the restoration of a church, including its mosaics. At a restaurant, Laura

'Nothing is
what it seems.'
— John Baxter

falls under the spell of two old British ladies, Heather (Hilary Mason) and Wendy (Clelia Matania), when Wendy gets something in her eye and Laura offers to help.

It is here the film starts its potent and politically problematic relationship with the grotesque ☺, linking disability and disfigurement with the supernatural. Heather is blind, with alarming milky cataracts and, as a scarred toilet attendant watches, she tells Laura that she saw Christine sitting between her and John. But do the old ladies really have Laura's best interests at heart? An insert of them later, cackling uproariously ☻, keeps us guessing, as John, the seer, stumbles blindly towards his fate – a meeting with the murderer who is terrorising Venice.

'I don't think I've been to a city where you can walk down a narrow street and you can hear footsteps getting louder and louder and louder,' Roeg told *Little White Lies* magazine. 'It is as if someone's always behind you.' As John and Laura grieve, argue and, in a celebrated sex scene, reconnect, Roeg piles on the menace. Walking the maze-like passageways at night, the pair find themselves alone yet constantly surrounded by figures watching silently from the windows ☽. A sign outside the church, meanwhile, warns 'Venice in Peril' – which may as well be the film's subtitle. And the authorities, including the clearly not-to-be-trusted police inspector (Renato Scarpa), seem to be keeping secrets even as they pull bodies from the canals.

SCARE RATING

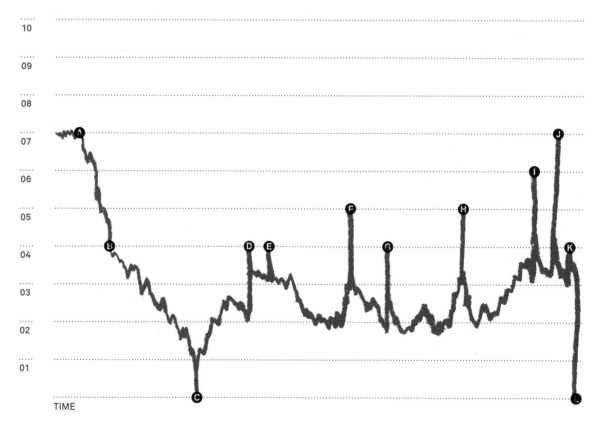

TIME

Further viewing

THE WICKER MAN 1973
Based on a terrific script by Anthony Shaffer, with songs by Paul Giovanni, Robin Hardy's eccentric folk horror was released on a double bill with *Don't Look Now*. Like Roeg's film, it features a myopic character lured into a trap in an exotic, untrustworthy location. Beginning with a title card thanking the residents of the (fictional) Summerisle for such privileged access, it follows Christian policeman Neil Howie (Edward Woodward) to a remote Hebridean island on the trail of missing schoolgirl Rowan Morrison (Gerry Cowper). Instead he finds suspicious, smirking locals indulging in all kinds of pagan naughtiness overseen by Lord Summerisle (Christopher Lee). Uncanny moments include the landlord's daughter Willow (Britt Ekland) trying to seduce Howie through the wall with her siren song 🅑, and scenes of naked locals dancing over a fire. But the film's reputation rests on its still-chilling climax, where the awful promise 🅙 of the title comes true.

DEEP RED 1975
Dario Argento's eeriest *giallo* uses dead space 🅘 as an ingenious plot point. When psychic Helga Ulmann (Macha Méril) is murdered in her art-filled apartment, jazz pianist Marcus Daly (David Hemmings) is first on the scene. He is convinced a painting he glimpsed holds the key to the crime – a painting now missing. After journalist Gianna Brezzi (Daria Nicolodi, Argento's future collaborator and partner) accidentally makes him the killer's next target, they investigate together, exploring a city of kinky, convoluted secrets. Primed with a typically propulsive Goblin score, the murder scenes are mini masterpieces. For maximum squirm factor, each is built around exaggerated every-day injuries – a scalding here; some smashed teeth 🅒 there – and preceded by a freaky children's doll 🅑 skittering towards the camera. 'I feel a presence, a twisted mind sending me thoughts!' Ulmann proclaims. 'Perverted, murderous thoughts!' Viewers will know exactly how she feels.

JACOB'S LADDER 1990
Pitched somewhere between David Lynch and M. Night Shyamalan, Adrian Lyne's psychological thriller goes down like a spiked drink. After being wounded in Vietnam, New York City postal worker Jacob (Tim Robbins) suffers terrifying visions of juddering, white-faced demons 🅔 on the subway. While the Biblical references suggest, none too subtly, what the matter may be (and a sample in the Thom Yorke/Unkle song 'Rabbit in Your Headlights' should carry a spoiler warning), the deluge of nightmarish imagery – passers-by with horns and tails, a bedlam basement full of dismembered limbs 🅒 a Satanic figure having sex with Jacob's girlfriend, Jezebel (Elizabeth Peña) – is indelible. There is even time for some wry social commentary. Pre-clean-up New York is so scuzzy and scary it might as well be the set from a horror film. As Jezebel says, exasperatedly, 'Jake, New York is filled with creatures.'

This symphony of unease builds to a crescendo with one of cinema's greatest shock endings ⚡. Believing it is Christine he sees, John follows a little girl in a red mac into a deserted building only to realise, too late, it is the murderer, an adult dwarf (Adelina Poerio), who cuts his throat.

As a piece of plotting, it seems impossible, insane. But as the central piece of the mosaic it fits perfectly, as if every frame of film has been warning what would happen, if only he/we could see it. Yet John remains blind to his gifts, to Laura's needs and his own, and he goes to the grave because he is unable to let go of his grief.

Unusually for the genre, Roeg ends the films on a positive note. Echoed from an earlier scene, we see John's funeral cortège, with Laura, poor little Johnny, and the two old women on a canal boat dressed in black. Despite her loss, Laura is smiling. Not only are John and Christine reunited in death, Roeg later admitted in his autobiography that she is pregnant by her late husband – the past, present and future entwined once again.

The Exorcist

To the devil a daughter

RELEASED 1973

DIRECTOR WILLIAM FRIEDKIN

SCREENPLAY WILLIAM PETER BLATTY
(ALSO NOVEL)

STARRING ELLEN BURSTYN,
MAX VON SYDOW, JASON MILLER,
LINDA BLAIR, LEE J. COBB

COUNTRY USA

SUBGENRE SATANIC

The Exorcist might be the most storied horror film of all time. Directed by William Friedkin from a script by William Peter Blatty, who also wrote the 1971 novel, its production involves so much myth-making it is hard to unpick the fact from the fiction. Upon release, it was supposed to have caused fainting, vomiting, even heart attacks among audiences. It was cursed, the crew said; evil, according to preacher Billy Graham; banned in England and Australia.

Although the film's grip has lessened over the years, thanks to numerous alternate edits and sequels (the best of which is Blatty's *The Exorcist III*), what charge remains comes not from Dick Smith's game-changing special effects, but the fact it is grounded in the real.

Inspired by the exorcism of a fourteen-year-old boy that took place in Georgetown, Washington, D.C., in 1949, it tells the story of Regan MacNeil (Linda Blair), the twelve-year-old daughter of actor Chris MacNeill (Ellen Burstyn). While her mother is shooting in Georgetown, Regan becomes possessed by an ancient demon (named Pazuzu in the 1977 sequel), who must be cast out by troubled priest Father Karras (Jason Miller) and the eponymous Father Merrin (Max von Sydow).

When we first meet her, Regan is just a normal little girl who wants a pony and reads movie magazines (admittedly, ones with her mother on the cover). As it turns out, it is not Regan the demon is interested in, but Father Karras, who is losing his faith after the death of his mother (Vasiliki Maliaros). Still, the muddy motivations take several viewings to make sense of.

Friedkin, known for his uncompromising directorial style, favoured gritty realism over Hollywood flash. 'When I saw the files at Georgetown University pertaining to the actual case, I knew that this needed to be something more than just another horror film, this had to be a realistic film about inexplicable events,' he explained in the Blu-ray introduction. Indeed, what makes viewers so pliable once the puke starts flying is that, for half its runtime, *The Exorcist* is essentially a drama about a very ill young girl at the mercy of modern medicine.

Although draggy by today's standards, and full of details that are only explained elsewhere, the early sections of the movie are

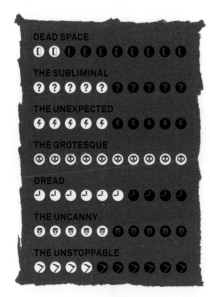

DEAD SPACE

THE SUBLIMINAL

THE UNEXPECTED

THE GROTESQUE

DREAD

THE UNCANNY

THE UNSTOPPABLE

> 'The demon is a liar. He will lie to confuse us. But he will also mix lies with the truth to attack us. Do not listen.'
> — Father Merrin

dusted with dread ④. In a lengthy prologue, when Father Merrin contemplates a statue of the demon Pazuzu in Iraq, the soundtrack buzzes with bees ❓. At Chris's Georgetown house, meanwhile, we see the wind scattering the leaves as if strange forces are brewing. Regan, we learn, has been playing with a Ouija board, talking to an invisible friend called Captain Howdy, and feeling her bed shaking at night. But these details are mentioned so breezily that the film's first foray into the grotesque is doubly shocking.

At a party held by her mother, full of movie folk, priests and D.C. movers and shakers, Regan sleepwalks downstairs, tells an astronaut (Dick Callinan) 'You're going to die up there,' then urinates 💀 on the rug. That night, Chris sees Regan's bed bucking like a wild animal ⚡ as her daughter screams. Later, at the hospital, we watch Regan pulled, prodded and penetrated by doctors, including undergoing a (purportedly genuine) arteriogram, which looks like the modern equivalent of medieval bloodletting 💀.

Seeing a young girl leaking what appears to be real blood primes the viewer's fight-or-flight instinct, leaving them more vulnerable to the supernatural shocks that come next, so it is no wonder that people reported experiencing physical responses. Even Blatty confessed to finding the scene difficult to watch. As he told the BBC documentary *The Fear of God*, 'The film has a power to move you and have a disturbing effect on the viewer, which is greater than the sum of any of its parts.'

SCARE RATING

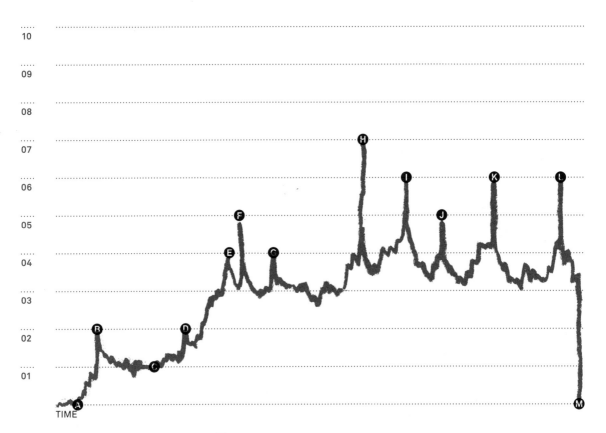

TIME

After a careful build-up, all hell breaks loose, with Friedkin using every trick at his disposal to create the sense that monumental evil has been unleashed before our eyes. Once Regan is fully possessed, there's no dead space, no dark corners to hide in: everything takes place in plain sight, often with practical effects performed 'live' on set.

'I was presented with the problem of taking this twelve-year-old little girl, a very pretty little girl with apple cheeks and a butterball nose, and making her into a demon,' recalled make-up artist Dick Smith in *The Fear of God*. Early tests were unsuccessful, until Friedkin hit upon a more realistic solution. 'The situation should come from something that Regan did to herself,' he said. 'I thought, what if, in the scene where she's masturbating with the crucifix, we saw that her whole face was streaming with blood, fresh blood, as though she had used the crucifix to scar herself?'

Besides offering all manner of repulsive details ☻ – milky-white eyes, black snaking tongue, a throat that bulges like a serpent consuming its prey – and moments of blasphemous shock ⚡, the special effects are so effective because you can *feel* them. When Regan vomits green bile (actually pea soup) at the priests, it steams. When holy water splits her skin, or she jabs a bloody crucifix into her vagina, it looks like it really hurts. Besides, having seen 'genuine' blood in the hospital scenes, how is the audience expected to know the difference?

'Your mother's in here, Karras. Would you like to leave a message?'
— Demon

While the film can, at times, feel like a full-on assault of the senses, some of its best scares operate on a subtler register. Asked where Regan is, the demon replies, 'In here, with us!', the uncanny 😈 choice of words matched by some extraordinary vocal work. At different points we hear Regan growling, wheezing, roaring and speaking in tongues to suggest that Pazuzu's power is truly legion.

Mostly this is down to voice actor Mercedes McCambridge, who recorded the demon's dialogue after consuming raw eggs, cigarettes and whiskey while lashed to a chair — if rumours are to be believed. 'Basically she performed it under great duress and I was stunned at what she allowed me to put her through,' admitted Friedkin.

Another famously uncanny moment is when Regan's head twists round 180 degrees, a grin of impish malevolence frozen on her face. Although the model work becomes less convincing the closer you look, what sells the effect is the sound — actually foley expert Gonzalo Gavira, who had impressed Friedkin on Alejandro Jodorowsky's *El Topo*, crinkling a cracked leather wallet into a microphone.

Over the years, the film has caused much furore due its use of near-subliminal images and noises ❓, which must have been even more effective before the advent of home video. During a mournful dream sequence of Father Karras's mother emerging from the subway, Friedkin inserts a flash of Pazuzu's alarming, black-and-white visage — actually an outtake from make-up tests performed on Blair's body double, Eileen Dietz. Later, Friedkin flashes the same image during the exorcism, then again, overlaid on Regan's face as she looks right at us as in *Psycho*.

The sound affects our fear responses in more mysterious ways. Throughout the film Friedkin makes use of industrial noises, pigs squealing on their way to slaughter, and thrumming insects — all designed to make viewers feel tense, however unconsciously. Even the theme music, taken from Mike Oldfield's 1973 prog-rock hit *Tubular Bells*, is in an unsettling 7/8 time signature. Together, these elements cohere to create the sense that there is something unnatural in the very fabric of the film itself.

But the main reason *The Exorcist* remains so effective is less to do with evil than with pain. While shooting, both Burstyn and Blair suffered real back injuries that Friedkin decided to keep in the film. The director also slapped Father William O'Malley (Father Dyer) before a take, fired blanks from a gun to shock Jason Miller, and god knows how McCambridge, a recovering alcoholic, reacted to his brand of 'duress'.

Clearly this kind of behaviour is unconscionable, but it dovetails exactly with the pain the characters are experiencing. Regan's arteriogram is, if Friedkin is to be believed, the equivalent of snuff cinema. When she is splashed with holy water she screams and screams in agony. Once it is all over, she huddles in the corner crying, and her mother – for one awful second – hesitates before comforting her. Watching another soul in pain, it seems, is pain enough for us all.

Further viewing

THE HOUSE OF THE DEVIL 2009
Beginning with some slightly dubious statistics – apparently more than 70 per cent of Americans believe in Satanic cults – and based on 'unexplained' (because fictional) events, Ti West's slow-burner could have easily been a short. Although 1980s acolytes will relish the period detail – a cassette Walkman, double denim, a cameo from genre favourite Dee Wallace – the story is bare bones at best. Against her better judgement, broke student Samantha Hughes (Jocelin Donahue) is hired by the mysterious Mr Ulman (Tom Noonan) to look after his elderly mother in an old dark house during an eclipse. Obviously this is a bad idea, but there is something about the build-up, all long zooms 🕐, wide open frames 🔲 and mounting unease, that makes the resulting tension feel merciless rather than manufactured. Indeed, viewers would be forgiven for jumping in shock ⚡ when the pizza boy arrives, let alone when eye-popping violence eventually explodes.

THE LAST EXORCISM 2010
Daniel Stamm's found-footage horror offers a clever take on Friedkin's classic. Charismatic Baton Rouge preacher Cotton Marcus (Patrick Fabian) agrees to let film-makers Iris (Iris Bahr) and Daniel (Adam Grimes) follow him as he demystifies the exorcisms he performs as acts of religious showmanship. But when he is called to Louisiana to help poor, seemingly possessed Nell (Ashley Bell) and her family, Marcus finds his usual tricks do not work. The roving camera provides several freaky moments, such as when the crew search for Nell only to find her perched on top of the wardrobe, staring 👁 into space. Later, a scene of impressively horrible contortion sees her bent over backwards in the barn, breaking her own fingers 😮 one by one. The final act's mad conflagration has been criticised in some circles for ruining the cerebral scares, but it makes for a memorably high-impact ending, shouting a lot louder than Friedkin's all-back-to-normal approach.

THE TAKING OF DEBORAH LOGAN 2014
Gerontophobia, or the fear of the elderly, provides the pulse of Adam Robitel's sophisticated debut, which shares DNA with M. Night Shyamalan's *The Visit*. Mia (Michelle Ang) and her crew are PhD students making a video thesis on dementia; Deborah Logan (Jill Larson) is their subject, an early stage Alzheimer's sufferer beginning to act erratically 😮 much to the consternation of her daughter Sarah (Anne Ramsay). Because the symptoms of her illness – physical deterioration 😮, hallucinations and violent outbursts – are broadly the same as those associated with possession, what follows is doubly distressing. Even before any supernatural interference, the ravages of the disease are as obscene as any horror film. The found-footage format makes excellent use of dead space 🔲 as the crew search Deborah's house during her many night-time rambles, and there's a near-subliminal ❓ insert of a snake-faced man – the real villain – slyly edited into a blank frame.

The Texas Chain Saw Massacre

Meat is murder

RELEASED 1974

DIRECTOR TOBE HOOPER

SCREENPLAY TOBE HOOPER, KIM HENKEL

STARRING MARILYN BURNS, PAUL A. PARTAIN, EDWIN NEAL, JIM SIEDOW, GUNNAR HANSEN

COUNTRY USA

SUBGENRE HICKSPLOITATION

Frequently named the greatest horror ever made, Tobe Hooper's fearsome breakthrough has a raw power that has not dissipated at all over the years. A drive-in movie shot like an art film, it feels less like an exploitation flick than the Woodstock generation's most enduring bad trip.

Screenwriters Hooper and Kim Henkel took their inspiration from the world around them. As the carefree 1960s bled into the cynical 1970s, news reports coming in from Vietnam showed American teenagers torn to shreds, while splatter films such as *Night of the Living Dead* and *The Last House on the Left* ushered in a new age of on-screen violence. Like *Psycho*, *The Texas Chain Saw Massacre* riffed on the crimes of Ed Gein, a 1950s murderer who made furniture from human skin and bones. Unlike *Psycho*, it could actually show the results.

Shot for $140,000 by a team of unknowns, first-timers and film students, the production took place under extremely punishing conditions amid the swelter of a Texas summer. But if there was hysteria in the air, at least they captured it on celluloid. As *Last House* director Wes Craven told writer Jason Zinoman: '*Texas Chain Saw Massacre* looked like someone stole a camera and started killing people. It had a wild, feral energy I'd never seen before. I was scared shitless.' He would not be the only one.

Although the film has been praised for its grimy authenticity, Hooper and Henkel were not above maximising the dread 🕐 by whatever means necessary. The title itself is a come-on, with its inflammatory language (only one person is killed by chainsaw, and four deaths barely constitute a massacre) and the odd, remedial spelling of 'chain saw'. The tagline, meanwhile, asks, 'Who will survive and what will be left of them?'

Narrated in flat, stentorian tones by John Larroquette, the opening crawl intensifies the sense of foreboding. A portentous device at the best of times, it recounts how for Sally Hardesty (Marilyn Burns), her 'invalid brother' Franklin (Paul A. Partain), a wheelchair

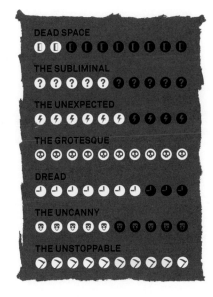

DEAD SPACE

THE SUBLIMINAL

THE UNEXPECTED

THE GROTESQUE

DREAD

THE UNCANNY

THE UNSTOPPABLE

user, and their friends, an 'idyllic afternoon drive became a nightmare'. If the inclusion of a date – August 18, 1973 – suggests that the events really took place, all the better.

Snapped piece by piece like crime scene photos, the first images are of rotting body parts stolen by grave-robbers and fashioned into a bizarre corpse sculpture ☺. While such a grotesque opening suggests that even worse is to come, this is actually the most graphic image in the film. Indeed, as Sally, Franklin and friends explore a bleak backwater Texas – all wide, open skies, abattoirs and roadkill – on their way to a showdown with chainsaw-wielding cannibal Leatherface (Gunnar Hansen) and his family, it is less the imagery that unnerves, than the sound.

Using tape feedback, tuning forks and broken instruments, the film-makers mapped out a hellish sonic landscape. From what sounds like a cracked cowbell clanging in tense off-beats, to the corrugated whir of industrial white noise, the unspoken implication is that the audience, like the characters, are heading for the slaughterhouse ❓. Before we get there, they encounter a demented hitchhiker (Edwin Neal) and stop at an empty gas station, where the proprietor (Jim Siedow) sells suspicious-looking BBQ and warns them to turn back. Naturally, they do not listen.

SCARE RATING

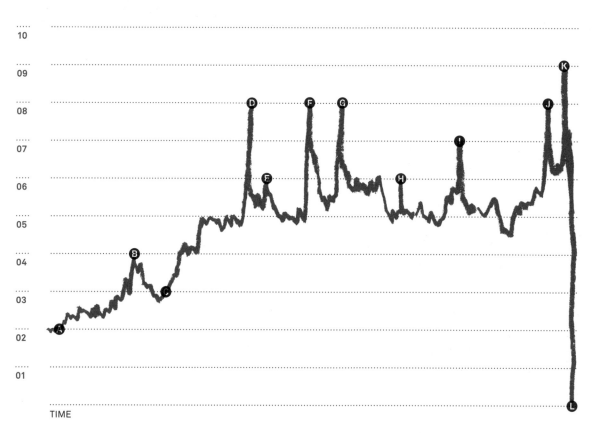

TIME

> 'The events of that day were to lead to the discovery of one of the most bizarre crimes in the annals of American history, The Texas Chain Saw Massacre.'
> — Narrator

If the first half hour is about dread, the second is about shock. Having slow-burned through the journey to the Hardestys' old family home, the film kills off everyone but Sally in twenty indelible minutes. Kirk (William Vail) and Pam (Teri McMinn) are the first to go, and suffer the most iconic fates.

While walking to a nearby farmhouse to see if there is gas, they discover rows of cars hidden under camouflage netting and a human tooth ⊙ on the porch, but foolishly persevere. Kirk heads into the dark entrance hall, at the end of which is a metal ramp, an industrial-looking entrance and a deep-red wall festooned with animal skulls. Undeterred, he practically skips inside, tripping and stumbling as Leatherface, a brute wearing a mask of human skin, fills the doorway ⚡. With the wet thunk of a hammer blow, Leatherface knocks Kirk to the floor, where he begins to twitch involuntarily. Stilling him with another smack, Leatherface then carts off his body and slams the metal shut. The terror here comes not from the heart-in-mouth surprise of the jump scare – or not *just* that – but from the fact that Kirk's messy, merciless death seems like an inevitability ◔. Kirk, we feel, is the trespasser here, while Leatherface, an out-of-work abattoir employee, is just doing his job. It is not murder we are watching, but slaughter; not sadism so much as efficiency.

Pam's death is more drawn out. Having explored the interior – a charnel-house Hades of rotting carcasses and macabre bone sculptures – she is grabbed by Leatherface and carried screaming through to the back room. Here, she is hung, squirming, on a meat hook as Leatherface dismembers Kirk by chainsaw. Though the scene is incredibly brutal, it is not, crucially, gory. As Hooper said of Pam's death, 'There's no blood running from her body into the tub, but you know what the tub is for.'

After finishing off Jerry (Allen Danziger) too, Leatherface runs to the window, chittering and moaning. Perhaps because he did not feature in the sequels, Hansen's performance rarely gets the recognition it deserves. Whether squealing like an animal, raging like an angry toddler, or fretting as to where all these teenagers might be coming from, Leatherface is a terrifying creation. While his cracked-skin mask is disturbing on its own – particularly when we see him lick his lips – there are clearly ugly, raging feelings underneath, a far cry from the blankness of Michael Myers in *Halloween* or Jason Voorhees in *Friday the 13th*. 'Man was the real monster,' Hooper told *Rue Morgue* magazine, 'just wearing a different face, so I put a literal mask on the monster in my film.'

For Hansen, a degree of method acting was involved. He visited a special-needs school as research, and kept in character far longer than recommended. 'It was 95, 100 degrees every day during filming,' he told writer Stefan Jaworzyn. 'They wouldn't wash my costume because they were worried that the laundry might lose it, or that it would change

colour. They didn't have enough money for a second costume. So I wore that mask twelve to sixteen hours a day, seven days a week, for a month.' It is little wonder, then, that the role began to take him over. Later on, when Sally is threatened with a hammer, 'I remember thinking: yes, kill the bitch,' Hansen told Zinoman. 'It was the one moment when I lost it and became Leatherface.'

The last thirty minutes are so relentless , it feels like we are watching events unfold in an awful alternate universe. After all, the first image of the film proper is the sun burning through the blackness during a solar eclipse, and Pam's horoscopes talk of 'malefic planets'. Following the death of her brother – by chainsaw, at last – Sally is chased, caught and tortured by Leatherface and his family, which includes the hitchhiker and the gas station proprietor, as well as the decrepit Grandpa (John Duggan), whose make-up represents one of the film's only obvious flaws.

The ensuing family dinner was shot over a twenty-six-hour day under baking hot lights, on a set full of rotting meat, and it has the

> 'My family's always
> been in meat.'
> — Hitchhiker

quality of real, leaking madness. The characters shriek and taunt Sally, Leatherface cuts her palm for Grandpa to drink (the wound was genuine because the fake blood would not work) and we can see actual trauma in Burns's eyes in the form of broken blood vessels. When she pleads for it all to stop, we know exactly how she feels. But, as Hooper told *Interview* magazine, 'You can't get away, you can't escape. You'll jump through a plate-glass window several times and end up being right back in the spider's web.'

The final scene is, in its own twisted way, oddly beautiful. Sally breaks free once more and makes for the road, where she flags down a slaughterhouse truck and a flatbed van, while Leatherface and the hitchhiker pursue her. After the hitchhiker gets flattened by the truck – a nice touch – Leatherface falls and nearly cuts his own leg off, but remains undeterred. We last see Sally in the back of the flatbed, caked in blood and screaming so hard it seems like it might tip over into laughter. As morning breaks around him, Leatherface pirouettes with his chainsaw; the world awake, but the nightmare continuing.

Further viewing

JUST BEFORE DAWN 1983
'Where we're going is no summer camp,' outdoorsy Warren (Gregg Henry) warns girlfriend Connie (Deborah Benson) and their buddies as they head into the Oregon mountains. But location is not the only element that distinguishes Jeff Lieberman's hicksploitation slasher from its 1980s brethren. Though the antagonists – huge, inbred twins (both played by John Hunsacker) who giggle like children 😈 – are not particularly menacing, Lieberman makes good use of them. One effective scene sees Megan (Jaime Rose) and Jonathan (Chris Lemmon) skinny-dipping in a beautiful lake, as one of the brothers lumbers through the waterfall mist behind them 🚰. Another has Jonathan attacked on an already perilous-looking rope bridge, only to find the other twin waiting on the other side ⚡. George Kennedy, meanwhile, provides solid support as a world-weary ranger with his trusty white horse, and Connie's takedown of the last brother standing has to be seen to be believed.

THE ORDEAL 2004
Set in rural Belgium as Christmas approaches, Fabrice du Welz's savage black comedy has a lunatic logic all of its own. Cabaret singer Marc Stevens (Laurent Lucas) scrapes a living playing old folks' homes. After his van breaks down in the middle of nowhere, he takes a room at the deserted Bartel Inn, where the attitude of the owner (Jackie Berroyer) shifts from hostility to possessiveness overnight. 'Don't go to the village!' he warns. When Marc stumbles upon a group of locals having sex with a piglet 😵 he soon sees why. But Bartel, it transpires, has designs of his own, convinced that Mark is his estranged wife, Gloria 😈. As the grotesqueries pile up, Marc finds himself beset on all sides by squealing livestock and amorous locals 🔪, as they storm the inn to claim him for themselves. The result plays like *Deliverance* remade by the League of Gentlemen.

THE HILLS HAVE EYES 2006
With Wes Craven's (deadly) blessing, French writer/director Alexandre Aja (*Switchblade Romance*) offers a slick, savage update on the uneven 1977 original. While crossing the New Mexico Desert on a convincingly tetchy family holiday, the Carters break down in the middle of nowhere and are attacked by mutant cannibals, the result of nuclear testing in the area. Long shots show the Carters surveilled from a distance by binoculars 🔭, and a raid leaves most of them dead or brutalised, with baby Catherine (Maisie Camilleri Preziosi) stolen for food. When new father Doug (Aaron Stanford) ventures into the hills to try and get her back, he finds a perfectly preserved village full of eerie mannequins 😈. Though their grievances with the government are legitimate, the mutants' deformed bodies and radiation-ruined faces are designed to repulse 😵. Revenge, when it comes, is so blisteringly violent that it destroys the Carters' veneer of civilisation completely.

43

Who Can Kill a Child?

Youth in revolt

RELEASED 1976

DIRECTOR NARCISO IBÁÑEZ
SERRADOR

SCREENPLAY NARCISO IBÁÑEZ
SERRADOR (AS LUIS PEÑAFIEL),
JUAN JOSÉ PLANS (NOVEL)

STARRING LEWIS FIANDER, PRUNELLA
RANSOME, ANTONIO IRANZO, MIGUEL
NARROS, MARÍA LUISA ARIAS

COUNTRY SPAIN

SUBGENRE KILLER KIDS

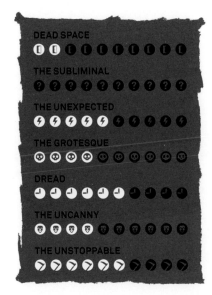

DEAD SPACE

THE SUBLIMINAL

THE UNEXPECTED

THE GROTESQUE

DREAD

THE UNCANNY

THE UNSTOPPABLE

Writer/director Narciso Ibáñez Serrador's controversial Spanish chiller begins with some of the most upsetting footage ever seen in horror cinema. Between snatches of giggles and Waldo de los Ríos's theme song, hummed in flat, childish voices ●, newsreel from Auschwitz, Biafra and Vietnam details the horrendous crimes that adults have perpetrated against children over the years: napalm on naked flesh, the bloated stomachs and rag-doll bodies. As Serrador explains on the DVD extras: 'We kill them. We kill them with wars. We kill them with bombs. We kill them with famine. The children are always the victims.' In truth, this introduction is almost too much for the film that follows, which is sledgehammer-subtle but singular in its strange, sun-baked style.

When a dead body washes up on the beach in the fictional Benavís, Spain, it is found by a little blond boy, then removed by the authorities. Next, we meet English tourists Tom (Lewis Fiander) and Evelyn (Prunella Ransome) as they arrive into town at fiesta-time. Tom, a seasoned traveller who speaks the local lingo and is never happier than when mansplaining things to his wife, is an unappealing protagonist. Evelyn, meanwhile, is more sympathetic. She is heavily pregnant with their third child, which Tom wanted to abort because they have two already. Oppressed by the crowds and noise, they decide to travel to a nearby island called Almanzora (also fictional). Before they leave, a neat bit of foreshadowing ● shows a group local kids attacking a piñata, then falling hungrily upon its contents. The next time we watch children swarm, the explanation won't be nearly so innocent.

Having arrived on the island, and chatted with some boys who are fishing – but refuse to reveal what bait they are using – the pair wander the eerily deserted streets. While Tom looks for provisions, Evelyn waits in a bar: the silhouette of a young girl appearing through the beads of the doorway behind her ●. The girl comes and strokes Evelyn's stomach in fascination ●, the meaning of which will not be apparent until later. When the girl leaves, the pair are interrupted by a distressed phone call from a Dutch woman trapped somewhere on the island, but then head to their hotel confused and alone.

'Oh yes, there are lots of children in the world. Lots of them.'
— Boy

While some viewers have criticised this exploratory section of the film for being too slow, it sustains the mystery without giving Tom and Evelyn enough reason to simply turn and run. The crisis point comes after forty-five minutes, in a jolting section of shock reveals and sudden violence.

In quick succession, Tom sees a girl beat an old man to death with his own stick 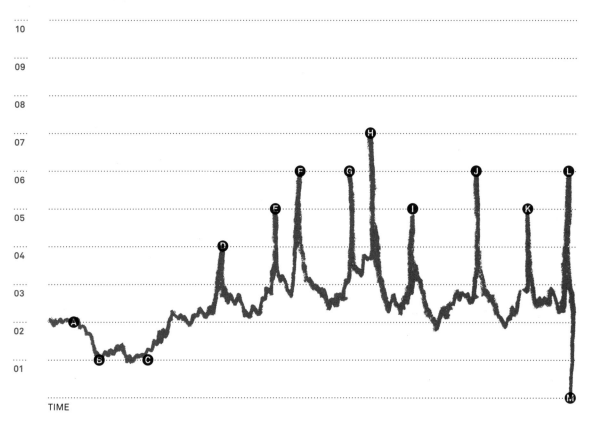, while a version of the theme song plays like strained circus music ⓖ. 'Why?' Tom screams at her, 'why have you done this?'. But she just laughs and runs off. Next, we watch a group of children playing piñata again, but with the old man's bloodied corpse ⓗ. Finally a local (Antonio Iranzo) appears in the hotel and explains how, two nights ago, the children of the island started killing everyone. He tried to fight back, but, 'Who can kill a child?'

Who indeed? From here the atrocities pile up, as Tom and Evelyn begin to comprehend the full extent of the horror and try to escape. One chilling scene shows a group of young boys laughing as they peek under the clothes of a female corpse in the church. Another, on the less inhabited side of the island, shows the children telepathically communicating with each other like something out of John Wyndham's 1957 sci-fi novel *The Midwich Cuckoos* (filmed as *Village of the Damned*). When a fisherwoman (Brit van der Holden) chides them, they just stare at her as their friends start to mass, silently, on the headland behind her ⓛ.

SCARE RATING

10

09

08

07

06

05

04

03

02

01

TIME

Further viewing

LONG WEEKEND 1978
Set in coastal Australia, where everything can kill you, and written by Ozploitation legend Everett De Roche, Colin Eggleston's horror takes the nature-fights-back flick to the nth degree. As their marriage disintegrates after an abortion, mismatched couple Peter (John Hargreaves) and Marcia (Briony Behets) go on an ill-fated camping trip to Moonda Beach – no matter that there is an abattoir just up the road, and the locals have never heard of it. The trouble begins right away. The pair drive around in circles for hours, and when they do pitch camp they find themselves beset by ants, eagles and the eerie moans of a dugong, which recall the cries of a human baby ⑧. Although De Roche lays things on a bit thick, and the characters (particularly the loathsome Peter) are begging for their comeuppance, things build to a genuinely disconcerting conclusion ⊙ and the punchline, when it comes, is pitch perfect.

FORTRESS 1985
Based on Gabrielle Lord's 1980 novel, itself inspired by real events, Arch Nicholson's Australian survival thriller tips over into *Lord of the Flies*-style horror at the last. British teacher Sally Jones (Rachel Ward) runs a tiny outback school. One day, four masked men kidnap her and the kids, drive them into the bush and trap them in a cave demanding a ransom. Led by Father Christmas (Peter Hehir), a volatile character with a particularly unsettling grinning Santa mask ⑨, the kidnappers (including future *Mad Max 2* star Vernon Wells) are made even more menacing because they barely show their faces. And although some of the kids are disconcertingly young, some are on the verge of puberty, adding sexual unease to the peril. Tense to begin with, the film becomes nightmarish and gruesome ⊙ as Sally and the kids fight back, and the sting in the tail is both shocking and apt.

THE CHILDREN 2008
Over a fraught New Year's holiday, Elaine (Eva Birthistle) brings her blended family – new partner Jonah (Stephen Campbell Moore), teenage daughter Casey (Hannah Tointon) and two little ones – to visit her rich sister Chloe (Rachel Shelley), husband Robbie (Jeremy Sheffield) and their brood at their picturesque country house. Upon arrival little Paulie (William Howe) is sick, and soon the others are exhibiting strange symptoms too: an extreme close-up of a pillow reveals an infestation of clustering CG germs ⊙. 'Did you ever hear of contraception?' asks Casey, rolling her eyes. Amid the controlled chaos, writer/director Tom Shankland creates an atmosphere of real dread ⊙, emphasising the kids' inherent otherness ⑨, whether they're staring off into the distance, speaking their own languages or scaring each other. When they finally attack, the violence is messy and motiveless, with crayons and climbing frames put to inventively bloody use.

TIMELINE

Ⓐ	5 MINS	CASUALTIES OF WAR
Ⓑ	10 MINS	BEACH BODY
Ⓒ	20 MINS	FIESTA TIME
Ⓓ	35 MINS	LOCAL GIRL
Ⓔ	45 MINS	STICK MAN
Ⓕ	50 MINS	PLAYING PIÑATA
Ⓖ	60 MINS	'WHO CAN KILL A CHILD?'
Ⓗ	67 MINS	CHURCHY LA FEMME
Ⓘ	77 MINS	RUN!
Ⓙ	85 MINS	JAIL TIME
Ⓚ	95 MINS	BABY BLUES
Ⓛ	104 MINS	SAFE HARBOUR?
Ⓜ	105 MINS	ENDS

What is so unsettling about the kids is not that they are scary or evil-looking (unlike in *Village of the Damned*), but that they turn to violence so blithely. As Serrador explains: 'They act like children because they *are* children and it's just some sort of game that they play, even though it's a macabre game.'

When Tom and Evelyn find themselves trapped in the town jail, with the children outside trying to batter down the doors, the film's rhetorical title becomes even more relevant. Not only have they contemplated abortion, they must now fight back to survive. The last act sees their taboo-breaking brutality push new boundaries ⊙. Tom shoots a little boy in the head; Evelyn is attacked from within by their unborn baby; and the resolution is so bleak it could have been borrowed from George A. Romero's *Night of the Living Dead*. Given the seriousness of his subtext, Serrador ends the film the only way he could have, with the children, victorious, plotting their next move. Today, Almanzora, tomorrow the world.

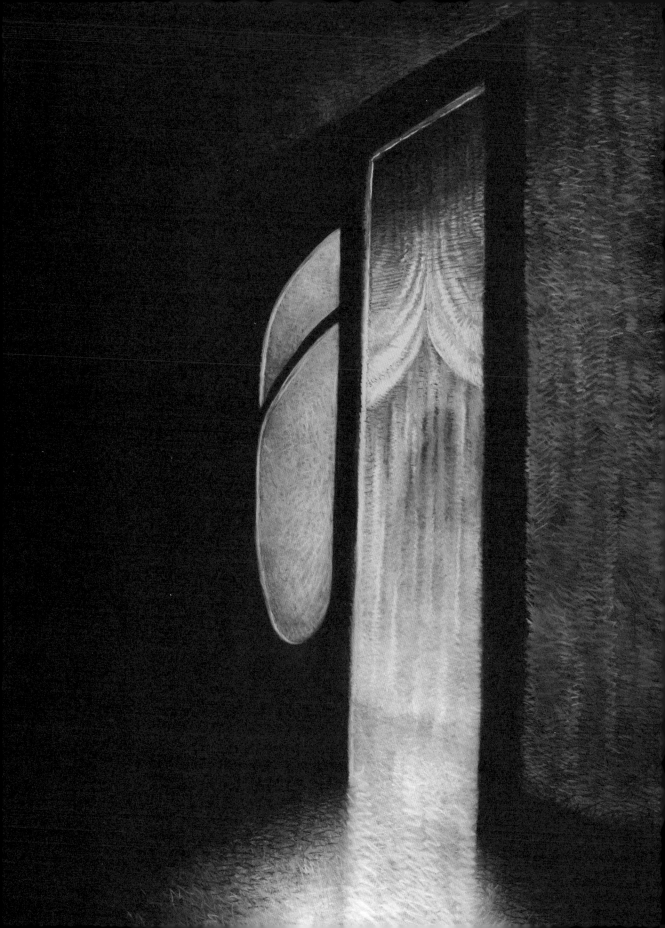

Suspiria

A discovery of witches

RELEASED 1977

DIRECTOR DARIO ARGENTO

SCREENPLAY DARIO ARGENTO, DARIA NICOLODI

STARRING JESSICA HARPER, STEFANIA CASINI, BARBARA MAGNOLFI, ALIDA VALLI, JOAN BENNETT

COUNTRY ITALY

SUBGENRE OCCULT

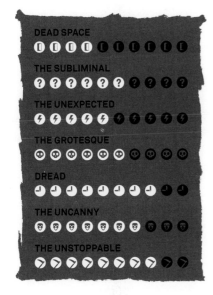

DEAD SPACE

THE SUBLIMINAL

THE UNEXPECTED

THE GROTESQUE

DREAD

THE UNCANNY

THE UNSTOPPABLE

The opening to Dario Argento's glorious, gale-force horror is so intense it is not clear whether the film – or the viewer – will recover. Unusually for the Italian maestro, whose previous *gialli* thrived on outlandish narrative about-turns, the plot is simple. American ballet student Suzy Bannion (Jessica Harper) arrives at the Freiburg Dance Academy (actually a witches' coven) during a storm, just missing a double murder. But as ever with Argento, it is not what happens, but how.

The first sequence plunges us straight into the maelstrom. Walking through the airport, Suzy heads towards the exit to hail a cab, but what should be a simple bit of scene-setting is instead suffused with heart-pounding dread ◔. The arrivals hall is swathed in swollen red light, the camera zooms suggestively towards the automatic doors, and the score, by frequent collaborators Goblin, has an unhinged quality all of its own.

Even before the credits are over, the music has the viewer on edge. Built around a demented nursery-rhyme theme, it is overlaid with whispers and banshee screams, and punctuated by the twang of the bouzouki. This Greek instrument sounds like the heartbeat of a mighty beast ◉, and calls to mind the ragged breathing of the antagonist, head witch Helena Marcos. Ever the agitator, Argento was known to blast the music during shooting. 'It was really loud,' he told *Another Man* magazine, 'it created a strong emotion while filming!'

The first major setpiece continues the hysterical tone. Outside the academy, Suzy sees a pupil, Pat (Eva Axén), running off through the woods. Later, at her friend Sonia's apartment (Susanna Javicoli), Pat senses something moving beyond the bathroom window, and a tremendously tense back-and-forth ◔ ensues. First, she sees washing flailing on the clothes line outside, then huge cat's eyes appear, then a hairy arm (actually Argento's) shoots through the glass to grab her ⚡. Next, she is stabbed in the heart in thumping close-up ◉, and hurled through the stained-glass roof below. The sequence ends with Pat hanging from a rope, as Sonia, impaled by red and blue shards of glass, lies dead beneath. 'First, I want to create opulent beauty,' Argento told *Vice*, 'and then kill it off with a stab.'

'A coven deprived of its leader is like a headless cobra: harmless.'
— Professor Milius

Over the years, Argento has been accused of favouring style over substance, but that is unfair here. *Suspiria*'s heightened visuals were inspired by the 'impassioned prose' of Thomas De Quincey's 1845 essay *Suspiria de Profundis*, and clever cultural references abound. For example, the academy is situated on Escher Straße – a nod to the artist M.C. Escher, whose impossible stairways and tessellating creatures can be seen on walls throughout the film.

Such cinematic excesses are employed with good reason: to disorient the viewer. As Suzy discovers, the academy is an impossible, Alice-in-Wonderland space where anything can happen. Huge decorative snakes slither up the staircases, real maggots fall from the ceilings ☺, and one room is entirely full of barbed wire, as Suzy's friend Sara (Stefania Casini) discovers to her cost.

Argento and his co-writer Daria Nicolodi originally conceived the story being about much younger girls, but kept the interiors the same to emphasise the fairy tale aspects, with too-high windows and huge rooms that dwarf the characters. Even the decor – all arterial reds, sapphire blues and sickly greens – feels malign. Although it was many years out of date by the late 1970s, Argento used the same three-strip Technicolor printing techniques as *The Wizard of Oz* to create a palette of oppressively vibrant colours. Combined with the expressionistic lighting and Goblin's demonic score, they lend the film a genuinely nightmarish quality.

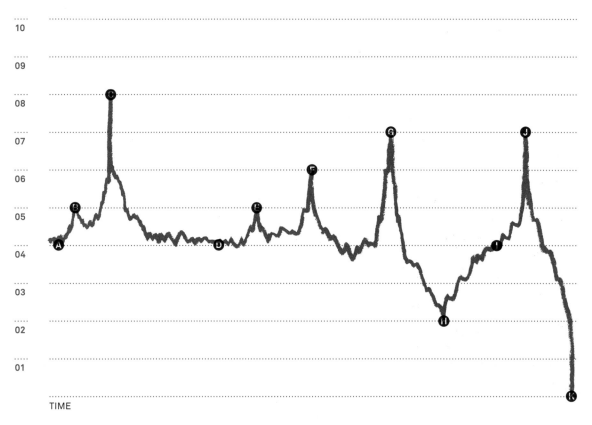

SCARE RATING

TIME

Further viewing

BLACK SABBATH 1963
Loosely based on short stories by Tolstoy, Maupassant and Chekov, Mario Bava's stylish portmanteau is notable for two things. First is the insane intro/outro from star Boris Karloff, which either constitutes a career high or low depending on your viewpoint. And second is the terrifying final tale 'The Drop of Water', which follows 'The Telephone', a mini *giallo*, and 'The Wurdulak', an Eastern European variant on the vampire story. The plot is simplicity itself. Nurse Helen Chester (Jacqueline Pierreux) is called to attend to the body of a dead medium – a truly horrifying mannequin 😵 with big eyes, a twisted jaw and greenish skin – from whom she steals a sapphire ring. But as a storm rages outside, casting her apartment in exaggerated hues, the deceased returns to claim her property, her awful presence announced by, among other things, a buzzing fly and the dreadful 🕐 drip-drip-drip of a tap.

THE EVIL DEAD 1981
Full of delirious colours, manic camera moves and gleeful, Looney Tunes energy, Sam Raimi's debut is hard to resist, despite the amateurish performances and threadbare production values. When Ash (Bruce Campbell) and his four friends turn up at the original cabin in the woods, they are menaced by 'deadites' – demons unleashed by the *Naturan Demanto* (a Sumerian version of Egypt's *Book of the Dead*) they find in the cellar. Whether floating impossibly across bubbling swamps, following eerily behind Ash's car at tree-height, or breaking through the window like a battering ram, the camera feels possessed 🕐. After Cheryl (Ellen Sandweiss) is assaulted by trees (a scene even Raimi regrets), the splatter begins in earnest, an orgy of dismembered limbs, drooling creatures and dribbling body fluids 😵. Stephen King was so impressed he called it 'ferociously original' in *Twilight Zone* magazine, kickstarting a franchise that flourishes to this day.

BLACK SWAN 2010
When goody-two-shoes dancer Nina Sayers (Natalie Portman) lands the lead role in the New York City Ballet's performance of *Swan Lake*, the stage is set for a startling psycho-sexual awakening. Ruthless company boss Thomas Leroy (Vincent Cassel) wants Nina to explore her dark side, her mom (Barbara Hershey) is overbearing to the point of insanity – with a room full of pen-and-ink drawings of her daughter – and new girl Lily (Mila Kunis) flits between seduction and sabotage. Soon Nina is seeing an evil doppelgänger stalking past her on the subway 👽 and gradually taking over her life – but how much of it is real? Writer/director Darren Aronofsky has a wicked grasp of how Nina's tortured physicality and fragile psyche feed into one another. So it feels inevitable when the film tips over into body horror 😵, with black feathers breaking painfully through her skin as the grisly transformation takes hold.

In one of its most celebrated sequences, blind accompanist Daniel (Flavio Bucci), who has been dismissed from the academy, walks home across a vast, empty square. As the *Suspiria* theme builds from breathy whispers to tribal drums, and his guide dog begins to bark, we see him from below, then far away, the camera seeming to surround him. 'Who's there?' he shouts, turning towards what looks like the gargoyle of an eagle atop a distant rooftop. Unprompted, the camera swoops down towards him, we hear beating wings, and see rushing shadows silhouetted on the walls 👽, but still nothing tangible appears. When everything quiets, the dog rips his throat out ⚡, but the sense is that the world is plagued by unseen forces, and that anything might happen at any time ➤.

Though nobody could accuse Argento of subtlety – indeed, you sense he might be affronted by the suggestion – the film also contains a near-subliminal scare that most viewers miss ❓. During the opening sequence, as Suzy harangues the cab driver amid lunatic swirls of light, it is just possible to discern a face reflected in the right-hand corner of the screen. It is Argento's and, if you look closely enough, he is screaming too.

Halloween

Eve of destruction

RELEASED 1978

DIRECTOR JOHN CARPENTER

SCREENPLAY JOHN CARPENTER, DEBRA HILL

STARRING DONALD PLEASANCE, JAMIE LEE CURTIS, NANCY KYES, P.J. SOLES, CHARLES CYPHERS

COUNTRY USA

SUBGENRE SLASHER

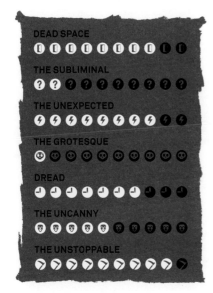

DEAD SPACE

THE SUBLIMINAL

THE UNEXPECTED

THE GROTESQUE

DREAD

THE UNCANNY

THE UNSTOPPABLE

When it comes to frightening people, originality is overrated, if not impossible. So for *Halloween*, John Carpenter simply borrowed from the best: the basic plot of *Black Christmas*, several scares from *The Innocents*, a theme tune that recalled *The Exorcist* and character names that nodded to Alfred Hitchcock. It even stars Jamie Lee Curtis, daughter of *Psycho*'s Janet Leigh. 'Horror films have been around since the beginning of cinema and each one leads to another so they continue to morph and change depending on society,' Carpenter told the BBC. 'None of this is new. There are just new ways of telling stories.'

Written in ten days with co-producer Debra Hill, and shot in twenty, *The Babysitter Murders*, as it was originally called, is an exercise in merciless minimalism. With no real gore, little sex and scant motivation for its masked killer Michael Myers, the result was a pure, dead-ahead dose of horror.

The opening sequence is all about dread ◔. Inspired by Orson Welles' *Touch of Evil*, it takes the form of a four-minute, seemingly unbroken Panaglide point-of-view shot that stalks through a suburban house in Haddonfield, Illinois, on Halloween night, 1963. To a soundtrack of starkly descending chords, we – the camera – spy on two teenagers making out through the window. Then, as they move upstairs for (extremely brief) sex, we pick up a kitchen knife, watch the boy leave, and head upstairs too. Next, we don a mask, which all but covers the lens, walk in on the girl, who's half-naked and brushing her hair, and stab her to death. At the scene's climax, the killer is revealed to be the girl's little brother, six-year-old Michael Myers (Will Sandin), in a Halloween costume.

However, it is not really about exposition, but anticipation. Point-of-view shots make the audience ask themselves anxious questions – 'What is going to happen next? What the hell are we going to see?' – but delay the answer. Moreover, cinematographer Dean Cundey's eerily smooth camera movements make the assailant seem almost supernatural, a possibility the rest of the film does not dispel.

Next, we skip forwards fifteen years to Smith's Grove Mental Hospital on the evening before Halloween, 1978. In the hammering

> 'It's Halloween,
> everyone's entitled
> to one good scare.'
> — Sheriff Brackett

rain, Dr Sam Loomis (Donald Pleasance) – a good deal more interesting than his namesake in *Psycho* – and nervous nurse Marion (Nancy Stephens) – a good deal less – arrive by car to transfer Michael Myers. 'Don't underestimate it,' warns Loomis, the film's Cassandra. 'I think we should refer to "it" as "him",' says Marion, but she soon learns.

When Carpenter's main *Halloween* theme strikes up again, we know something is amiss. 'Since when do they let them wander around?' says Marion, innocently as, up ahead, we see patients milling about in the darkness, their white robes giving them the appearance of ghosts 🅐. Before Loomis can alert the guards at the perimeter, Michael leaps on top of the car 🅐 and grabs Marion, who crashes. She struggles free, and falls back into the passenger seat, but a hand appears in the dead space behind her 🅘 smashing the glass. The scene ends with Michael driving off to fulfil the awful promise of that tagline: the night he came home.

Back in Haddonfield on Halloween morning, we meet sweet, sensible teenager Laurie Strode (Curtis), described as 'seventeen and pretty in a quiet sort of way' in the script. Her dad (Peter Griffith), a real-estate agent, asks her to drop off a key at the Myers house. In most films the scenes that follow would be dull, mere placeholders before the main event, but Carpenter's timing and framing are so immaculate he makes them just as scary as what happens later that night.

SCARE RATING

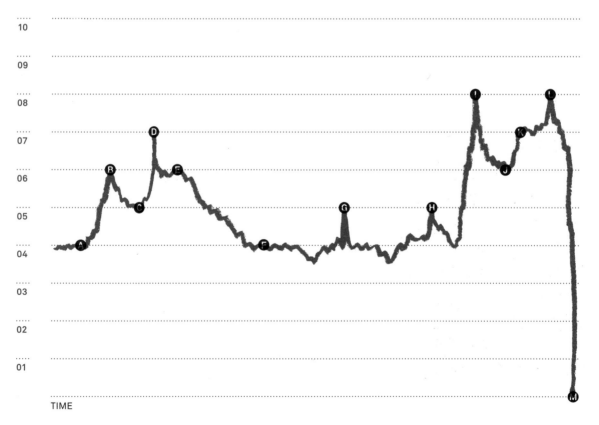

10

09

08

07

06

05

04

03

02

01

TIME

As we watch Laurie dropping off the keys from inside the house, Michael's silhouette steps into frame with a sudden doomy chord Ⓐ. Outside, when she walks off along the pavement, he stands watching, his breathing heavy and disconcerting. Later, at school, while the teacher talks of destiny, Laurie sees Michael through the classroom window, wearing a white mask Ⓑ, staring. 'There was a movie called *The Innocents* made in the sixties where the ghosts are standing across a pond, just looking,' Carpenter told writer Jason Zinoman. 'There's something arresting about it. It stuck in mind when making *Halloween*.' Laurie looks again, and Michael is still there. But the next time, he is gone. This is a pattern Carpenter repeats as Laurie meets her friends Annie (Nancy Kyes, stage name Loomis) and Lynda (P.J. Soles). They talk about boys and babysitting, and walk home along the sleepy suburban streets.

Because Michael keeps appearing – behind a hedge, among the washing lines – the sense of encroaching doom is palpable Ⓔ. And because Carpenter favours wide, empty frames and unattributed point-of-view shots, it feels like he could be lurking anywhere Ⓕ. 'That's all we had,' Carpenter told *Consequence of Sound*. 'We only had the style because we had a very slim plot: an escaped lunatic comes back to this town and starts killing these babysitters.'

> 'Death has come to your little town, Sheriff. Now you can either ignore it, or you can help me to stop it.'
> — Dr Sam Loomis

Although masked murderers would soon become a genre cliché, it is worth remembering how effective Michael Myers' appearance is. The mask's flat, white contours betray no emotion – no features even – and the eyeholes are so deep we see only blackness behind ❷. Not bad considering production designer Tommy Lee Wallace made it from a $1 William Shatner mask. 'He widened the eye holes and spray-painted the flesh a bluish white,' Carpenter told halloweenmovies.com. 'It truly was spooky looking. I can only imagine the result if they hadn't painted the mask white. Children would be checking their closet for William Shatner!'

If Loomis's famous speech to Sheriff Brackett (Charles Cyphers) – 'I spent eight years trying to reach him, and then another seven trying to keep him locked up, because I realised that what was living behind that boy's eyes was purely and simply evil,' – feels a little over the top, it is because what makes Michael scary is, as Carpenter told *Deadline*, 'an absence of character'. He never speaks, we only see his real face once (on reflection, probably a mistake), and he is played, as an adult, by three different actors (Nick Castle, Tony Moran and Wallace himself). The script even refers to him as 'the shape'; although Laurie and the kids she babysits call him 'the boogeyman'. 'In Hollywood there's an old saying: "The better the villain the better the movie."' Carpenter told Zinoman. 'That's not necessarily the case in the sense of what's scary. What's scary is something that's random, that's unknown. The unknown killer that walks up to you for no reason is utterly terrifying because you are defenceless.'

When night falls, Michael gets to work offing Laurie's friends. Annie is strangled from the back seat ❶ as she starts her car. Bob (John Michael Graham), Lynda's boyfriend, is rushed and stabbed ❹ in the kitchen. And Lynda herself endures the film's crassest punishment: a post-coital – topless – throttling by telephone cord with Michael dressed, rather stupidly, in a sheet and Bob's glasses. The climax, though, which has Michael stalking Laurie from house to house and room to room, is tense as hell ❹, with several tremendous scares.

Laurie finds her friends' bodies, backs away, and supports herself against a darkened doorway. In a moment clearly inspired by the appearance of Quint in *The Innocents*, we gradually make out Michael's mask in the murk ❶. Later, when it seems like she has killed him, he sits bolt upright behind her as she sobs ❶.

The sense here is not of a flesh-and-blood human killer, but of an unstoppable force ❷. To this end, Carpenter's jittery, ticker-tape synthesiser score is supremely effective. Like *The Exorcist* theme, it is in an irregular metre, with a repeated motif that conjures a sense of inevitability; that, whatever you do, you will be caught.

True to form, Loomis appears and empties his gun into Michael, who falls from the balcony, presumed dead. There follows an iconic

exchange that lends the horrors we have just witnessed a mythic quality. 'It *was* the boogeyman,' says the traumatised Laurie. 'As a matter of fact,' agrees Loomis, 'it was.' Sure enough, when he looks outside, Michael's body has gone.

The final images – of empty rooms, silent houses, watchful streets – are set to a soundtrack of heavy breathing 🎭. 'I wanted the audience not to know whether he was human or supernatural,' Carpenter told CBS. 'He had no character. He was blank. He was simply evil. He's like the wind, he's out there. He's gonna get you.' Carpenter could not have known it at the time, but this was just the beginning of a franchise – not to mention a genre – from which there would be no escape.

Further viewing

BLACK CHRISTMAS 1974
Inspired by a series of real murders that occurred in Montreal, this proto-slasher directed by Bob Clark (*Deathdream*) would provide a handy tick list of genre staples for the films that followed. As the eponymous holiday approaches, the residents of a Canadian sorority house (including Olivia Hussey and Margot Kidder) field obscene, seemingly *Exorcist*-inspired phone calls from an unknown source, then find themselves stalked by an intruder who climbs in through the attic and moves through the house with almost supernatural ease 🕐. Favouring strong, sexually confident women over helpless victims, and suspense over gore, Clark's less-is-more approach really pays off. The motiveless killer is only glimpsed in snatches – a hand here, a pair of livid, flashing eyes there 🎭 – and the open-ended conclusion is shocking in its cruelty. John Carpenter was clearly taking notes.

WHEN A STRANGER CALLS 1979
The reputation of Fred Walton's stalker movie rests on two standout sequences. At the beginning of the film, babysitter Jill Johnson (Carol Kane) is menaced by a nuisance caller. 'Have you checked on the children?' he asks, matter-of-factly. What is so effective is not the intrusion itself – Jill keeps calm, locks the doors and phones the police – but its relentlessness ⏩. The caller's repeated refrain, intercut with metronomic close-ups of a swinging pendulum and Dana Kaproff's nerve-rattling score, amp the dread up to unbearable levels 🕐. You can guess what is coming, of course, but the anticipation only adds to the mounting unease. The middle of the film, which cuts to seven years later and concerns the stalker (Tony Beckley) escaping from mental hospital and being tracked by cop John Clifford (Charles Durning), is forgettable. But the ending, in which Jill is the grown-up with vulnerable kids of her own, manages to up the stakes yet again.

TERROR TRAIN 1980
Playing out like a particularly racy Agatha Christie flick, Roger Spottiswoode's classy slasher traps Alana Maxell (Jamie Lee Curtis) and her student friends on a snowy steam train ride with a killer. An effective prologue shows Doc (Hart Bochner) and friends pranking Kenny (Derek MacKinnon) with a stolen corpse 😵, which leaves the poor sap screaming in disgust. Fast forward three years and it is time for a little payback. During a New Year's Eve costume party, complete with magician (a young David Copperfield) and band, someone starts attacking the passengers onboard, using different masks to conceal their identity. Although familiar enough to begin with, the film makes the most of a decent cast and an unusual, peril-filled location. The last stretch, which sees Alana pursued through the empty carriages by a murderer in a creepy old man mask 🎭 is extremely unsettling.

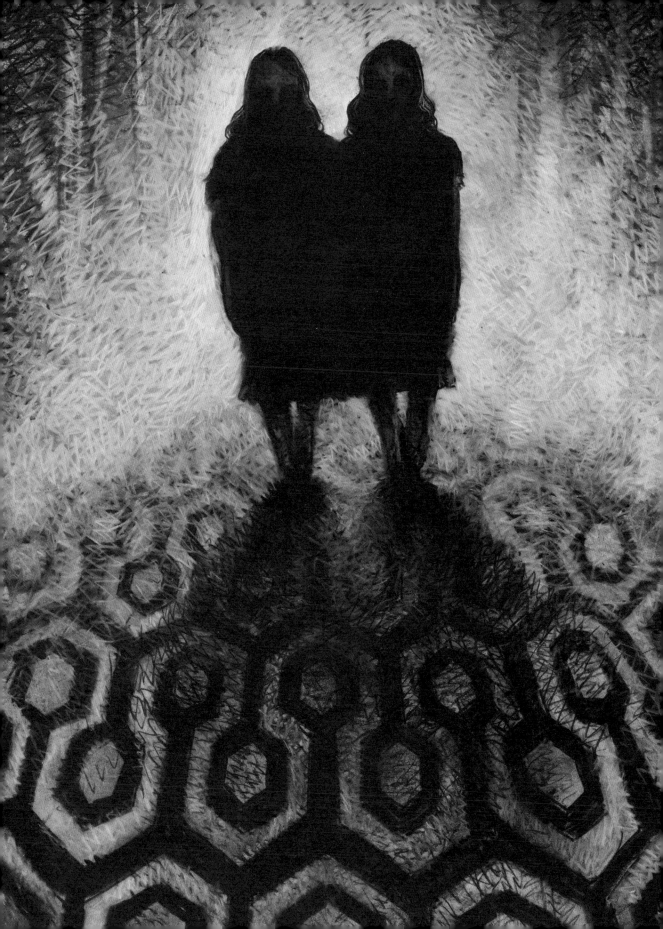

The Shining
Overlook classic

RELEASED 1980

DIRECTOR STANLEY KUBRICK

SCREENPLAY STANLEY KUBRICK,
DIANE JOHNSON, STEPHEN
KING (NOVEL)

STARRING JACK NICHOLSON, SHELLEY
DUVALL, DANNY LLOYD, SCATMAN
CROTHERS, BARRY NELSON

COUNTRY USA

SUBGENRE SUPERNATURAL

On paper, Stanley Kubrick was the perfect director to adapt Stephen King's 1977 novel. After all, he had mastered difficult books before (*Lolita*, *A Clockwork Orange*) and specialised in stories about characters crushed by huge, soulless 'machines' (*2001: A Space Odyssey*, *Full Metal Jacket*). But where King's work was passionate and loosely plotted; Kubrick's was cerebral and controlled. Indeed, the author was so unimpressed with Kubrick's vision, he told *Deadline*: 'It's like a big, beautiful Cadillac with no engine inside it.' Perhaps a fairer assessment is that, as a film, *The Shining* is incomplete and unbalanced – a maze without a centre. But it still contains moments of horror that stand up to any in the genre.

Failed writer Jack Torrance (Jack Nicholson) takes a job as the winter caretaker of the Overlook, a large, empty and secluded hotel in the mountains. He brings his wife Wendy (Shelley Duvall) and son Danny (Danny Lloyd), whose invisible friend Tony – actually an outlet for his second sight, or 'shining' – has premonitions of terrible things to come ◕. At the interview, hotel manager Stuart Ullman (Barry Nelson) tells Jack of a previous caretaker, Charles Grady, who developed cabin fever and murdered his wife and two daughters with an axe. If that were not warning enough, Jack's reaction, 'Well, that is *quite* a story,' should set alarm bells ringing.

While the Torrances tour the hotel, cook Dick Halloran (Scatman Crothers), who also has the shining, tells Danny about the Overlook. 'Some places are like people, some shine and some don't,' he says, adding that, 'A lot of things happened right here, in this particular hotel, over the years – and not all of them was good.' 'What about room 237?' asks Danny. 'Stay out,' is Halloran's not-particularly-helpful response ◕.

As winter sets in, Danny and Jack are both affected by the hotel's malign influence, although concrete explanations are few and far between. 'I read an essay by the great master H.P. Lovecraft where he said that you should never attempt to explain what happens, as long as what happens stimulates people's imagination, their sense of the uncanny, their sense of anxiety and fear,' Kubrick told writer Vicente

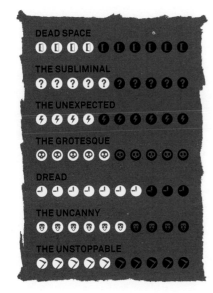

DEAD SPACE

THE SUBLIMINAL

THE UNEXPECTED

THE GROTESQUE

DREAD

THE UNCANNY

THE UNSTOPPABLE

'Little pigs, little pigs, let me come in. Not by the hair of your chinny-chin-chin? Well then I'll huff and I'll puff, and I'll blow your house in.'
— Jack Torrance

Molina Foix. When it comes to the uncanny, few could dispute the film's glacial power.

Recreated by production designer Roy Walker in a series of cavernous yet claustrophobic sets at Elstree Studios, Hertfordshire, the Overlook is a place where nothing makes sense. When we follow Jack from the foyer to Ullman's office, the room is lit by an architecturally impossible window looking out on the snow, rather than into the centre of the hotel. Meanwhile, pieces of furniture move between shots, props change colour, and Wendy and Danny watch a TV with no power cord. Whether we notice them or not, these near-subliminal details ❷ must be considered intentional, and intended to unsettle.

While Wendy and Danny explore the hotel's hedge maze, Jack stands by a scale model inside and watches them appear as tiny figures ❸ beneath him. As the camera zooms in closer, and the music crescendos, it feels like the characters' fates are mapped out for them; that the Overlook is a place where history is cursed to repeat itself, just as Jack will channel Grady by attacking his family in the famous 'Here's Johnny!' sequence.

Though the cause of the hauntings is never explicitly stated, the Overlook was built on a native American burial ground, and seems to represent the brutal founding of America. On the drive to the hotel, Wendy and Jack talk of the Donner Party, a group of pioneers who

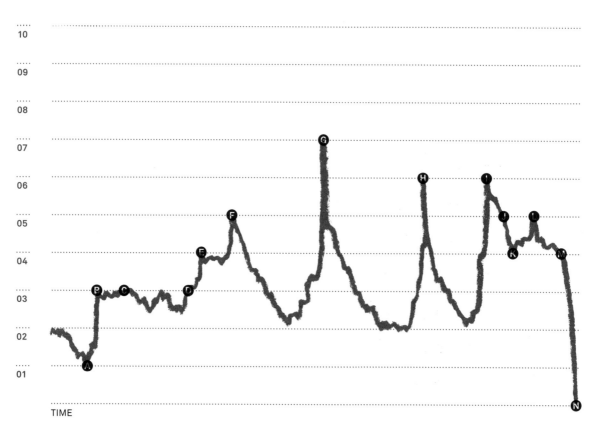

SCARE RATING

10

09

08

07

06

05

04

03

02

01

TIME

resorted to cannibalism while lost in the mountains. Meanwhile, an American flag stands on Ullman's desk; the hotel is full of native American textiles; and the blood-spewing elevators suggest mass genocide. As a theory this throws up more questions than it answers – not, as Kubrick realised, necessarily a problem in horror – but the subtext feels retrofitted, arising from the film-maker's concerns rather than the characters', so it distracts rather than disconcerts.

Where *The Shining* chimes best with Kubrick's talents is in the deployment of dread 🕐. Indeed, the shining itself is a form of dread, sending Danny, Halloran and (it is implied) Jack snapshots of the hotel's brutal past. Before Danny has even set foot in the Overlook, he sees rivers of blood 👁 pouring from the elevator and quick cuts of the Grady daughters (actually identical twins Lisa and Louise Burns) in their matching outfits.

The extended tracking shots, by Steadicam inventor Garrett Brown, create a sense of anticipation, following just behind Danny's tricycle as he pedals through the corridors, the soundtrack flaring loud then soft as the wheels move from wooden floor to rug and back again. This means that Danny sees around each corner before we do, but not fast enough to change course – like the shining itself 🕐. In one iconic scene, it is the Grady daughters standing there, holding hands.

'I'm sorry to differ with you, sir, but you are the caretaker. You've always been the caretaker.'
— Delbert Grady

'Come and play with us, Danny,' they say in unison 😈, as cymbals crash and Kubrick cuts to their blood-spattered corpses 💀. 'For ever and ever and ever.'

The film's standout sequence comes a little later, as Jack enters room 237 while, elsewhere, Dick Halloran and Danny stare off into space 😈, as if watching the horror unfold at a distance. It begins as a Steadicam shot from Jack's point of view, which floats towards the bathroom, with heartbeat-like percussion on the soundtrack 🕐. Jack opens the door with a slow push to reveal a figure in the bathtub, the shower curtain drawn. It is a naked woman (Lia Beldam), who comes closer to kiss him. Mid-embrace, the score turns to dissonant strings and Jack looks in the mirror to see her turned into a rotting crone (Billie Gibson) 💀 with a shrieky, reverberating laughter. Now the Steadicam point of view – and the power – belongs to her, and Jack backs away in horror, simultaneously seduced and repulsed by the Overlook and its ghosts.

Further viewing

SESSION 9 2001
Brad Anderson's not-quite-ghost story shows isolated characters gradually overwhelmed by the atmosphere of a troubled place. In this case it is a team of contractors hired to clear a derelict Massachusetts mental hospital. Just as the asbestos they are treating leaves a deadly residue, so the building – an especially eerie location full of broken medical equipment, graffiti and mementoes left by the inmates – affects them all in different ways. Overworked boss Gordon (Peter Mullan) becomes increasingly estranged from his wife and new baby; while law-school dropout Mike (Stephen Gevedon) obsesses over the therapy sessions he finds on a series of old tapes. Although Anderson can't quite tie all the loose threads together, there are creepy moments aplenty as the characters lose themselves – in more ways than one – in the endless corridors, while the voices of former patients 😈 swamp the soundtrack.

REINCARNATION 2006
Cleverly riffing on Kubrick's effort, this meta-horror from Japanese director Takashi Shimizu (*Ju-On: The Grudge*) concerns a film crew making a movie about a historic hotel massacre which left twelve people dead. It even (briefly) features a room 237 – although the crime itself took place in 227. When fragile actress Nagisa Sugiura (Yûka) is cast as the killer's daughter and final victim, she starts seeing a little girl (Mao Sasaki) holding a creepy doll everywhere, even under the subway train she is travelling on 😈. Though the hotel itself is now derelict, the movie set offers an exact replica and Nagisa glimpses the killer (Atsushi Haruta) standing behind the director 🎬, and corpses 💀 in the flash of the continuity camera. By the climax, the different strands come together as Shimuzi intercuts the killer's Super8 footage with the new film, and Nagisa hallucinates his victims creaking towards her as shambling, grey-faced ghosts 🕐.

LAST SHIFT 2014
Antony DiBlasi's supernatural thriller combines a striking location with smart, sins-of-the-fathers plotting. When rookie cop Jessica Loren (Juliana Harkavy) reports for duty at the about-to-be-decommissioned police station her dad worked at, strange things begin to happen. Despite the fact the phones have been rerouted, she receives distress calls relating to a historic, Manson-style massacre 🕐, then a vagrant (J. LaRose) wanders in, urinates on the floor, and starts ransacking the back rooms. All alone and unable to leave, Loren finds herself locked in a holding cell in the darkness, with something shining her torch back at her. 'I'm going to hurt you,' whispers a voice 😈, before the lights flicker on to reveal she is surrounded by bloody corpses with sacks over their heads ⚡. As the night goes on, and the hauntings get more acute, the sense is that the building itself has a score to settle.

We have already seen Jack drinking in the Gold Room bar with figures from the past – including one Delbert Grady (Philip Stone), who insists that Jack has always been the caretaker – but it is about this point we realise how crazy he really is. Has there ever been a more chilling distillation of a broken mind than the words, 'All work and no play makes Jack a dull boy,' typed out over and over again 🔵? The problem is, thanks to the casting of the volcanic Nicholson, Jack has *always* seemed like a man on the verge of violence.

In fact, this was Kubrick's intention: 'Jack comes to the hotel psychologically prepared to do its murderous bidding,' he said. 'In the hotel, at the mercy of its powerful evil, he is quickly ready to fulfil his dark role.' But he has forgotten Lovecraft's dictum. Or to put it another way, a man attacking his family for no reason is horror; but a man attacking his family because a hotel told him to is something else entirely.

Well before the final descent into violence – foreseen by Danny/Tony repeating the word 'redrum' ('murder' backwards) in that strange, scratchy voice 🔵 – comes a moment more chilling than any of Jack's outbursts. Danny walks into the bedroom to find Jack sitting, staring out the window like something inside him has stopped working. He picks Danny up, plays with his hair, holds him close and says he wishes they could stay 'for ever and ever and ever'.

The result is a rare, tender moment, beautifully played (especially by Lloyd), that tells us all we need to know. Danny loves his dad, but is scared of him. Jack loves his son, but will not be able to stop himself from hurting him. The idea of someone torn between their good and bad instincts is so much more frightening than the cartoon Big Bad Wolf Jack turns into, huffing and puffing until the whole house falls down.

Eventually, Halloran returns to the hotel and Jack kills him with an axe. Then he chases Danny around the maze until he freezes to death. But Kubrick – wisely – chooses to end the film with the uncanny rather than the explosive. Before the credits, we see a black-and-white photo of revellers at the Fourth of July Ball, 1921. Moving in closer, we recognise the figure at the front as Jack 🔵, but what has happened? Has he, as Grady suggested, always been the Overlook's caretaker? Is he a reincarnation of an earlier employee? Has the hotel chewed him up and swallowed him whole?

Kubrick is not telling, but you also get the nagging sense he does not know – or care. As he told Michael Ciment: 'A story of the supernatural cannot be taken apart and analysed too closely. The ultimate test of its rationale is whether it is good enough to raise the hairs on the back of your neck.' In which case, job done.

The Entity

The man who wasn't there

RELEASED 1982

DIRECTOR SIDNEY J. FURIE

SCREENPLAY FRANK DE FELITTA

STARRING BARBARA HERSHEY, RON SILVER, DAVID LABIOSA, MARGARET BLYE, JACQUELINE BROOKES

COUNTRY USA

SUBGENRE SUPERNATURAL

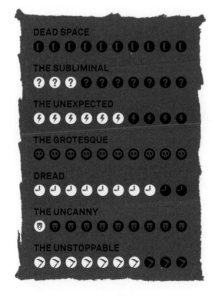

DEAD SPACE

THE SUBLIMINAL

THE UNEXPECTED

THE GROTESQUE

DREAD

THE UNCANNY

THE UNSTOPPABLE

Even before you know it is based on a true story, *The Entity* is a distressing prospect. Adapted by Frank De Felitta from his own 1978 novel, it is built around a series of supernatural sexual assaults experienced by Californian single mother Carla Moran (Barbara Hershey), a fictional stand-in for the real complainant, Doris Bither, who died in 1999. To make matters worse, the narrative seems to mimic the emotional arc of an abuse survivor, moving from shock and shame through to anger and, finally, some kind of acceptance.

Sensitively directed by Sydney J. Furie, the film introduces us to Carla as she rushes home from night school to her three kids: teenaged Billy (David Labiosa) and the younger Julie (Natasha Ryan) and Kim (Melanie Gaffin). But even amid the intimate chaos of family life, the camera seems to be watching Carla through the window ⏺.

Then, while she prepares for bed, it happens. As she brushes her hair and puts on cold cream, we hear a dog-whistle whine. Something slaps her, her lip begins to bleed, and she is thrown back on to the bed and pinned down by forces unseen, as Charles Bernstein's score erupts into pounding electronic thuds ⏺. These will accompany each attack, putting us in Carla's place for the duration, then dissipating gradually, like emotional aftershocks ⏵. When it is over, she screams and the kids rush in, her terror palpable in panicky whip-pans around the room. 'Mum, there's no one in the house,' Billy tells her as the camera closes in on them, locked in the dead space ⏺ with their pain.

Cruelly, the second attack happens later that night, and is all the more alarming because we know what is coming ⏺. While Carla sits up in bed with the light on, the room begins to shake, she smells something foul and her breath turns to steam in the sudden cold, before the camera rushes towards her ⚡. As those awful, deafening thuds begin again ⏺, she takes the kids and flees to the house of her best friend Cindy (Margaret Blye).

From here, the attacks get increasingly violent, occurring while Carla is driving, in the bath and then in front of the kids. But when Cindy persuades her to seek medical help, gradually the supernatural horror is supplanted by the horrors of the system.

'If it is me, if it's really me creating all this. If I'm that sick, then I have to be stopped. But if it isn't me . . .'
— Carla Moran

While Carla tells Dr Sneiderman (Ron Silver) the specifics of what happened, she is shown from a variety of canted angles, her world turned on its axis. Indeed, her house, which is already on an incline, is shot in such a way that it appears to be sinking into the earth. Her self-image becomes equally unstable: blurring or splitting between different mirrors when she tries to look at herself. And who can blame her? The assaults are petrifying and choreographed so that we, too, feel Carla's pain, whether staying on her eyes as she is held down or feeling the impact as her face smashes into the camera during the bath attack. Even the calmer moments are suffused with dread, such as when Cindy and Carla share a bed, and we see the tree branches outside silhouetted as flickering fingers ❹.

As in *The Exorcist*, medical intervention only makes things worse. Sneiderman blames the attacks on spectres from Carla's past (she was abused by her father), while his peers, a room of anonymous (male) doctors, blame masturbation and 'Dionysian fantasy'. When he hears what is going on, Carla's lover Jerry (Alex Rocco) leaves her, reasoning, 'I could have taken anything, disease, cancer . . .'. But it is men who are the real cancer here, with Carla suffering as much at the hands of the patriarchy as she does from any poltergeist. 'I got sick of hearing that it would go away as soon as we got down to the basic problem, as though it was in me,' she tells the sympathetic but painfully stubborn Sneiderman.

SCARE RATING

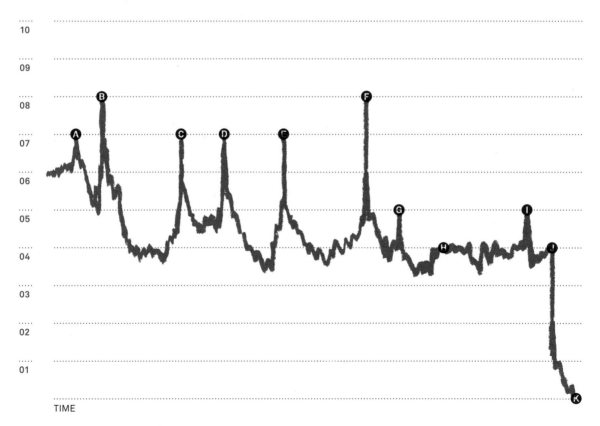

TIME

Further viewing

PARANORMAL ACTIVITY 2007

A found-footage horror stripped down to its barest essentials, Oren Peli's $11,000 debut is one of the most successful films in genre history, notching up $193 million at the box office and starting its own formidable franchise. Obnoxious yuppies Katie (Katie Featherstone) and Micah (Micah Sloat) are being menaced in their own home, so they set up a camera in the bedroom to investigate what is going on. Blue-lit, static and pregnant with awful possibility 🕐, the night-time shots are the film's trump card, showing the couple beset by slamming doors, moving sheets and cloven footprints while they are at their most vulnerable. Even though we never see what torments them, the film amps up the unease to breaking point 🕑 – apparently Steven Spielberg was so terrified he returned his screener in a binbag, convinced that what he had watched was real.

V/H/S 2012

A found-footage portmanteau from a group of promising young filmmakers, *V/H/S* is a mixed bag with some excellent sequences. Directed by David Bruckner (*The Signal*), 'Amateur Night' is a tough watch, as a bunch of bros hit the bars looking to score, then film the results on their (incredibly glitchy) camera glasses. Back at the motel, as their casual sexism threatens to turn into sexual assault, their victim Lily (Hannah Fierman) turns the tables with memorably monstrous results 🙂. 'The Sick Thing That Happened to Emily When She Was Younger' by Joe Swanberg is made up of Skype calls between James (Daniel Kaufman) and Emily (Helen Rogers), who suffers mysterious assaults during the night, while spooky figures appear in the apartment behind her 🕐. The final story, '10/31/98' by Radio Silence, is a show-stopping tale of Halloween partygoers who find themselves exploring a real haunted house 🕑, and serves to leaven the misogyny.

THE NIGHTMARE 2015

Rodney Ascher's enquiry into the horrors of sleep paralysis – a process whereby dreamers 'wake' unable to move and experiencing terrifying visions of old hags, aliens or strange men stalking them – is technically a documentary, but the re-enactments are so frequent, and so frightening, it feels more like fiction. Purporting to tell the 'story of eight people and what waits for them in the darkness', it consists of interviews with sufferers from across the globe intercut with cinematic inserts that put us in their position as it happens. This means lots of slow pans across insinuating spaces as dark figures wait in the corner 🕐 and static shots of night creatures slowly moving towards us 🕑. Every so often, Ascher breaks the fourth wall, showing actors crossing sound stages or camera crew hiding at the edges of the frame 🕒, until it is hard to be certain what is 'real' any more.

TIMELINE

Things only begin to improve when people in power – actually a pair of university parapsychologists (Richard Brestoff and Raymond Singer) Carla meets in a bookshop – begin to believe her. Having photographed 'the entity', as they call it, they construct an elaborate experiment to trap it with liquid nitrogen in a replica of Carla's house built in a gymnasium hall.

While these climactic scenes add a scientific sheen to the horror of what has gone before, they also function as a kind of therapy for Carla. In re-enacting her traumas in a safe space, she is able to bring them out into the open and neutralise them as much as possible. Though the experiment fails, she tells the entity, 'You can do anything you want to me. You can torture me, kill me, anything. But you can't have me. You cannot touch me.' And that, we pray, is that.

Sadly for Carla/Doris, things do not work out quite so neatly. Back in the house, with everything – the camera angles included – seemingly returned to normal, she hears a voice saying, 'Welcome home, c*** 🕐.' Though she has survived, and stood up for herself, things will never be the same again 🕑. 'The real Carla Moran is today living in Texas with her children,' a title card tells us. 'The attacks, though decreased in both frequency and intensity, continue.'

Angst

Nightmares in a damaged brain

RELEASED 1983

DIRECTOR GERALD KARGL

SCREENPLAY ZBIGNIEW RYBCZYŃSKI,
GERALD KARGL

STARRING ERWIN LEDER, ROBERT
HUNGER-BÜHLER, SILVIA RYDER,
EDITH ROSSET, RUDOLF GÖTZ

COUNTRY AUSTRIA

SUBGENRE SERIAL KILLER

Horror films often force us to look through the eyes of serial killers, but rarely do they dramatise what it feels like as they commit their crimes. Based on the case of Austrian psychopath Werner Kniesek, and using some of the alienation techniques of New German Cinema, *Angst* places us squarely at the shoulder of a recently released convict (Erwin Leder) as he goes on a murderous rampage. 'We wanted to provide a deep look inside his deranged psyche via mainly real-time narration and his inner voice,' said co-writer/director Gerald Kargl, who collaborated with co-writer/cinematographer/editor Zbigniew Rybczyński, in the DVD notes. The results were so disturbing the film was banned all over Europe.

Wild-eyed, wet-lipped and near-mute throughout, our antagonist (billed elsewhere as 'K') leaves prison and goes to a service station café, where he gulps down a sausage – disgustingly 😳 – while eyeing the other customers. Upon leaving, he hails a taxi, planning to throttle the driver (Renate Kastelik) with his shoelace, but is thwarted and runs off through the woods. Next, he stakes out a nearby house, massacres the residents, and attempts to escape in their car, only to find himself back at the café, surrounded by police, the awful circle complete.

From the start, the grammar of the film is all wrong. K's movements are accompanied by a voiceover spoken by a different actor (Robert Hunger-Bühler) calmly explaining his inner thoughts, and including passages from other real-life killers' confessions – most notably Peter Kürten, the 'Vampire of Dusseldorf'. Not only is this highly disconcerting 😳, it gives the viewer no other context but K's.

Rybczyński's extraordinary camerawork has the same effect. Except for the opening image, which drifts eerily down from the cityscape to the ground, there are no establishing shots. Instead we watch K either from above, like a distant god unable or uninclined to stop him, or from a 'mirror box', a contraption which makes his face huge in the frame, pivoting with him as he moves. 'The camera was fixed on a ring which loosely swung around the actor,' explained Kargl. 'This produced the effect of him always staying in focus, isolated from his surroundings. He lives in his own world.'

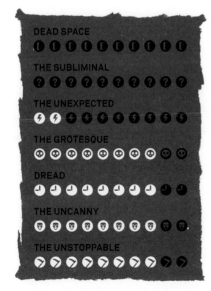

DEAD SPACE

THE SUBLIMINAL

THE UNEXPECTED

THE GROTESQUE

DREAD

THE UNCANNY

THE UNSTOPPABLE

'The fear in her eyes and the knife in the chest. That's my last memory of my mother.'
— K

It is hard to overstate just how harrowing that world is. In the café, K's chewing is intercut with close-ups of the two girls watching, all red lips and bare legs. 'They literally provoked me,' he says in voiceover, and we realise he is planning to kill them there and then. In the cab, past and present collide as he reminisces about beating his first girlfriend with a belt while eyeing the back of the driver's neck greedily.

Later, as he works his way through the house, throttling the mother (Edith Rosset), drowning her son (Rudolf Götz), a wheelchair user, in the bath, and knifing her daughter (Silvia Ryder) in a tunnel underneath the house, he confesses to being scared, but not of being caught. 'I was in a state of mind that excluded every kind of logic,' he says in that maddening monotone. 'I was afraid of myself.'

The final killing is among the genre's most graphic, as K stabs the daughter repeatedly in the face, slurps her blood, vomits ⊙, then has sex with her corpse before falling asleep. According to Ryder, the blood came from a cow; the vomit from Leder himself. Whatever the truth, it is hard to see the artifice.

As soon as he wakes, K is already planning his next atrocity ⊘. An extremely drawn-out sequence shows him washing, changing into new clothes (a white tuxedo), bringing the car round to the tunnel, then dragging the bodies to it one by one and loading them into the boot. 'I decided to take the family with me. The thought excited me tremendously.' he says. 'I wanted to get new victims as soon as

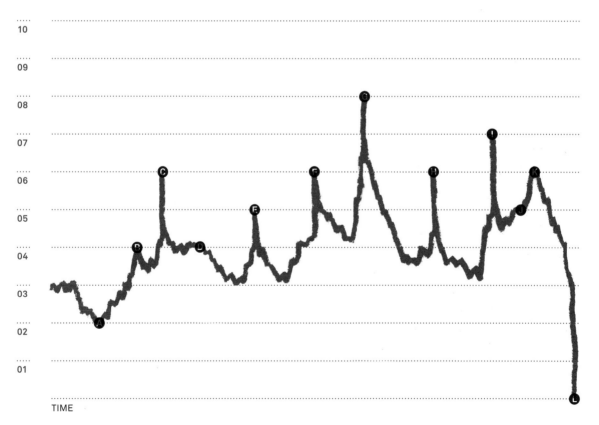

SCARE RATING

10

09

08

07

06

05

04

03

02

01

TIME

Further viewing

THE POUGHKEEPSIE TAPES 2007
Based on found footage supposedly shot by a serial killer, John Edward Dowdle's faux-documentary combines a nasty, squalid streak with a disconcerting sheen of professionalism. When police raid a house in Poughkeepsie, New York, they discover hundreds of snuff films showing an unseen murderer stalking and torturing his prey. To add context, Dowdle intercuts these with vox pops of neighbours, relatives and law enforcement officers discussing each case – but the tapes themselves remain the star. They range from the distressing (the abduction of a little girl) to the disgusting (a woman being kept as a pet), although one sequence goes for dread. Having broken into a victim's house, the killer sets up the camera to film her unawares, then hides in the closet, eking out the attack 🕐 as long as possible. A clever punchline suggests he might be watching the film from the seat beside you. Unfortunately it did not receive a cinema release.

I SAW THE DEVIL 2010
Korean thrillers are often so baroque and bloody they tip over into horror, and Kim Jee-woon's brutal revenge flick more than qualifies. A terrifying opening sequence shows serial killer Jang Kyung-chul (Choi Min-sik) attacking and abducting Jang Joo-yun (Oh San-ha). 'It's going to be easy since your skin is so soft,' he tells her as he butchers her and adds her remains to a crate of body parts 😕. When the police find her severed head in a stream, there is a strikingly eerie moment as, moved by the current, it slowly turns to face us 😐. But the woman's husband, Kim Soo-hyun (Lee Byung-hun), is a police officer too, and more interested in vengeance than justice, tracking and torturing Kyung-chul with a relentlessness ➡ that borders on psychosis. Caught by a giddy, 360-degree camera, the scene in which Kyung-chul kills a cab driver and his passenger amid ferocious spurts of blood suggests a world spinning out of control.

UNDER THE SKIN 2013
Jonathan Glazer's hallucinatory sci-fi horror, loosely based on Michel Faber's 2000 novel, is an uncanny exploration of an alien consciousness. With dyed brunette hair and a clipped English accent, Scarlett Johansson plays an extra-terrestrial driving around Scotland preying on lone men. And what a species they are. From puffed-up club lotharios to lonely bachelors, we see them as she does: a breed of pathetic specimens who follow her, willingly, to their fate – being 'processed' into meat 😕 in her incredible, inky black lair 🕐. Using non-actors and hidden cameras, Glazer paints the world of humans as a chaotic, confusing place; while Johansson's blankness and Mica Levi's sparse, dissonant score give the film a Kubrickian chill. Its most infamous scene sees Johansson watching a couple drown as their baby cries on the shore 😐. Needless to say, her maternal instincts remain totally unengaged.

TIMELINE

- Ⓐ **8 MINS** CELL
- Ⓑ **14 MINS** CAFÉ
- Ⓒ **18 MINS** TAXI DRIVER
- Ⓓ **25 MINS** ANOTHER STAKEOUT
- Ⓔ **35 MINS** THREE-PRONGED ATTACK
- Ⓕ **44 MINS** BATHTIME
- Ⓖ **52 MINS** DOWN IN THE TUNNEL
- Ⓗ **65 MINS** MOVING THE BODIES
- Ⓘ **76 MINS** DRIVING LESSON
- Ⓙ **80 MINS** CAFÉ II
- Ⓚ **83 MINS** 'I'LL TAKE THEM ALL'
- Ⓛ **87 MINS** ENDS

possible. I wanted to show the corpses to the new victims.' Instead, he crashes the car, a stressful scene in which bystanders try to intervene, K grunts and moans, and the camera lurches through 360 disorienting degrees.

When he finds himself back at the café, among the same customers, eating the same food, the sense of déjà vu is overwhelming 😐; K's predatory worldview unwavering. Though the customers look at him as a deeply sinister specimen, all sweaty and blood-spattered, he looks on them as prey. Indeed, even as the police arrive to arrest him, he is calculating how best to 'take them all' – no remorse, no sense of self-preservation, just an untameable lust for violence. As he says in voiceover: 'That urge to torture a human, that's one thing you never get rid of.'

In the years that followed the film's release, Kargl has admitted to going too far, particularly during the daughter's murder. But the whole film goes too far. It is *about* going too far; stepping off the deep end and immersing yourself in K's suffocating subjectivity until, by the end of 87 horrendous minutes, you cannot take any more. Perhaps it was also too much for Kargl – he has never made another film.

Henry: Portrait of a Serial Killer

Man with a movie camera

RELEASED 1990 (COMPLETED 1986)

DIRECTOR JOHN MCNAUGHTON

SCREENPLAY RICHARD FIRE,
JOHN MCNAUGHTON

STARRING MICHAEL ROOKER,
TRACY ARNOLD, TOM TOWLES,
RAY ATHERTON, DAVID KATZ

COUNTRY USA

SUBGENRE SERIAL KILLER

Sometimes horror is not a question of restless spirits and sleepless nights, but a sick, sinking feeling of disgust at what human beings are really capable of. Inspired by the confessions of American serial killer Henry Lee Lucas – many later recanted – co-writer/director John McNaughton's debut was shot for just $100,000 and brings a dose of ugly, kitchen-sink conviction to the genre. 'The most horrific thing is the reality of darkness available to human beings in the depths of their souls,' McNaughton told *Deadline*. 'It was just a matter of making it look real, as if the audience were dropped into the rooms with these people, into the cars, and you're there.' Perhaps it is no wonder, then, that after its initial festival screenings in 1986, the film stayed unreleased until 1990.

The opening sequence offers a mission statement for this new, matter-of-fact strain of horror. After the credits, we see a series of corpses arranged like dolls in awful tableaux. One (Mary Demas) lies in the grass, her eyes open, as if awake ☻. Another (also Demas) sits, half-stripped, on the toilet, a bottle jutting out of her face ☻. Another still (Denise Sullivan) floats in the river as an empty bleach bottle bobs past: just another piece of rubbish. On the soundtrack we hear raised voices, arguments, screaming – the white noise of a disordered mind – but the disconnect between the violence and its consequences places us squarely in the killer's shoes.

This is Henry (Michael Rooker), a shark-eyed ex-con working as an exterminator in Chicago. Early on, we see him scouting for victims at the mall, then following a woman (Monica Anne O'Malley) home in his car as the music intensifies – all moody chords, squealing guitars, and footstep percussion ☽. Eventually her husband (Bruce Quist) turns up and Henry drives off, a lucky escape.

Mostly, though, we just watch him going about his day-to-day life. He shares a crummy flat with Otis (Tom Towles), whose sister Becky (Tracy Arnold) has arrived from out of town, fleeing an abusive relationship. While a burgeoning tenderness grows between her and Henry, there is also an inherent tension ☽, because we know what he is capable of. When Becky asks him about killing his mother, he

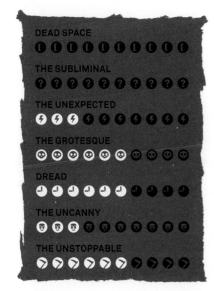

DEAD SPACE

THE SUBLIMINAL

THE UNEXPECTED

THE GROTESQUE

DREAD

THE UNCANNY

THE UNSTOPPABLE

'Open your eyes, Otis. Look at the world. It's either you or them.'
— Henry

cannot get his story straight, relating a tale of extraordinary abuse in flat, emotionless tones, before admitting that he shot her. 'I thought you said you stabbed her?' says Becky. The fact they are, by this point, holding hands tells us things are not going to end well.

The film's second, and most disturbing, strand involves Henry schooling Otis in the art of murder. While they have sex with two prostitutes (Demas and Kristin Finger) in Henry's parked car, we hear those chords once more, and the camera moves towards the vehicle like a predator or peeping tom 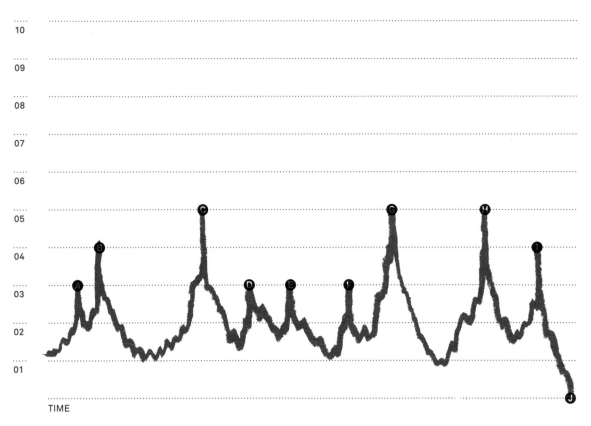. Henry breaks one girl's neck and the other begins to scream, so he breaks hers too – just like that – then drags the corpses out into the alley. 'What's gonna happen when they find those bodies?' asks Otis. 'Nothin',' says Henry, for whom killing is mundane: 'Always the same, always different.'

The repulsive Otis proves an eager pupil, and once they have stolen some video recording equipment, they stake out a suburban house for the film's most upsetting sequence. 'We shot two takes and after the second take, which is the one that plays, I just turned and said, "None of us are going to heaven after shooting this,"' McNaughton told Roger Ebert.

They are certainly not. On grainy video filmed by Henry, we see Otis pawing a screaming woman (Lisa Temple) as her husband (Bryan Graham) lies, bagged and bleeding on the floor. Their son (Sean Ores)

SCARE RATING

10

09

08

07

06

05

04

03

02

01

TIME

Further viewing

RED, WHITE AND BLUE 2010
At first, British writer/director Simon Rumley's harrowing revenge flick feels like just another scuzzy divebar drama, albeit beautifully shot and acted. Set in and around Austin, Texas, it introduces three characters with nothing to lose then sets them on a collision course that can only end in tragedy. Erica (Amanda Fuller) has joyless sex with just about every man she meets. Iraq veteran Nate (Noah Taylor), who shares the same flophouse, has psychopathic tendencies and will do anything to protect her. Garage rocker Franki (Marc Senter), one of Erica's exes, is watching his mother slowly dying of cancer. As this love triangle plays out, Richard Chester's stark, atonal score builds to a crescendo of panicking pianos as if warning us of the violence to come 🕐. When it does, it is horrendous, encompassing torture, suffocation and dismemberment 😶. But even as the characters commit unforgiveable acts we still feel the depths of their pain.

CHAINED 2012
Directed by Jennifer Lynch, daughter of David, *Chained* details the making of a monster. After watching a horror film at the cinema, Tim (Evan Bird then Eamon Farron) and his mother Sarah (Julia Ormond) see the real thing up close, when they hail a cab driven by Bob (Vincent D'Onofrio), who locks them in, drives them to his house and drags Sarah off screaming into the basement flat 🕐. But instead of killing Tim too, Bob makes him his slave, rechristening him Rabbit and training him to dispose of the women he kidnaps. With his thick vowels and volatile, spittle-flecked temper, Bob is a scary prospect, but his insistence on showing Rabbit how to 'crack the human puzzle' is where the real horror lies. Whether playing Top Trumps with dead women's driving licences, or teaching anatomy lessons on the bodies of terrified victims 😶, his desire to pass on his knowledge is abuse in its purest form.

CREEP 2014
A loose, improvised-feeling piece written by and starring Mark Duplass and Patrick Brice (who also directs), this found-footage horror takes place at the remote lodge where Aaron (Brice), a videographer, has been hired to film the final days of cancer sufferer Josef (Duplass) for the latter's unborn son. Whether jumping out to surprise Aaron ⚡ or getting in the bath for some 'tubby time', Josef is clearly not playing with a full deck, turning from manically annoying to melancholy on a dime. But is the diagnosis, or something deeper, to blame for his eccentricities? Things take a darker turn when Aaron discovers a sinister-looking wolf mask in the closet, which Josef calls 'Peachfuzz', the film's working title. Later, when Aaron tries to leave, he finds Josef standing, blocking the door, wearing the mask 🐺. 'Are you just trying to scare me?' Aaron asks, clearly rattled. Josef simply nods his head 🕐.

interrupts, so Henry puts down the camera and grabs him. Then they kill all three, the immediacy of the format making us participants in the violence. As McNaughton told *Deadline*, 'When you see the actual footage they've created, while they're creating it, it's now. You're there, there is no place to hide.'

But he has another, even dirtier, trick up his sleeve. In fact, Henry and Otis are watching the footage at home on TV, so when Otis presses rewind, we see the mother struggling in jerky slow-motion, as chintzy circus music plays on the soundtrack 🎪. The first time we watch the murders they are shocking; the second time, obscene.

Things come to a head when Henry finds Otis sexually assaulting Becky, and they stab him in the eye 😶 and stomach as he shrieks in pain. For once, the violence is personal, up close and out of control, but Henry carries on as normal, dismembering and disposing of the body then hitting the road with Becky.

Though we hope they will drive off into the sunset together, the joke is on us. The next morning, Henry leaves their motel alone, stopping to drop a bloody suitcase by the side of the road before moving on to the next town. 'Always the same, always different' indeed.

Ring

A monster calls

RELEASED 1998
DIRECTOR HIDEO NAKATA
SCREENPLAY HIROSHI TAKAHASHI,
KÔJI SUZUKI (NOVEL)
STARRING NANAKO MATSUSHIMA,
HIROYUKI SANADA, RIKIYA ÔTAKA,
YÛKO TAKEUCHI, RIE INO'O
COUNTRY JAPAN
SUBGENRE J-HORROR

If horror films are stories we tell ourselves to make sense of death, then *Ring* is a film about those stories. Swathed in myths and urban legends that mutate and spread of their own accord – going viral long before the phrase was popularised – it began the J-horror wave that swept the genre into the new millennium.

Kôji Suzuki's problematic 1991 source novel had been adapted before, into a 1995 TV movie called *Ring: Kanzenban*. But screenwriter Hiroshi Takahashi took a freer approach, flipping the gender of the main character, reporter Reiko Asakawa (Nanako Matsushima), and making her a single mother to little Yôichi (Rikiya Ôtaka) and ex-wife to psychic university professor Ryûji Takayama (Hiroyuki Sanada). The resulting film is essentially a dread-filled detective story bookended by two scenes of terror. The latter of which is so petrifying that it shatters what critic Rosie Fletcher called 'an unspoken pact with the viewer – one we didn't necessarily even know we had made'.

In the opening sequence, schoolgirls Tomoko (Yûko Takeuchi) and Masamai (Hitomi Satô) discuss a cursed video. After watching it, viewers receive an eerie phone call, before perishing exactly one week later. In fact, Tomoko viewed the tape with three friends at a holiday cabin, and dies in freeze-framed fright at something she sees on TV. When her friends pass away on the same day, Reiko – who is also Tomoko's aunt – investigates. She finds the tape, watches it and copies it for Ryûji, but Yôichi sees it too. Together, Reiko and Ryûji must get to the bottom of the mystery before their deadlines expire.

The first scene, an intimate chat between Tomoko and Masamai, is full of foreboding 🕐. Having admitted watching the video, Tomoko then denies it and the pair collapse into giggles – until the phone rings. They stop and stare, a canted angle of the clock suggesting that time is running out. 'Is it true?' asks Masamai. Tomoko nods, close to tears. In another swift reversal, it is Tomoko's mother on the phone, and they laugh off the tension once more. But with Masamai gone to the bathroom, the TV clicks on, we hear the crackle of static, and Tomoko turns to meet her fate.

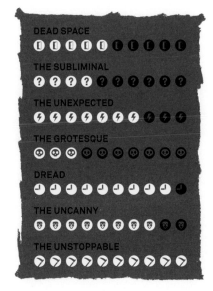

DEAD SPACE

THE SUBLIMINAL

THE UNEXPECTED

THE GROTESQUE

DREAD

THE UNCANNY

THE UNSTOPPABLE

Exactly what that fate might be will not become clear until the climax, which makes it all the more powerful. Indeed, by simultaneously building up and delaying the reveal, the film promises to show us something so scary we will not be able to take it 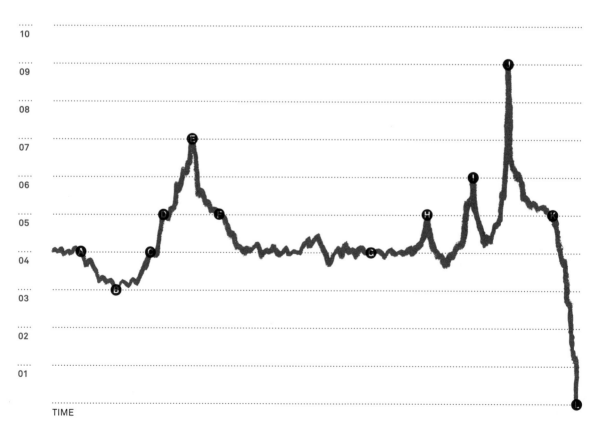. No wonder the UK home entertainment release carried a disclaimer refusing to accept responsibility 'for any injuries or fatalities that may occur during or after the viewing of this videocassette'.

Japanese cinema is full of *onryō*, or vengeful ghosts, and Nakata has admitted a debt to 1960s Hollywood efforts such as *The Innocents* and *The Haunting*. But what sets *Ring* apart is how it mixes classic, almost M.R. James-like, conceits of curiosity and consequence with millennial anxieties about technology, isolationism and teen suicide.

Even without the tape, an expression of post-mortem rage from murdered psychic Sadako (Rie Ino'o), the film evokes a bleak, blue-grey world of disconnected people leading busy, lonely lives. Yôichi and Reiko are more like flatmates than mother and son, while he and his father pass each other in the rain like strangers. This, Nakata seems to be saying, is a rotten universe, ripe for haunting.

Before Reiko finds the tape, she sees a photo of the dead school friends, their features blurred into awful new shapes 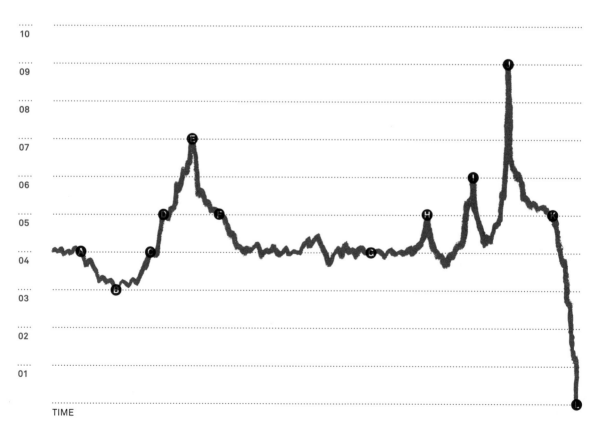. When two of their bodies are pulled from a car, she pauses the

SCARE RATING

10

09

08

07

06

05

04

03

02

01

TIME

'It's all my fault. First Tomoko died, then those three others. It should have stopped there, but it didn't. Because of me.'
— Reiko Asakawa

footage on a face twisted in fear as the soundtrack groans and gurgles. 'Their hearts just stopped,' she is told. But what – or who – could cause them to die like that?

Besides the slow countdown to her death, Reiko does not make an especially compelling heroine, and the one decent piece of detective work she does almost proves to be her downfall. Using Tomoko's photo, she identifies the holiday cabins they visited and heads there herself to find the video.

Sure enough, it is sitting in an unmarked case at reception, as a grainy cutaway, complete with demon growls on the soundtrack ◑, shows us. Similarly, it is a random gust of wind that alerts her to Tomoko's photographs, and Yôichi sees the tape claiming, 'Tomoko told me to.' Clearly something very much wants it to be found.

The first act ends with Reiko watching the tape: a mini masterpiece of the uncanny ◉. In snowy black and white, we see a series of seemingly disconnected images: a woman combing her long, dark hair in a mirror that moves between shots; the word 'eruption' written over and over again; people crawling on the ground; a figure in strange headgear standing by the sea; an eye with the word 'Sada' written inside it; and, finally, a well in an otherwise empty clearing.

'We didn't want to give to the viewer any reference points, so there is no reference whatsoever to where the scene is taking place or where it was shot or where the light and dark is coming from' Nakata told offscreen.com. 'We really wanted to give that scene a dreamlike atmosphere where you are not able to tell what's what.'

In this case, the well could be considered a liminal space: a place of transition between worlds. It also has special significance for Nakata as there was one at his relatives' farmhouse when he was a child. 'My parents told me, "You should never go too close to that well!"' he said in an interview with the online critic Quint. 'I was imagining that it was bottomless or if I put my feet in the water I'd be drowned or grabbed by some strange creature.'

After Reiko turns off the tape, we see a white figure standing silently behind her, reflected in the TV screen ◐, but when she turns it has gone. Then the phone rings, but we hear nothing but high, whirring strings ◑. The threat is clear: the clock is ticking and she has just one week to live.

The second half is full of plot contrivances. Having singled out a voice on the tape speaking in a specific dialect, Reiko and Ryûji journey to the island of Oshima – the home of that dialect – where they flesh out the tape's backstory, mostly through convenient flashes of ESP. It relates to a psychic called Shizuko Yamamura (Masako) who committed suicide by throwing herself into a volcano, her disgraced lover Dr Heihachiro Ikuma (Daisuke Ban), and her

> 'Nobody made it. It wasn't made at all. That video is the pure, physical manifestation of Sadako's hatred.'
> — Ryûji Takayama

daughter Sadako (played as a child by Chihiro Shirao), whom Ikuma killed by pushing down a well.

The well, it transpires, is under the holiday cabin, and Reiko and Ryûji race back to find Sadako's body, which lies sunk in the stagnant water at the bottom. As Reiko searches for the corpse, a ghostly white hand wraps around her wrist ⚡, its fingernails broken from trying to climb free. Next, she finds a skull covered in black hair, which slips off with sickening ease ☻. Having alerted the authorities to Sadako's final resting place, Reiko outlives her week-long deadline and it seems the curse is lifted – but Ryûji is not so lucky.

In the film's most celebrated scene, indeed one of *film*'s most celebrated scenes, Ryûji's TV turns on to show the well, an ominous creaking noise on the soundtrack ◑. Slowly, Sadako climbs out and comes towards the screen, all trailing hair and weird, jerky movements ☻. This uncanny effect was achieved by having Ino'o, a kabuki theatre performer, walking backwards, then playing the film in reverse. As the phone rings, and Ryûji scrambles for it, we see her shambling closer and closer, at the edge of the TV screen then, somehow, pushing through it ❯.

Next, she crawls across the floor towards him, her swollen fingertips spidering out before her. Soon she is standing over him, ready to claim her next victim, but the only feature we can make out beneath the veil of her hair is an evil eye, horribly distended, with stringy red veins bisecting the white ☻. No wonder Ryûji dies screaming in terror, like Tomoko before him.

Besides Sadako's alarming appearance, what makes the scene so frightening is that it suggests what we are watching can hurt us; that horror movies have the power to reach through the TV and get us, like those ill-defined well-dwellers Nakata was scared of as a child. The screen feels like a barrier, but it is actually a liminal space too, between the familiarity of our world and the film's awful fictions. *Psycho* may have made the genre unsafe, but *Ring* makes the medium unsafe.

In a clever coda, Reiko realises the tape must be copied and passed on to avoid the curse ❯, and sets off into the coming storm to show it to her father, thus saving Yôichi from Sadako. The point is simple, but powerful: it is not just stories that can – or must – go viral, it is fear too.

Further viewing

NIGHT OF THE DEMON 1957
An update of M.R. James's 1911 short story *Casting the Runes*, Jacques Tourneur's fleet-footed supernatural thriller begins with Professor Harrington (Maurice Denham) begging Satanic cult leader Dr Karswell (Niall MacGinnis) to call off a curse he was passed via a piece of parchment. It is no use – instead Harrington dies in terror, as a huge fire-breathing demon comes to claim him 🕐. Enter sceptic Dr Holden (Dana Andrews), who takes on both the curse and the professor's niece Joanna (Peggy Cummins), and ends up in a race against the clock to give back the parchment. Whether conjuring storms at a children's party, or discussing ancient evil while dressed as a clown, painted face and all, Karswell makes for a marvellously sinister villain. Holden, meanwhile, quickly goes from arrogant know-it-all to marked man, constantly watching his back 🕐 while he discovers, as Karswell puts it, that, 'Some things are more easily started than stopped ▶.'

TOKAIDO YOTSUYA KAIDAN 1959
Based on a classic nineteenth-century kabuki play, Nobuo Nakagawa's pacey horror packs one hell of a punch and was an avowed inspiration on *Ring* director Hideo Nakata. Lowly samurai Lemon Tamiya (Shigeru Amachi) and his scheming servant Naosuke (Shuntarô Emi) murder their way into favourable marriages with Machiavellian flair. When Lemon tires of his wife, Iwa (Katsuko Wakasugi), they poison her and kill her masseur, Takuetsu (Jun Ôtomo), then nail the bodies to shutters and sink them in the river. The final act sees Lemon tormented by their ghosts, especially the disfigured Iwa, who appears suddenly, suspended from the ceiling above him ⚡; out of the bloody river waters with one eye bulging like Sadako 💀; and from a crack in the earth. The sense, as in *Ring*, *Ju-On: The Grudge*, *Shutter* and much Asian horror of the 1990s and 2000s, is that vengeful spirits surround us and cannot simply be calmed ▶.

AUDITION 1999
Takashi Miike's tale of a wronged woman's vengeance is hard to describe without major spoilers. Several years after the death of his wife, middle-aged businessman Ryo Ishibashi (Shigeharu Aoyama) decides it is time to begin courting again. With the help of his friend Yasuhisa (Jun Kunimura), a film producer, he auditions candidates as if for a movie. After quizzing each potential date on everything from loveless sex to Tarkovsky, Ryo settles on former ballet dancer Asami (Eihi Shiina), explaining that, 'I could tell you take life very seriously.' Just how seriously will soon become apparent. The first time Ryo calls, we see Asami curled up in a ball, her hair covering her face like a J-horror ghost 🕐. A huge sack sits in the corner of the room which, when the phone rings, starts to move ⚡. Asami, it transpires, is no wallflower, and the violent lengths 💀 to which she will go add an almost supernatural element to her crusade ▶.

The Blair Witch Project

If you go down to the woods today

RELEASED 1999

DIRECTOR DANIEL MYRICK, EDUARDO SÁNCHEZ

SCREENPLAY DANIEL MYRICK, EDUARDO SÁNCHEZ

STARRING HEATHER DONAHUE, JOSHUA LEONARD, MICHAEL C. WILLIAMS, BOB GRIFFIN, JIM KING

COUNTRY USA

SUBGENRE FOUND FOOTAGE

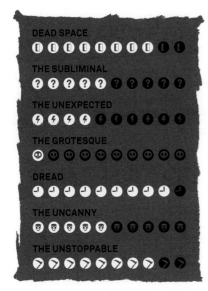

DEAD SPACE

THE SUBLIMINAL

THE UNEXPECTED

THE GROTESQUE

DREAD

THE UNCANNY

THE UNSTOPPABLE

'In October of 1994 three student filmmakers disappeared in the woods near Burkittsville, Maryland, while shooting a documentary. A year later their footage was found.' So reads the most famous title card in horror history. While the starkness of the words matches the lo-fi dread 🕐 of what follows, what is most striking is that, bar some jagged editing, this is the sole signal that *The Blair Witch Project* is a work of fiction.

Across 80-or-so minutes, the film relies on none of the usual tricks – no score, no special effects, no non-synch sound – just actors Heather Donoghue, Michael C. Williams and Joshua Leonard (each using their real names and improvising their dialogue) lost in the woods and scared out of their wits. As a piece of cinema it is, or was, unique: less a story than a traumatic shared experience.

'We were starting from an authentic place of wanting to make a movie that was actually scary,' said co-director Dan Myrick. 'We wanted *The Blair Witch Project* to be something where you got out of the theatre and you were legitimately freaked out.' In which case, mission accomplished.

Inspired by 1970s pseudo-documentaries such as *The Legend of Boggy Creek* and *In Search of Ancient Astronauts*, film school buddies Myrick and Eduardo Sanchez dreamt up a movie that would make a virtue of its limitations. The plan was simple: equip their actors with cameras, send them out into Seneca Creek State Park on the trail of the Blair Witch, torment them at night with eerie noises, then present the results as fact.

There had been 'found-footage' films before, of course, the most notable being Ruggero Deodato's controversial *Cannibal Holocaust*. Banned in many countries, this 1980 Italian Video Nasty tells the story of a documentary crew lost in the Amazon, through rolls of their film recovered by a rescue mission (hence the term 'found footage'). The atrocities captured – and, eventually, perpetuated – by the crew are discussed by a professor viewing the tapes, but *The Blair Witch Project* would offer no such respite.

'OK, here's your motivation. You're lost, you're angry in the woods, and no one is here to help you.'
— Josh Leonard

Though it would go on to make $250 million worldwide on a budget of $60,000, *The Blair Witch Project* began as a series of spooky images thought up by Myrick and Sanchez as students. According to Myrick: 'We came up with the last scene in the movie first. We just thought it would be really creepy if you're walking through the woods at night and you come across this abandoned house.' Said Sanchez: 'Imagine that you're walking into that house with a camera, and the camera can't cut away – there's no edit, you can't distract the audience with something else, they're stuck, it's point-of-view cinema ⬤. As an audience member, you either walk out or you have to ride this one, almost continuous, take into this creepy house and right down into the basement.'

Originally planned as a more traditional documentary built around the actors' footage, the film was edited down until only that footage remained, and the effect is electrifying. By relying solely on what the characters/cameras see – or do not see ⬤ – the film turns every moment into a visceral now, the narrative taking on the look and logic of a nightmare.

But even nightmares need context, so Myrick and Sanchez came up with a piecemeal backstory cribbed from Civil War folklore, the Salem witch trials and their own imaginations. Before Heather, Mike and Josh head into the woods, the people of Burkittsville explain the town's chequered history in a series of talking-head interviews. In

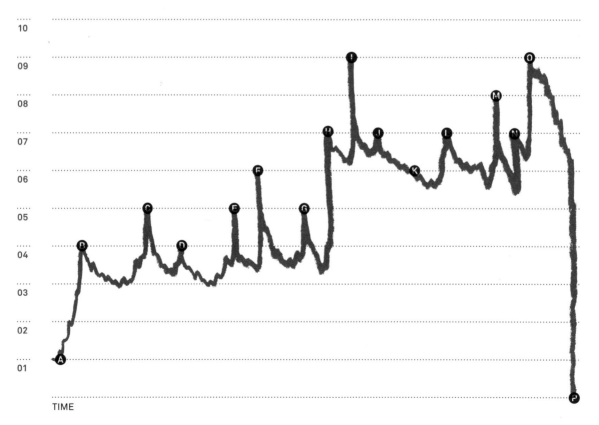

SCARE RATING

TIME

1785 a young woman called Ely Kedward was banished from the Blair township (later Burtkittsville) accused of witchcraft. From then on, the Blair Witch became a catch-all folk legend, blamed for all kinds of mysteries and murders, whether appearing as an 'old woman whose feet never touched the ground' 😵 or an eerie figure covered in hair 😊. The most infamous incident occurred in the 1940s, when local hermit Rustin Parr killed seven children, apparently at the witch's bidding. His MO was particularly chilling: he took his victims down to his basement in twos, making one stand in the corner while he killed the other. After the last murder, he proceeded to walk into town and announce, 'I'm finally finished.'

As told to Heather and the boys, these stories overlap and undercut each other, but that is how legends work, and the details are specific enough to be unnerving, but general enough that anything that happens in the woods can be blamed on the witch – however mundane. And the events that follow *are* mundane. For the most part the only tangible threats the characters encounter are piles of rocks (or cairns), stickmen hanging from the trees and a bloody tooth 😊, but they are enough to suggest a malevolent supernatural presence without ever dispelling the ambiguity.

Indeed, even at the climax, the Blair Witch herself remains tantalisingly unseen. 'We knew we needed a pay-off,' said Myrick.

'We couldn't just have this huge build-up and not have something, a WTF? moment, at the end. We were racking our brains about what was going to happen.'

As filmed, the final scene finds Heather and Mike tired and scared, having lost Josh the night before. To the sound of his distant screams, they stumble upon a derelict house with children's handprints lining the walls, presumably the work of Rustin Parr. Josh is nowhere to be seen, but as Heather follows Mike into the basement, 'Mike is standing in the corner ❸ and he's obviously alive, but he doesn't turn,' said Sanchez. 'What the hell would make Mike Williams not turn at that moment and help his friend?' said Myrick. 'Then, a beat later she gets hit from behind ❹, the camera goes down and goes black, and you're just left with, "Oh shit, there's something there – there's *somebody* there – affecting them." But we're not sure what.'

While this last sequence is both iconic and terrifying, it begs the question: how does a film that avoids most tried-and-tested horror techniques manage to be quite so scary?

Unlike the slick studio productions of the 1990s, *The Blair Witch Project feels* real. The woodland locations – all spindly trees and faded autumnal leaves – are clearly not sets, and the darkness is, at times, absolute. 'What a lot of people don't realise is just how dark it is,' said Myrick. 'We're so used to seeing filmic versions of woods where they're all lit with arc lights and you can see for hundreds of yards into the forest as people are walking through. But that's not the case at all – it's pitch dark. That's why it's so dramatic when you're looking at that black space and all you can see is Heather or Mike's breath. You know they're in this void, and you don't know what the hell's out there and that is terrifying.'

Within that endless dead space ❶, it is easy to imagine seeing things that are not there, and the film becomes a kind of Rorschach test for the audience. 'I cannot tell you how many times people swear they saw something in the woods,' said Myrick. 'I mean it's classic projection, where people say, "Oh, the scene with the campfire, I saw the Blair Witch in the background." No! We didn't have anybody back there, but people have a propensity to see more on the screen than what's really there.'

According to Sanchez, 'Part of the reason it's so effective is that it doesn't explain much. There's still this mystery, all these questions, just like why UFOs, Bigfoot and ghosts are still scary because there's no definitive proof on anything. People always want to explain everything, like everything has to have a reason, but I think good horror always has this element of why the hell did that happen? A bit of randomness actually makes things scarier, just like in real life.'

The Blair Witch Project would cast a long shadow: inspiring all sorts of fan theories, spin-off books, a 2000 sequel and a 2016 reboot.

But perhaps its secret is even simpler than Myrick and Sanchez acknowledge. The history of horror cinema is the history of watching people *pretending* to be afraid. But often Heather, Mike and Josh are genuinely unnerved. One of the film's most famous shots sees Heather almost hyperventilating with fear as she apologises straight-to-camera ⬤ for endangering their lives. Though the scene has been satirised for the sheer volume of tears/snot expelled, the intense, unpolished nature of her performance makes us question how much acting was involved. Ultimately, Heather looks exhausted, defeated and at the end of her wits because she is. And, as *Peeping Tom* made clear, watching people being scared – really scared – is the scariest thing of all.

Further viewing

THE TUNNEL 2011
Mixing found footage and faux-documentary. Carlo Ledesma's familiar but effective horror concerns a news crew coming unstuck while investigating a network of tunnels under Sydney. Recounted through interviews with the survivors – driven anchor-woman Natasha (Bel Deliá) and blokey cameraman Steve (Steve Davis) – it mimics the tell-then-show aesthetic of bad TV to authentic effect. Once underground, however, the film steps up a gear. From makeshift homeless digs to abandoned air-raid shelters to an underground lake vast enough to lose a crew member in, the location proves highly evocative, the juddering camera, often in night-vision mode, suggesting that something lurks around each corner ⬤. One effective scene features sound guy Tangles (Luke Arnold) hearing whispers in his headphones ⬤, and there are jump scares ⚡ aplenty as the crew find themselves hunted through the endless, green-hued darkness.

WILLOW CREEK 2014
Taking more than a few cues from *The Blair Witch Project*, Bobcat Goldthwait's short, sharp found-footage movie follows a couple (Alexie Gilmore and Bryce Johnson) as they attempt to shoot a Bigfoot documentary in Six Rivers National Forest, Northern California, the site of the famous 1967 Patterson–Gimlin film. What sets them apart from the usual monster fodder is that they are charming, their camera work is steady and – crucially – they are nice to each other. The body of the film sees them meet and mock the assorted crackpots of Sasquatch country (not all of them actors) who warn them ⬤ not to continue on their mission. When they do get into the woods, though, it is a different matter. A pivotal sequence, including one stunningly simple 11-minute shot, sees them clinging together inside a torchlit tent ⬤ as an unseen menace prowls the dark outside. Moving from shimmering fear to outright terror, it is a masterclass in minimalist horror.

THE WITCH 2015
Subtitled 'A New England folktale', writer/director Robert Eggers' moody debut follows a family of English settlers in the 1630s. Banished from the plantation over a religious dispute, they eke out a hard-scrabble existence on a homestead near the woods, praying and fasting to appease their god. It does no good. While Thomasin (Anya Taylor-Joy) is playing peekaboo with her baby brother, he disappears, presumed stolen by a wolf – or a witch. Next we glimpse him by firelight, with rough, hag-like hands ⬤ caressing his naked flesh in preparation for sacrifice. For the most part, though, Eggers is content to conjure an atmosphere of foreboding ⬤, with long shots of the watching forest scored by wailing voices and scything strings. In this bleak, godforsaken place, it feels like nature itself has turned bad, as evidenced by an evil-looking hare and Black Philip, the family goat, who the younger children claim talks to them ⬤.

The Others
Forgive us our trespasses

RELEASED 2001

DIRECTOR ALEJANDRO AMENÁBAR

SCREENPLAY ALEJANDRO AMENÁBAR

STARRING NICOLE KIDMAN,
FIONNULA FLANAGAN, CHRISTOPHER
ECCLESTON, ALAKINA MANN,
JAMES BENTLEY

COUNTRY SPAIN

SUBGENRE GHOST STORY

With all the trappings of a classic British ghost story, *The Others* slyly turns audience expectations on their heads at every opportunity. Written, directed and scored by a Spanish-Chilean, shot in Cantabria, Spain, and starring an Australian, it is not even remotely British.

Set in Jersey in 1945, the film introduces Grace (Nicole Kidman) and her children Anne (Alakina Mann) and Nicholas (James Bentley), as they wait for their husband/father Charles (Christopher Eccleston) to come home from the war. 'Now, children, are you sitting comfortably?' is the opening line, but the script favours harrowing Old Testament ideas of limbo and damnation over fairy tales.

We first meet Grace as she wakes with a scream, and she projects an aura of icy fragility throughout. The staff, we learn, fled under mysterious circumstances a week before, so new servants Mrs Mills (Fionnula Flanagan), Mr Tuttle (Eric Sykes) and Lydia (Elaine Cassidy), who is mute, have come from the village to replace them. As Grace shows Mrs Mills around, she explains that her children are photo-sensitive, and must be kept locked in the darkness at all times, effectively turning every room into dead space ❶. Meanwhile, Anne talks to a little boy called Victor, who is one of 'the others', a family of 'intruders' including a blind old lady Victor says is a witch ☠.

Although the film works through a tick list of haunted-house tropes – fog-shrouded grounds, doomy religious iconography, a music room piano just begging to be played by hands unseen – it always feels personal, because Amenábar based *The Others* on his own childhood terrors. 'I was a very easily scared boy,' he told hollywood.com. 'Of course, I was scared of ghosts, so many of the fears the children have are to do with the kind of fears I used to have.'

In a clever twist, seen before in the 1974 British film *Voices*, it is not Victor and his family who are the ghosts, but Grace and the children, who must come to terms with the fact that they are dead. Thanks to an elegant script and some exceptional performances, the ambiguities deepen, rather than dispel, the scares.

While Nicholas lies in bed, Anne has an off-camera conversation with Victor. Is it genuine or is she just trying to frighten her brother?

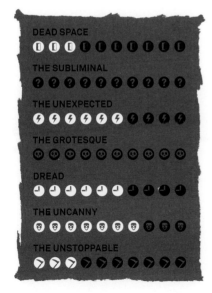

DEAD SPACE

THE SUBLIMINAL

THE UNEXPECTED

THE GROTESQUE

DREAD

THE UNCANNY

THE UNSTOPPABLE

'Sometimes the world of the living gets mixed up with the world of the dead.'
— Mrs Mills

When Nicholas threatens to call their mother, she tells Victor, 'Touch his cheek so he knows you're real.' The next shot is tight on Nicholas's face **Ⓛ**, so we never know if the finger that appears **Ⓕ** belongs to Anne or Victor.

Later, Grace hears heavy footsteps on the floor above and blames Lydia – who she then spots outside in the garden **Ⓙ**. Running upstairs to the room in question, which is full of furniture covered in white sheets, she hears someone breathing **Ⓖ** beside her, then backs away into a statue of Jesus **Ⓗ**, perhaps the real villain of the piece.

The Others' most frightening moments come courtesy of the blind lady. When Anne is left alone in the dark to try on her communion dress, Grace returns to see her daughter sitting on the floor, and begins to tell her off – until she spies a creased hand **Ⓘ** where Anne's should be. Moving closer, she sees the woman's face staring out from under the veil, and starts screaming, 'What have you done with my daughter?' as Anne shrieks in shock. Such is the violence of Grace's response, and the coiled panic of Kidman's performance, it does not come as much of a surprise when we learn that she has killed the children, then herself – hence waking with a scream at the start of the film.

Later, as Anne and Nicholas cower in the closet, they hear ragged breathing **Ⓚ** – not their own – before the blind woman flings open the doors **Ⓛ**. But it is only when they see her in the middle of a séance with

SCARE RATING

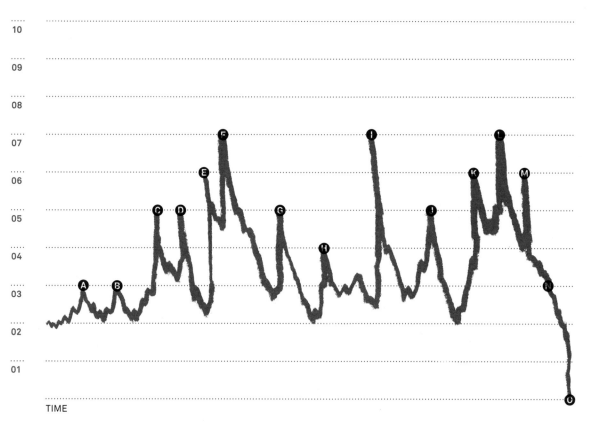

TIME

Further viewing

THE HAUNTING OF JULIA 1976
Based on the 1975 novel *Julia* by Peter Straub, Richard Loncraine's grown-up ghost story is set amid the melancholy of a London autumn. A shocking opening sequence shows Julia Lofting (Mia Farrow) unable to save her daughter Kate (Sophie Ward) when she chokes on an apple, even attempting an emergency tracheotomy to no avail. Upon her release from hospital, Julia leaves her husband Magnus (Keir Dullea) and moves into a huge house to grieve, but is the childish presence she feels there Kate? After a spooky seance 🕐 and a series of unexplained deaths, Julia begins to play detective. Loncraine favours supernatural inference over out-and-out scares, and a scene of Julia lying asleep in bed, as tiny fingers trace lines across her skin, sets the unsettling tone 🅑 perfectly.

SILENT HOUSE 2012
An American remake of the Uruguayan film *La Casa Muda*, Nathan Larson and Laura Lau's psychological horror makes good use of a gimmick first trialled in Hitchcock's *Rope* back in 1948. Although it appears to be one continuous shot, it is actually made up of a series of 12-minute takes combined to look seamless. Sarah (Elizabeth Olsen) is helping her dad (Adam Trese) and uncle (Eric Sheffer Stevens) clear their summer house, a shut-up mansion where it feels like the sun has never shone. As the camera follows her from floor to floor, she starts to hear creaking noises 🕐 and see intruders in the dead space 🅘 around her, causing her to replay traumas from the past. As an exercise in sustained suspense it works well, reducing the horror film to its essence: a scared woman locked in the dark with her memories – and whatever else is in there with her.

THE HOUSE AT THE END OF TIME 2013
Written, directed and produced by Alejandro Hidalgo, this was a huge hit in its native Venezuela. In 1980s Caracas, mother Dulce (Ruddy Rodríguez) awakes in the night to the sound of screams. Her husband Jose (Gonzalo Cubero) lies stabbed and bleeding on the floor, and something drags her son Leo (Rosmel Bustamante) off into the shadows ⚡, never to be seen again. She is arrested for their murders, and the film skips forward thirty years to the day of her release, when she and her priest (Guillermo Garcia) try and make sense of what happened. Her verdict? 'The house did it.' Though it trades on familiar tropes such as half-glimpsed figures 🅘 and rattling doors 🕐, the film explores the undying limits of a mother's love in scary, surprisingly moving ways.

TIMELINE

- 🅐 **8 MINS** GRAND TOUR
- 🅑 **14 MINS** BIBLE BASHING
- 🅒 **23 MINS** WHO'S CRYING?
- 🅓 **26 MINS** 'TOUCH HIS CHEEK'
- 🅔 **32 MINS** UPSTAIRS FOOTSTEPS
- 🅕 **35 MINS** JESUS CHRIST!
- 🅖 **47 MINS** PIANO PLAYING
- 🅗 **56 MINS** INTO THE FOG
- 🅘 **66 MINS** VEILED LADY
- 🅙 **77 MINS** 'FIND THE CURTAINS'
- 🅚 **85 MINS** GRAVESTONES
- 🅛 **90 MINS** 'STOP BREATHING LIKE THAT'
- 🅜 **95 MINS** 'WE'RE NOT DEAD!'
- 🅝 **100 MINS** 'THIS HOUSE IS OURS!'
- 🅞 **104 MINS** ENDS

Victor's father (Keith Allen) and mother (Michelle Fairley) that they realise she is a medium and they are the ghosts, although there have been clues scattered throughout.

Anne says her toast tastes funny, and she 'liked it better before'. Charles, meanwhile, wanders briefly back into their lives from a limbo of his own. Even Grace seems to have inklings: 'I'm beginning to feel totally cut off from the world,' she says. Indeed, the film is full of symbols of miscommunication: Lydia's muteness (which Amenábar experienced himself, having fled Chile for Spain as a child), the post that has not been delivered, a photo album containing only pictures of the dead (including an image of Amenábar himself). Even the choice of Jersey is telling. Like Grace's house it was 'occupied' by enemies during the war, and the Channel Islands represent a kind of neutral space, a limbo, between France and England.

As is common in millennial ghost stories, most notably *The Sixth Sense*, *The Others* ends on a moving note rather than a frightening one. Victor and his family leave and put the house for sale, and Grace and the children remain as its custodians – until the next time. 'I don't know if there even is a limbo,' Grace admits to the kids, having relinquished her religious certainty and learned the awful truth about their deaths. 'I'm no wiser than you are. But I do know that I love you. I've always loved you. And this house is *ours*.'

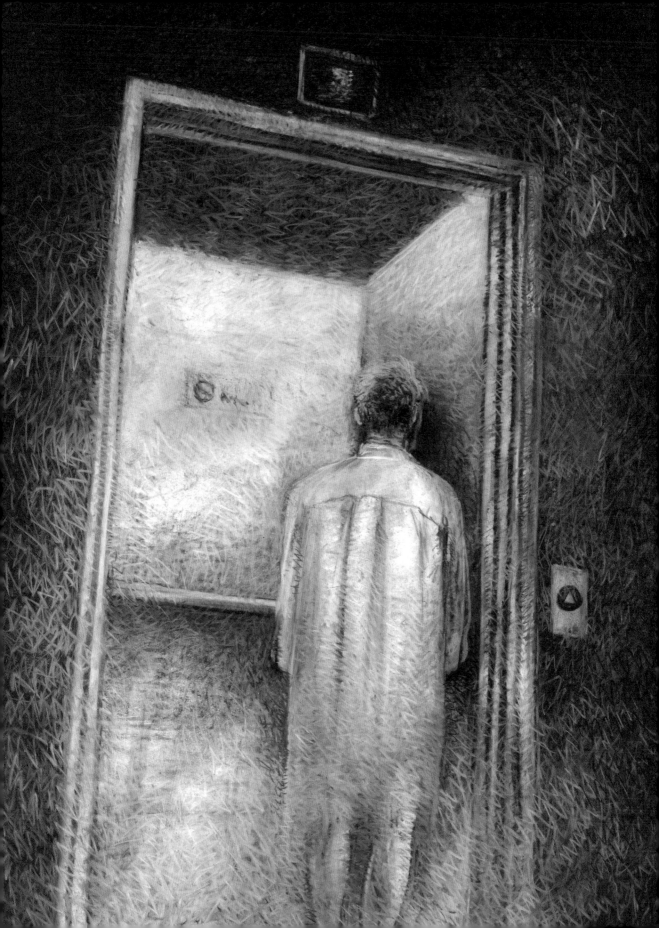

The Eye

She sees dead people

RELEASED 2002

DIRECTOR DANNY AND OXIDE PANG

SCREENPLAY DANNY AND OXIDE PANG

STARRING ANGELICA LEE,
LAWRENCE CHOU, SO YAT-LAI,
CANDY LO, KO YIN-PING

COUNTRY HONG KONG/SINGAPORE

SUBGENRE GHOST STORY

The organ transplant that gives the recipient special powers is one of oldest plots in horror cinema, dating back at least as far as 1924's *The Hands of Orlac*. But Hong Kong film-makers the Pang brothers take it for another spin in this patchy, sometimes petrifying, chiller.

'The story was inspired by a dramatic suicide on the news,' they told the *Austin Chronicle*. 'A young woman ended her life after regaining her sight from a cornea transplant only a week before. So we began to hypothesise what she could have possibly seen that was so devastating.'

In the film, Mun (popstar Angelica Lee, Oxide's future wife) a blind violinist, wakes from an operation able to see, but imperfectly. Instructed to rest her eyes as they heal, she meets fellow patient Ying-Ying (So Yat-lai), a perky eleven-year-old with a brain tumour, whose chances of reaching the end credits are as poor as the synth score.

During the night, Mun watches an elderly patient leaving the ward with a dark figure ●. Out in the corridor, she can just about see someone in the distance, making an unearthly moaning sound ●. 'Madam, are you alright?' she asks, but the old woman (Yuet Siu Wong) disappears, and Mun shuts her eyes. Next, the moan comes from right beside her ●, and the woman flickers past. Turning back to face Mun, she glides closer. 'I'm freezing!' she cries, before disappearing for good.

Encounters of this kind occur repeatedly and, while they would be terrifying for anyone, Mun is especially vulnerable. According to the Pang brothers, 'As someone who has been blind for most of her life, she is not be able to understand or talk about the eerie visions she sees.' For example, on the taxi ride home with her sister Yee (Candy Lo), Mun watches a businessman (Tao Leung) walking heedlessly through heavy traffic ●, but says nothing. This, for her, is the new normal.

When it finally kicks in, the main plot is a direct steal from *Ring*. As Dr Wah and Mun travel to Thailand to find the donor, a shunned psychic (Chutcha Rujinanon) who hung herself after her predictions of doom were ignored. But before then there are some memorably unsettling scenes.

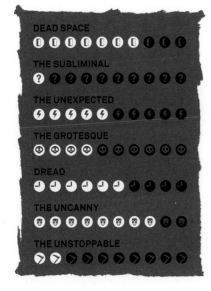

DEAD SPACE

THE SUBLIMINAL

THE UNEXPECTED

THE GROTESQUE

DREAD

THE UNCANNY

THE UNSTOPPABLE

'When I was at the hospital I saw a man, he took that old lady with him. The next morning the old lady was dead.'
— Mun

Outside her grandmother's flat, Mun encounters a dead boy (Ming Poon) who has lost his report card and eats offerings from the shrine beside his family's front door. At a handwriting lesson, she hears someone ask, 'Why are you sitting in my chair?' and sees a woman (Nittaya Suthornrat) with black smudged eyes standing in the corner ⊙. But when Mun turns around, rattled, she is gone. Mun looks to her teacher (Tian Nan Wu), who is just out of focus in the background. As the shot changes, the woman appears again behind Mun's head ⓐ, her fingers outstretched as if ready to attack. 'Why are you sitting in my chair?' she demands, her eyes turned white, before launching herself at Mun ⓕ.

In a noodle bar, Mun glimpses the ghost of a woman (Si Won Ho) and her baby through the steamy glass. 'You can see them too?' asks the waitress (Yuk Ha Lo). 'Normally they don't want to be seen.' Considering the ghost's next move is to start licking the meat with a weird CG tongue ⓖ, perhaps that should come as no surprise. 'All of the shops nearby have been bought up, but my boss refuses to sell,' the waitress continues, 'he seems to be expecting his wife and child to visit.' Indeed, the film repeatedly documents the old ways dying out – the archaic lessons, the scientific procedures supplanting traditional beliefs, the lost souls overlooked in the clamouring crowds.

SCARE RATING

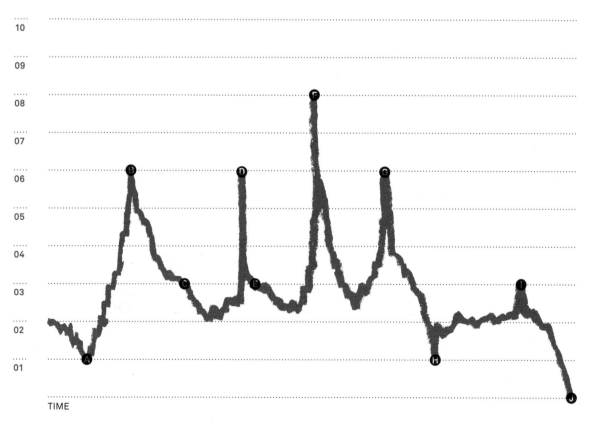

TIME

Further viewing

SIXTH SENSE 1999

'I see dead people,' confesses troubled nine-year-old Cole Sear (Hayley Joel Osment) to child psychologist Malcolm Crowe (Bruce Willis) in M. Night Shyamalan's box-office smash. If you cannot guess the twist, you might want to check your own pulse, but Cole's predicament is frightening all the same. Shot in long, insinuating takes in moody Philadelphia, and aided by Osment's empathetic performance, the film shows the poor boy beset by apparitions: whether voices from the closet ⊕; corpses hanging in the school corridors; or a dead cyclist standing by the car window as Cole and his mother (Toni Collette) wait in a traffic jam ⚡. Most frightening of all are the night visits he receives from a woman with slit wrists (Janis Dardaris) ☺, or a sick little girl (Mischa Barton) who undoes the pegs to his den one by one ◔. Each has secrets to spill, and only Cole to hear them.

A TALE OF TWO SISTERS 2003

Elegantly made if a touch esoteric, writer/director Kim Jee-woon's eerie horror is based on an obscure Korean fairy tale. Beginning with Su-mi (Im Soo-jung) in a mental hospital, it follows her to a secluded country estate, where she and her sister Su-yeon (Moon Geun-young) visit their distant dad (Kim Kap-soo) and his overbearing new wife Eun-joo (Yum Jung-ah). But everything is not as it seems. The clocks have stopped, the interactions are stilted, and the atmosphere is just slightly off. At night, Su-yeon's bedroom door creeps open ◔ and pallid fingers appear around the edges. Su-mi sees a terrifying, broken-necked figure ☺ coming for her, blood dribbling down her legs in an acknowledgement of the film's sexual unease. And in a perfectly judged jump scare, Eun-joo is grabbed by a hand emerging from under the sink ⚡. Though explanations are a long time coming, the film switches from dreamy to hysterical, surreal to downright scary on a dime.

DEAREST SISTER 2016

A thought-provoking drama studded with spooky intervals, Laotian director Mattie Do's second film is an update of the classic Monkey's Paw tale with points to make about poverty, and how inequality makes all of us cruel. Lowly country girl Nok (Amphaiphun Phommapunya) needs money for her family, so she is brought to the city to look after her rich cousin Ana (Vilouna Phetmany), whose sight is failing. 'Did you hear screaming last night' Nok asks the unhelpful help (Manivanh Boulom). 'You get used to it,' is the brutal answer. Ana, it turns out, sees spirits who whisper the winning lottery numbers – something Nok soon turns to her advantage. From dark figures haunting the periphery of Ana's vision ①, to a long-nailed crone with black flies forming a veil over her face ☺, the spectres are vivid and frightening. But, of course, with each lottery win comes a curse.

TIMELINE

Before the disappointing final act, which involves a huge gas tanker explosion that leaves Mun blind once more – there are two fantastic scares. At her Grandma's apartment block, Mun goes to get into a lift and sees an old man (Sungwen Cummee) standing in the corner, who does not appear on the CCTV above ☺. Sensibly, she waits for the other lift instead, then checks it is empty – properly empty. Once inside, her eyes widen, her vision sharpens and he's suddenly behind her. What follows is excruciatingly tense ◔, with the floor counter clicking upwards and Mun trying not to panic as the old man glides past her, his feet not touching the floor. When he spins towards her, we see that half his face is missing ☺ – either a fantastic special effect or an extremely crass bit of casting – and she flees the lift before he can get her.

The next is more reflective. As Dr Lo and Mun travel by train, the window looks out on the blue-grey gloaming behind them. When they enter a tunnel, and the window goes black, we see a staring face reflected back ①, which leaches away with the next burst of sky. Hong Kong, it seems, is a city full of ghosts, if only people stopped to notice.

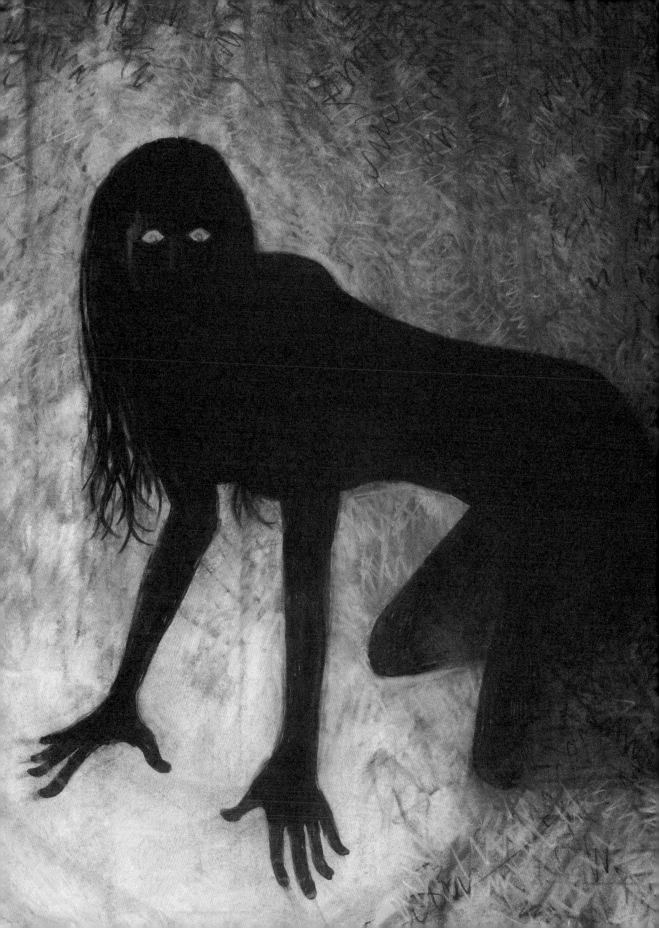

Ju-On: The Grudge

Don't go in the house

RELEASED 2002

DIRECTOR TAKASHI SHIMIZU

SCREENPLAY TAKASHI SHIMIZU

STARRING MEGUMI OKINA, MISAKI ITO, TAKASHI MATSUYAMA, TAKAKO FUJI, YUYA OZEKI

COUNTRY JAPAN

SUBGENRE J-HORROR

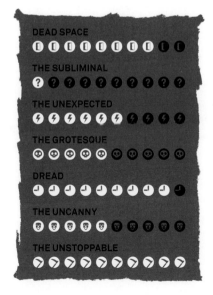

In an ordinary home on an ordinary street in Tokyo's Nerima district, an act of violence has left a curse that consumes all who enter. While this may sound like an intriguing starting point for a movie, it is, in fact, the whole story. Shimuzi's archetypal J-horror features no real heroes or villains, no gothic backdrops and few special effects. Jumping back and forth in time and space, it is infuriatingly hard to follow, repetitive and more like watching a series of YouTube clips than a proper film. It is also absolutely terrifying – like replaying *that* scene from *Ring* over and over again.

Appropriately enough for a narrative that keeps replicating itself, the material first appeared in a series of shorts and straight-to-video films, continuing on into an international franchise. The plot is simple, if, at times, incomprehensible. The opening titles tell us that *Ju-On* means 'a curse born of a grudge held by someone who dies in the grip of anger. It gathers in places frequented by that person in life, working its spell on those who come into contact with it and thus creating itself anew.' In this case that means Rika (Megumi Okina), a social worker sent to visit an elderly woman called Sachie (Chihayako Isomura) in a house where – unknown to the characters – a man called Takeo Saeki (Takashi Matsuyama) murdered his wife Kayako (Takako Fuji) and the family cat. What happened to their young son Toshio (Yuya Ozeki) remains a mystery.

Upstairs, Rika hears a cat in the closet, finds Toshio there too, and comes down to question Sachie, who is rocking back and forth in fear. But it is only when the camera pivots around, and an awful, crick-crick-cricking death rattle begins, that we realise she is not looking at Rika 🕐. Kayako's ghost, in the form of an all-enveloping, black-eyed shadow, has come to take her, and Rika passes out in fear. This is the pattern that repeats throughout the film, as the curse claims Sachie's family, Rika's colleagues, and everyone who sets foot inside the house – often in the most mundane of places.

'One of the most important things that I'm going for in *The Grudge* is that all these scares can happen in everyday life,' Shimuzi told *IGN*,

97

and the standout sequence in which Hitomi (Misaki Ito), Sachie's daughter, meets Kayako and Toshio bears this out. In the toilets at work, she sees feet passing beneath the door, then hears the crick-crick-crick sound as a black-haired figure slides out of a cubicle **J** towards her. At home, in the lift, we see Toshio's face looking in from every single level **G** she passes. Finally, while she cowers in bed watching TV, she hears the crick-crick-crick noise again and looks about her in fear. As icy glockenspiel notes play on the soundtrack, the covers rise at her feet and she peers underneath to see Kayako's shocked-white face staring back **F**.

For the most part, the scares follow a format that, in itself, creates a sense of ever-simmering dread **J**. Toshio appears in the dead space of the house, looking down from the bannister or scuttling behind **I** victims when their backs are turned. Often there is a jump scare **F** thrown into the mix, such as when he springs up from beneath the bed and miaows **G**. Meanwhile, the score mixes high notes with something more unearthly, the sound of deep tectonic shifts, then we hear the crick-crick-crick that denotes Kayako's approach.

Before we see her, her victims turn towards her in fear, which only serves to make the apprehension worse. There is a terrific moment after Sachie's son Katsuya (Kanji Tsuada) watches his wife, Kazumi (Shuri Matsuda), die of fright. He cries, bites his nails, hears

SCARE RATING

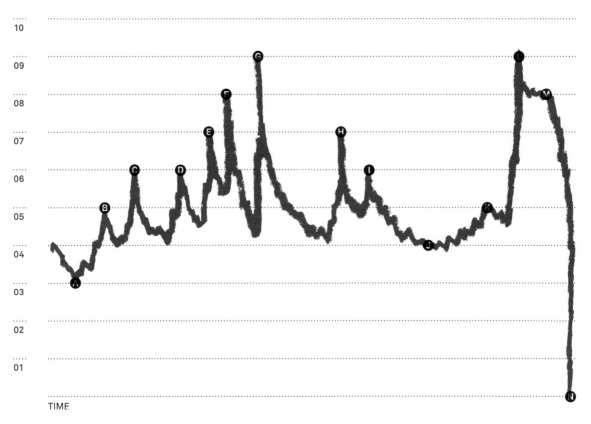

TIME

Further viewing

ONE MISSED CALL 2003

An uncharacteristically muted J-horror from Takashi Miike (*Audition*), *One Missed Call* features the usual tech and teen suicide fears, but gradually gets under the skin. Yumi (Ko Shibasaki) and her school friends become the victims of a mobile phone curse whereby a creepy ringtone 🕐 tells them they have missed a call from their own number, and the message is the last thing they say before they die 🕐. While the early, *Final Destination*-style killings are familiar, things pick up when the antagonist – troubled mother Marie Mizunuma (Mariko Tsutsui) – is identified. Yumi's friend Natsumi (Kazue Fukiishi) gets a spectacular death scene, strangled by her own broken arms 😵. But the film's best scare is its subtlest. At the Mizunuma flat, as Yumi investigates, a white face peeks out of the cupboard behind her 🕐, an eerie, blink-and-you'll-miss-it moment announced only by a slight craning of the camera.

MAMA 2013

In a cabin in the woods, suicidal stockbroker Jeffrey Desange (Nikolaj Coster-Waldau) plans to kill himself and his two little girls, until something stops them. 'Daddy there's a woman outside,' says one. 'She's not touching the floor. 🕐' This sets the tone for writer/director Andy Muschietti's chilling debut, which features a spindly black ghost with gorgon hair played by Javier Botet, a 6ft 6in Spanish actor who appeared as memorably gangly monsters in *[Rec]* and Muschietti's own *It*. Five years on, the girls (Megan Charpentier and Isabelle Nélisse) are found, alive but feral, and adopted by their uncle Lucas (also Coster-Waldau) and his rock-chick girlfriend Annabel (Jessica Chastain). Mama, however, has other ideas. Whether floating just off-screen 🕐 while playing with the kids, creeping out of the closet in a blur of inky limbs or appearing all of a sudden behind Annabel in the darkness ⚡, she will not give them up without a fight.

SATAN'S SLAVES 2017

Writer/director Joko Anwar's Indonesian box-office smash, a loose reboot of a classic 1980s horror, is quietly but consistently terrifying. Once a successful singer, Mawarni (Ayu Laksmi) is now a bed-ridden invalid, looked after by her daughter Rini (Tara Basro) and three younger sons, and haunted by her past decisions – among other things. One night, Rini hears her mother's bell ringing, and we follow her through the house to the bedroom, where she sees the patient standing, spooked, at the window 🕐. Then the bell rings again, and we realise it is not her mother standing there 🕐. Though Mawarni passes on, her spirit is more persistent, appearing as a sheet-covered figure in the hallway ⚡, and tormenting her oldest son Tony (Endy Arfian) in his bed at night. One scene has her calling his name through a radio set, then appearing in the corner of his room 🕐, ordering him to comb her long, black hair once again.

movement off-screen, then freezes as a shadow falls across his face 🕐. Before he turns to look, you can see in his eyes that he *knows* it is something unspeakable. Not that this will save him.

Kayako does not disappoint. In the climactic scenes, she comes crawling down the stairs to claim her victims on splayed, splintered limbs 😵; her eyes unblinking as if she has seen terrible things; that crick-crick-crick the sound of bones that will never knit or a mouth stretched so wide her soul might leak out. When it comes, death is slow, inevitable, a consequence not of violence but of terror.

The penultimate shots are of eerily empty streets with missing persons posters on the walls, the inference being that this evil will keep spiralling outwards. But with no end to the story, there is no catharsis, no reason to stop being afraid. We finish in the attic, where Kayako's body was first discovered. Now it is Rika who sits there, dead, with blood on her face. It is only a matter of time before the noise – and the curse – begins again.

Shutter

Scary stories to tell in the dark room

RELEASED 2004

DIRECTOR BANJONG PISANTHANAKUN, PARKPOOM WONGPOOM

SCREENPLAY BANJONG PISANTHANAKUN, PARKPOOM WONGPOOM, SOPHON SAKDAPHISIT

STARRING ANANDA EVERINGHAM, NATTHAWEERANUCH THONGMEE, ACHITA SIKAMANA, UNNOP CHANPAIBOOL, TITIKARN TONGPRASEARTH

COUNTRY THAILAND

SUBGENRE GHOST STORY

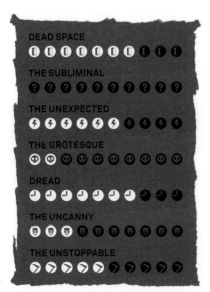

DEAD SPACE

THE SUBLIMINAL

THE UNEXPECTED

THE GROTESQUE

DREAD

THE UNCANNY

THE UNSTOPPABLE

Spirit photography is when 'ghosts' appear in pictures by accident or design. It is a rich subject for a horror film, because the genre performs the same trick by design rather accident. Directed by Banjong Pisanthanakun and Parkpoom Wongpoom, who co-wrote the screenplay with Sopon Sukdapist, *Shutter* is a sophisticated Thai spook story about a photographer, Tun (Ananda Everingham), and his girlfriend, Jane (Natthaweeranuch Thongmee). After a night out drinking with his obnoxious friends, they run over a woman (Achita Sikamana) and drive off, only for her to start haunting their life and work.

Besides featuring some 'genuine' – and genuinely scary – spirit photographs, the film makes ingenious use of cameras, dark rooms and deserted studios. While shooting a group of graduates, Tun glimpses the woman, now a white-faced spectre, in the crowd ❶, but when he scans back across the rows she has gone. Later, in the dark room, an evocative place of dripping taps and deep red light, Jane arrives to find the sink overflowing. First, she sees tendrils of long black hair, then fingers creeping over the side, then a woman's head emerging impossibly from the water ❷.

'In terms of how she looks, we didn't try to be too different from the J-horror ghosts trending at the time,' Pisanthanakun explained. 'But we tried to create ways for her to appear that felt fresh and special because we'd never seen them before.'

While taking wedding pictures in a studio, Tun finds himself alone in the dark, with only the camera flash to see by. In the strobing light, the woman appears far behind him ❶, then right up close ❷ as he calls for help. But photography is not just a medium to see the ghost, it is key to her grievances. Jane, who is still at college, spots the woman – Natre – in a picture in the science lab, and gets the truth from Tun. Natre was a shy girl he dated then dumped when he was a student. She became obsessed with him and threatened to kill herself, so to scare her off his friends sexually assaulted her while he took pictures.

This sorry story might have ended with Natre's suicide, but instead she came back for vengeance, killing Tun's friends one by

'These photographs represent more than macabre urban legends. They are signs. Why would the dead return to the living without a message to convey?'
— Editor

one and then appearing in front of their car that fateful night. As one character says, 'Sometimes spirits long for their loved ones.' Quite why Tun inspires so much female devotion is another matter.

With these awful secrets coming to light, Natre begins to appear everywhere. 'I tend to be scared of the common ghosts we could potentially see in our daily life,' Wongpoom told *Weekender*, 'such as in the elevator, car or bedroom.' 'All we're trying to do is to scare the audience the most,' said Pisanthanakun. 'The design, the appearance, the story, the atmosphere, *everything* is important.'

As Tun and Jane drive through the dark to meet Natre's mother (Vasana Chalakorn), he sees Natre lying in the road. She gets up and he speeds off, but then there she is again, creeping across the passenger-side window ⓔ, as the soundtrack shivers and swells. Tun accelerates, and when he looks again, she is gone. Turning back to the road, he sees her sitting on the front of the car, white-faced and grinning ⓖ. Natre, it transpires, committed suicide some time ago, but her mother refused to bury the body.

Tun and Jane retire to their hotel room. In the night, he wakes up and looks around the room, the curtains blowing ominously. As he tries to get back to sleep, the sheets slowly tauten around him, and it becomes apparent that something is pulling them away ⓗ. It is several awful seconds before he sees Natre at the end of the

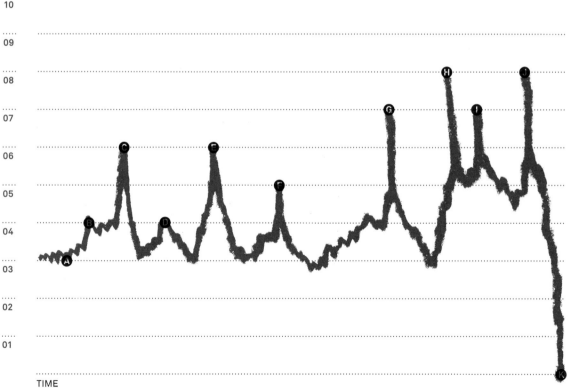

SCARE RATING

10

09

08

07

06

05

04

03

02

01

TIME

Further viewing

DARK WATER 2002

Perhaps the loneliest film of the J-horror cycle, this modest ghost story is *Ring* director Hideo Nakata's second Koji Suzuki adaptation. In the middle of a messy divorce, fragile Yoshimi (Hitomia Kuroki) looks for a new home for her and her young daughter Ikuko (Rio Kanno). Having rented a flat in a decaying apartment block, they find themselves haunted by the spirit of a missing girl called Mitsuko (Mirei Oguchi), as a damp patch spreads across the ceiling. The supernatural manifestations begin subtly, with Yoshimi feeling a hand in hers in the lift 🌙, before realising it is not Ikuko's. Next she finds a black hair in the drinking water 💀, Mitsuko's lunchbox keeps appearing in strange places, and she glimpses a little figure in a mac at the end of the corridor 💀. Although, unease is the default mood, the film offers an affecting tribute to the power of motherhood.

THE CANAL 2014

'Who wants to see some ghosts?' asks Dublin film archivist David (Rupert Evans) to a class of bored school children in Ivan Kavanagh's derivative but effective horror. But he quickly comes unstuck when he discovers an old crime scene video detailing a killing that took place in his house in 1902. Soon he is following his wife Alice (Hanna Hoekstra) to her lover's place with a hammer in his hand and murder in mind, then hiding in a (supposedly haunted) public toilet by the canal, as spooky footsteps pass the cubicle door 🌙. Alice goes missing and, while the police dredge the waters for her body, David begins to hear whispers in the walls 🔊 and see a ghostly figure 🔦 threatening his son Billy (Calum Heath). The sense of Asian horror transplanted to Ireland reaches its apex in the scene where, as in *Ring*, something reaches out of the screen to claim a victim.

GHOST STORIES 2017

Adapted by writer/directors Andy Nyman and Jeremy Dyson from their West End play, *Ghost Stories* is an Amicus-style portmanteau, linked by the investigations of Philip Goodman (Nyman), a debunker of myths and magic. Handpicked by a mysterious paranormal expert, Goodman must unravel three supernatural stories. The first is the best, following night-watchman Tony Matthews (Paul Whitehouse) as he guards a derelict asylum, while the lights, his radio and walkie-talkie glitch 🌙 and cut out. The other two tales, concerning a teenager (Alex Lawther) attacked in the woods, and a poltergeist bothering a businessman (Martin Freeman) at home, are weaker, but details such as the figure in a hoodie stalking the background 🔦 suggest sinister forces at work. At the climax, the pieces begin to fit together, and we realise Goodman is more haunted than his subjects.

bed ⚡ – a highly effective scare borrowed from *Ju-On: The Grudge*. With sickening purpose, she crawls towards him, then disappears. He checks under the bed, around the room, relaxes, but of course the next close-up 🔦 has her rotting face right next to his.

There follows an extraordinary chase sequence through the hotel, with Natre stalking across the ceiling 🌙 towards Tun. In the stairwell, he keeps coming back to the fourth floor – an unlucky number associated with death across South East Asia 💀 – where Jane arrives, before turning into Natre, her wrists cut, shrieking, 'Didn't you love me?' Unwisely, Tun gets out on to the fire escape ladder in the pouring rain. While the camera cranes above him, we hear the distant clang of metal 🌙, and soon Natre is climbing face-down towards him ➤.

Once Natre has been cremated, and Jane has found the incriminating negatives, the film has a killer sting in the tail revealed, of course, by camera. Since the accident, Tun has suffered neck pain and gained weight, but he only finds out why when he hurls a Polaroid camera to the floor in anger and a self-portrait emerges. In the image, Natre's ghost is – and has always been – sitting on his shoulders 💀: the spirit photograph she longs for, and he deserves.

The Descent

Not alone in the dark

RELEASED 2005

DIRECTOR NEIL MARSHALL

SCREENPLAY NEIL MARSHALL

STARRING SHAUNA MACDONALD,
NATALIE MENDOZA, ALEX REID,
MYANNA BURING, SASKIA MULDER,
NORA-JANE NOONE

COUNTRY UK

SUBGENRE CREATURE FEATURE

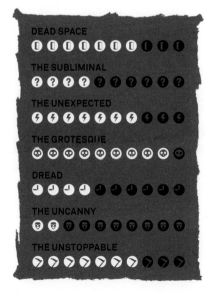

DEAD SPACE

THE SUBLIMINAL

THE UNEXPECTED

THE GROTESQUE

DREAD

THE UNCANNY

THE UNSTOPPABLE

If there is one guiding principle for survival horror, it is to put the characters in situations so perilous that the audience is on the edge of their seats even before the horror element emerges. In other words, a story that works before the monster appears, should work even better after – depending, of course, on the strength of your monster.

The Descent, the second film from writer/director Neil Marshall (*Dog Soldiers*), features some unforgettable monsters in the form of 'crawlers': blind, cannibalistic humanoids which have evolved undisturbed for centuries underground. Yet the first 50 minutes are about stranding the characters – a group of old female friends/ adventurers – in an uncharted cave system with all kinds of dangers lurking around every corner. As sensible Rebecca (Saskia Mulder) points out, 'Down there it's pitch black. You can get dehydration, disorientation, claustrophobia, panic attacks, paranoia, hallucinations, visual and aural deterioration.'

'It was deliberately a three-act concept of introducing the characters and getting them into the cave,' Marshall told *Screen Anarchy*. 'Then we spend the second act just exploring the horror of the cave and caving itself, the claustrophobia and all these other elements. Just milk that for all it's worth, milk it for all the tension that we can get out of it, and just when you think things can't get any worse; let's make them worse.' Indeed, the results are so effective that *Collider*'s reviewer Hunter Daniels called the film scarier than 'having a gun shoved in my mouth'. He should know – this actually happened to him after the screening.

We first meet Sarah (Shauna MacDonald), BFF Beth (Alex Reid) and frenemy Juno (Natalie Mendoza) white-water rafting. On the way home a striking, shockingly staged car crash ⚡ sees Sarah's husband Paul (Oliver Milburn) and daughter Jess (Molly Kayll) impaled with pipes, and she wakes up traumatised in hospital, having lost them both.

A year later, the friends head to the Appalachian Mountains (actually Scotland) with sisters Rebecca and Sam (Myanna Buring), plus Juno's protégé Holly (Nora-Jane Noone), to explore Boreham

Caverns. 'It's for tourists,' complains Holly. 'Might as well have hand-rails and a fucking gift shop.' But despite the tough talk, Sarah remains fragile, with Jess's laughter 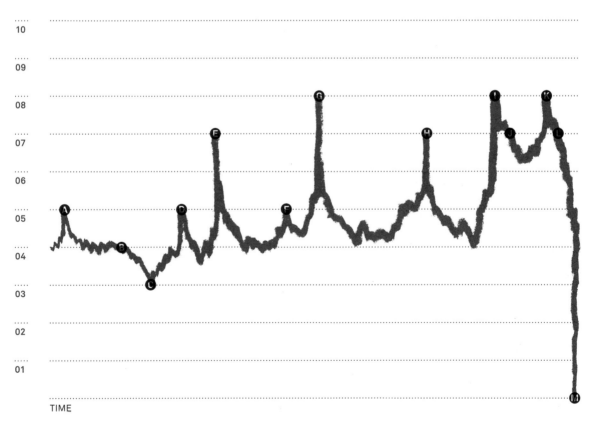 haunting her waking hours and those pipes piercing her dreams 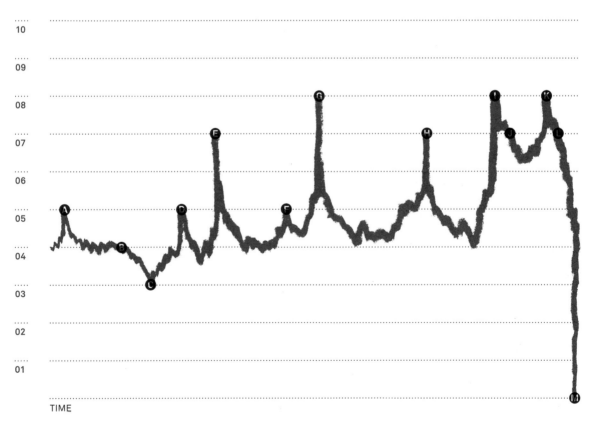. Indeed, for her, the film is as much about coming to terms with the death of her family as it is about surviving the cave and the crawlers.

In contrast to the early, exploratory moments of the climb, which feature a lush orchestral score and elegant camera moves, Marshall suffuses the underground scenes with claustrophobia 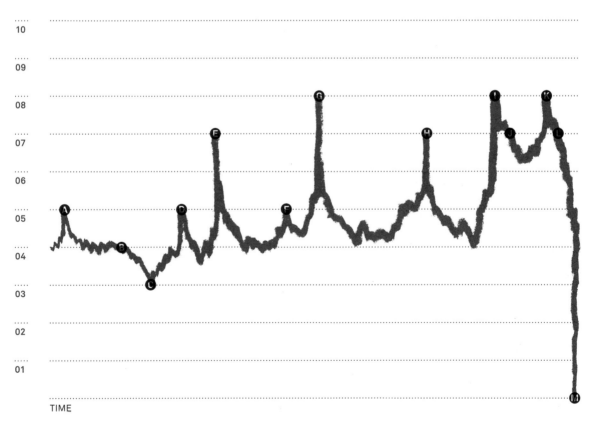. The score turns electronic, the soundtrack breathy and echoey, the cinematography close-up and intrusive. Indeed, cast in the smoky light of a red flare, the cave – actually a series of extraordinary sets built by production designer Simon Bowles at Pinewood Studios – takes on an appropriately hellish hue.

Stuck in a tight tunnel, Sarah panics, so Beth comes back to calm her. 'The worst thing that could have happened to you has already happened and you're still here,' she says. 'This is just a poxy cave and there's nothing left to be afraid of, I promise.' At this, as if brought on by the mention of Sarah's loss, a deafening burst of music signals the start of a rock-fall 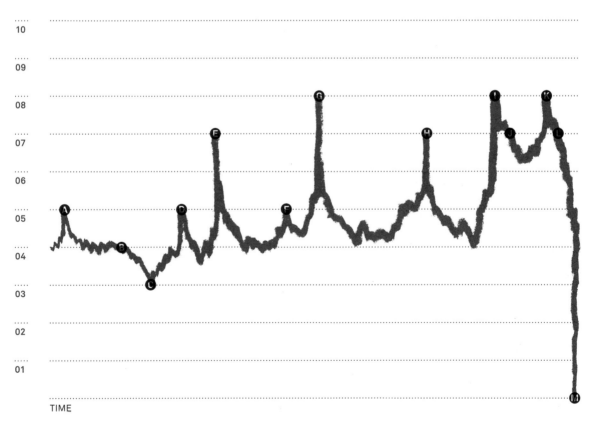, and the pair only just make it to the safety of the next chamber, a backdraft of air sounding like the cave itself is exhaling 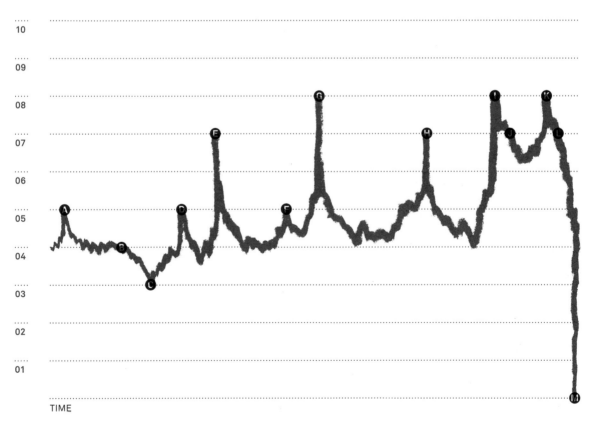.

From here things quickly deteriorate. True to form, Juno has actually taken the group off-map – the discovery of ancient climbing

SCARE RATING

10

09

08

07

06

05

04

03

02

01

TIME

> 'It hasn't got a name, it's a new system. I wanted us all to discover it. No one's ever been down here before.'
> — Juno

gear shows just how far – so nobody knows where they are and no rescue party is looking for them. Holly falls and suffers an open leg fracture, which occasions some impromptu (and ill-advised) surgery from Sam 😊. Then, as Sarah scans a chamber full of animal bones with an infra-red camera, and the group's unease tips into hysteria, a crawler appears in the darkness behind Beth for a beautifully timed jump scare ⚡.

To increase the surprise, Marshall kept the actors playing the crawlers away from the leads. 'They had no idea what they were going to look like,' he told *Indie London*. 'They got really on edge about it, so when we did the take and introduced the crawlers, they just snapped and went running off into the dark screaming.' MacDonald disputes this: 'Neil kept us apart from them, but because we knew they were Geordie lads dressed up with KY Jelly all over them, we knew it wasn't going to be that scary.'

Geordie lads or no, Marshall is careful to seed the idea of the crawlers' existence early on. In the first chamber, as Sarah looks about her, a distant figure squats in the far left-hand corner of the frame ⓛ. Later, after the rock-fall, Sarah shines her torch over the ceiling ledges, picking out a silhouette that, on the next pass, has disappeared ❓. You could watch the film over and over without catching either of these details, but the effect is that the audience, like the actors, suspects something else is down there in the darkness, even if they are not sure what 🌓.

After this first salvo, the shit really hits the fan. Holly is killed and eaten by crawlers, the group splinters, and Juno mortally wounds – then deserts – Beth, in the process revealing both her cowardice and the affair she was having with Sarah's husband. Not that there is any time for navel-gazing. Directed with customary blood and thunder by Marshall, the confrontations that follow are epically gory, with pick axes hammered into skulls, fingers forced into eye sockets and heads smashed against walls 😵.

The crawlers, meanwhile, are imaginatively disgusting, all white, glistening skin and dribbling mouths 😀, and their evolutionary path is convincing enough that *The Descent* could be seen as 'a film about a happy society of monsters being attacked by these girls', as Marshall told KPBS, 'because they mete out as much terror and pain as the crawlers ever do.' Indeed, through the process of the film, we watch Sarah graduating from victim to warrior with gusto. 'She has to become as primal and as savage as the crawlers,' said Marshall. 'When she's standing there with the fire in one hand and the bone in the other, I just thought, "That's symbolic of her journey." She's almost becoming one of them.'

Only Sarah and Juno survive until the finale, which sees them facing down a chamber full of crawlers. Having put Beth out of

TIMELINE

- Ⓐ **3 MINS** CAR CRASH
- Ⓑ **13 MINS** NIGHTMARE
- Ⓒ **20 MINS** INTO THE CAVE
- Ⓓ **24 MINS** CRAWLER SILHOUETTE
- Ⓔ **32 MINS** ROCK-FALL
- Ⓕ **45 MINS** BUSTED LEG
- Ⓖ **52 MINS** INFRA-RED CRAWLER
- Ⓗ **72 MINS** LIFE AFTER BETH
- Ⓘ **85 MINS** JUNO VS SARAH
- Ⓙ **88 MINS** BREAKING GROUND
- Ⓚ **94 MINS** SURPRISE PASSENGER
- Ⓛ **96 MINS** NO WAY OUT
- Ⓜ **100 MINS** ENDS

'Judging from what we've seen, they use sound to hunt with, like a bat. And they've evolved perfectly to live down here in the dark.'
— Sam

her misery with a rock, and learned of Juno's betrayal, Sarah incapacitates her rival with an axe blow to the leg, then heads for freedom. But even here the sense is that the threat cannot be overcome, only evaded, and we leave Juno alone in the endless dark, with silent armies massing above her ◗.

There is no escape for Sarah either. In the superior UK cut, a protracted sequence sees her breaking through the earth as if reborn, running to her car, and driving as far and as fast as she can away, the rumble of a huge logging truck recalling the tragedy that killed her family. Having put a safe distance between her and the cave, she stops the car and leans out the window to vomit, only for Juno to appear next to her ◐, alerting her to the fact she has been dreaming.

Next Sarah wakes far underground as a cacophony of creature noises swells around her. Not only is this the cruellest of twists – the US version, taken up in the so-so 2009 sequel, shows her getting and staying free – it plays into the hands of those who suggest the crawlers' function is metaphorical.

Sarah, so the theory goes, has PTSD, is taking psychiatric medication that wears off throughout the ordeal, and suffers visions of her daughter that repeatedly intrude into reality. Moreover, she is the first to see any sign of the crawlers, and at one point her scream blends into one of theirs. Could they be figments of her imagination, making her the killer? Or could the entire climb be taking place in her subconscious, with each friend representing a different aspect of her personality (Beth is loyalty, Juno sexuality, Holly adventure, and so on) and the crawlers standing in for her psychological demons? The evidence for this is scant, but not easy to discount.

In the hospital at the start of the film, we hear Sarah's heartbeat flatline before she races through a nightmare of encroaching darkness. Later, in a dream, her daughter turns into a crawler. Finally, and most mystifyingly of all, she keeps seeing her daughter's fifth birthday cake, but at the end of the film the five candles have become six, the number of lives lost underground.

Though these are intriguing asides, to pursue them too far is to detract from the film's gut-punch power. The dangers of the cave are too tangible; the crawlers too corporeal; the violence too visceral to be figments of Sarah's imagination. Indeed, having created a situation that is truly nightmarish, for it to be just a dream would be the ultimate cruelty.

Further viewing

CREEP 2004
British writer/director Christopher Smith's slick debut owes a big debt to Gary Sherman's 1972 film *Death Line*, which features a cannibal picking off the stragglers at Russell Square Tube station. After leaving a work party in town, and being attacked by her colleague Guy (Jeremy Sheffield), obnoxious Londoner Kate (Franka Potente) gets trapped in the Underground overnight, encountering give-a-shit staff, rough sleepers and a deformed killer (Sean Harris) who lives and hunts there. From over-lit ticket halls to pitch-black tunnels, the film makes great use of the environment, but it is Harris's performance that really stands out. With horrible, pancake skin that resembles a crawler's 💀 and a penchant for putting on surgeon's scrubs and performing amateur surgery 🕐, he makes a memorably disturbing villain. The first big reveal even brings to mind *The Descent's* infra-red scare, as a torch flickers to life in the darkness, illuminating his mangled face ⚡.

AS ABOVE, SO BELOW 2014
Scarlett Marlowe (Perdita Weeks), the hero of John Edward Dowdle's exhilarating found-footage flick, is a Lara Croft-style adventurer with a devil-may-care attitude and daddy issues galore. Having rounded up historical expert George (Ben Feldman), cameraman Benji (Edwin Hodge) and a bunch of French explorers lead by Papillon (François Civil), she heads down into the catacombs under Paris to look for legendary alchemist Nicholas Flamel and the philosopher's stone. With hundreds of miles of barely stable, skull-filled tunnels to get lost in, the peril levels are already high 🕐. Underground, they pass naked worshippers performing a black mass, find an old-fashioned telephone 📞 still somehow ringing, and happen upon long-lost explorer 'The Mole' (Pablo Nicomedes) who tells them, ominously, 'The only way out is down.' Soon they're wandering in circles, scared out of their wits, and questioning if there is a way out after all ➤.

RAW 2016
Writer/director Julia Ducournau's French-Belgian body horror combines heady sexual symbolism with some indelible imagery. When life-long vegetarian Justine (Garance Marillier) goes to the same veterinary college as her sister Alexia (Ella Rumpf), she and her fellow newbies are forced to endure a series of dehumanising hazing rituals during 'rush week'. One unsettling shot shows them creeping towards the camera in slow-motion 💀, like exotic, new creatures – or crawlers. After being covered in animal blood, and forced to eat rabbit kidneys, Justine develops a disgusting rash 💀 on her stomach. The next day, she starts experiencing cravings for meat, preferably human. The film's pivotal scene sees her sucking on a severed finger, and is so lip-smackingly graphic 💀 that it caused faintings at festival screenings. Soon, the siblings are roaming the empty highways then leaping out in front of cars to secure fresh victims. But once Justine starts killing, how can she stop?

Wolf Creek

No picnic at Hanging Rock

RELEASED 2005

DIRECTOR GREG MCLEAN

SCREENPLAY GREG MCLEAN

STARRING JOHN JARRATT, NATHAN PHILLIPS, CASSANDRA MAGRATH, KESTIE MORASSI

COUNTRY AUSTRALIA

SUBGENRE SERIAL KILLER

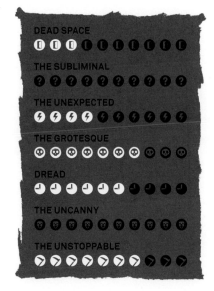

DEAD SPACE

THE SUBLIMINAL

THE UNEXPECTED

THE GROTESQUE

DREAD

THE UNCANNY

THE UNSTOPPABLE

Torture porn is rarely scary because it misunderstands how horror works. It is not the sadism that counts, but our fear of it; not the idea that the characters cannot escape, but the hope they might.

Inspired by Australian outback killers such as Ivan Milat and Bradley James Murdoch, Greg McLean's debut has a fearsome reputation. And yet much of its impact comes not from the – mostly implied – violence, but from how much we care about the central characters, a result of the cast's likeable performances and the time spent with them before the hammer falls.

Beginning with sun, sea and shots in Broome, Western Australia, the first act follows British gap-year girls Liz (Cassandra Morgan) and Kristy (Kestie Morassi) – both of whom are actually Australian – and Sydney boy Ben (Nathan Philips) across the outback towards Cairns. At this point the biggest drama is a will they/won't they? romance between Liz and Ben. (Spoiler: they will; another spoiler: it makes no difference.) But the journey is also taking them further out of their depth, the narrative hinting at dangers to come even as the mood remains upbeat.

We see that hicksploitation staple, a signpost peppered with bullet holes ◓; flocks of exotic birds startling; the car alone in the endless desert; but it is not until Emu Creek, the last petrol stop for miles, that there is a tangible threat. As Ben pays at the bar, a toothless local called Bazza (Andy McPhee) makes lewd comments about the girls. Although the situation is soon defused, a shot of Bazza and cronies afterwards suggests – at the very least – more chauvinist interference to come.

At Wolf Creek, a huge meteor crater and 'the world's fifth biggest UFO sighting area' according to Ben, the trio find that their watches have stopped, and the car will not start. 'Looks like we might be spending the night,' says Ben. 'This is fucked,' complains Kristy. 'Bitch,' Ben mutters, a stark example of how quickly human relationships break down in a crisis. Later, Mick Taylor (John Jarratt), a bluff outbacker, drives past in his truck and offers to tow the trio to his camp at the abandoned Navithalim Mining Co. – a near anagram

'Oh, I get around, you know. Never know where I might pop up.'
— Mick Taylor

of Ivan Milat. With little option, they agree, only to wake tied up (Liz), tortured (Kristy) and crucified (Ben).

'The Australian culture is bright sunny beaches, *Crocodile Dundee* and all that kind of shit, and the shadow side of that is xenophobia, homophobia, sexism, racism, all the stuff that we squash down but is alive and well,' McLean told convictcreations.com. Teasing one minute, threatening the next 🕐 – he even trots out Dundee's, 'That's not a knife!' gag – Mick is the perfect poster boy for this duality, a toxic product of the country's unchecked masculinity and unforgiving landscape. 'Sydney? Poofter capital of Australia,' he tells Ben, before admitting, 'Just playing with you, tiger. Never been over there myself.'

Like the family in *The Texas Chain Saw Massacre*, Mick used to kill 'vermin' for a living, until modern poisons made him redundant and he turned his attentions to humans. While he taunts Kristy, who he has chained up, half-naked, we see the headless carcass 💀 of a previous victim who lasted a 'good few months'. As McLean told *Assignment X*, 'The idea of a psychopath who captures someone and keeps them alive, that to me is the most terrifying thing you can possibly imagine.'

Having shot and briefly subdued Mick, Liz and Kristy escape, but the film keeps on twisting the knife – first they have to go back to Mick's body for his keys, then they have to return to the compound for another car. The tension is all the greater once we know the horrors

SCARE RATING

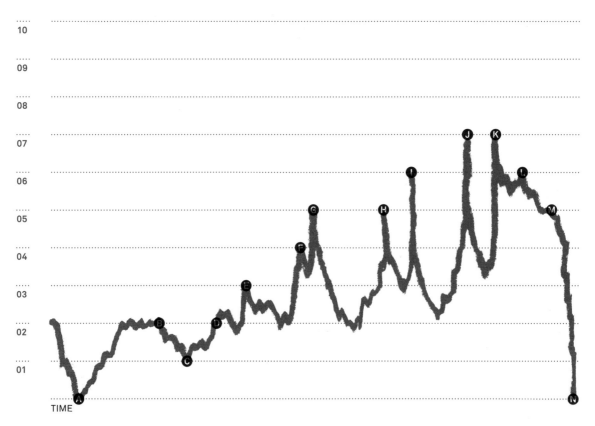

TIME

Further viewing

VISITING HOURS 1982

A cut above most of its contemporaries, Jean-Claude Lord's sadistic Canadian slasher features a fully fleshed-out villain in the form of misogynist psycho Colt Hawker (Michael Ironside). Infuriated by her TV show (well, it is produced by William Shatner), Hawker breaks into the home of feminist journalist Deborah Ballin (Lee Grant) to attack her. This extremely tense sequence features two great jump scares ⚡ – although the first is Ballin's escaped parrot hurtling towards the camera – before Ballin ends up as a patient in County General Hospital. Here, she befriends nice nurse Sheila Munroe (Linda Purl), only for Hawker to go after them both. With his clammy skin and quick temper, Hawker makes a compelling adversary, whether cutting an old woman's life support system then taking a photo as she looks on helpless, or infiltrating the operating theatre just as Ballin's anaesthetic takes hold 🕐.

SWITCHBLADE ROMANCE 2004

Alexandre Aja's debut features one of cinema's most insulting twists, but as an exercise in suspense over substance it is hard to beat. Lovers Marie (Cécile de France) and Alex (Maïwenn) head to the former's family home in rural France for a holiday. But in the night an intruder (Philippe Nahon) massacres Marie's family, then kidnaps Alex in his van, with Marie in hot pursuit. Set to a score that sounds like burning synapses, and spattered with head-severing, throat-slashing gore 😵, the home-invasion sequence really lives up the original title, *High Tension* 🕐. And as Marie follows the killer to a petrol station, where she tries – and fails – to get help, the pace never relents 🔁. Beautifully shot and breathlessly edited, the film has a real sense of the mechanics of violence, with the characters heaving axes, barbed wire-covered stumps and circular saws at each other to make sure they do as much damage as possible.

IN FEAR 2013

On their way to a music festival in Ireland, new couple Tom (Iain De Caestecker) and Lucy (Alice Englert) take a detour to an out-of-the-way hotel to celebrate their two-week anniversary. Trouble is, it is nowhere to be found and, as darkness falls, they find themselves driving in circles following signs that lead back to each other. 'We're not lost,' complains Tom, 'we're in a fucking maze.' Director Jeremy Lovering brings an intimate, improvised feeling to proceedings, putting us right there in the car with the characters as their confusion slowly turns to trepidation; the hanging trees and narrowing lanes becoming menacing in the twilight 🕐. When Tom stops to pee, Lucy sees a figure standing just outside the glow of the headlights 🔆. Later, they find her clothes strewn across the road. Clearly, someone is messing with them, and though the third act brings few surprises, the atmosphere is thick with awful possibility.

TIMELINE

he is capable of 🕐. 'Please don't leave me,' Kristy begs Liz, a heartbreaking bit of acting. 'What if he catches me again?'

In a garage full of Mick's victims' cars, with different currencies and drivers' licences pinned to the walls, we begin to see the full extent of his crimes. Liz even finds Ben's camera, which shows Mick's van parked behind them as far back as Emu Creek. As if to prove his omnipotence, Mick is waiting for her in the back seat 🔆 with a knife, threatening to sever her spine, turning her into a head on a stick 😵, a Milat speciality.

Kristy makes it as far as the road before Mick shoots her down like an animal. Ben, meanwhile, stumbles to freedom only to be accused of murdering his friends, whose bodies are never found. It is indicative of the film's pessimism that the only time Ben and the girls attempt to look for one another is in a deleted scene.

The last shot shows Mick, rifle in hand, strolling towards a bronze Outback sunset. That his silhouette fades into the sky before it disappears into the horizon suggests he is not just out there awaiting his next victims, but elemental – part of the landscape itself – and never to be stopped 🔁.

The Orphanage

Suffer little children

RELEASED 2007

DIRECTOR J.A. BAYONA

SCREENPLAY SERGIO G. SÁNCHEZ

STARRING BELÉN RUEDA, FERNANDO CAYO, ROGER PRÍNCEP, MABEL RIVERA, MONTSERRAT CARULLA

COUNTRY SPAIN

SUBGENRE GHOST STORY

Combining subtle scares with an almost Spielbergian emotional sweep, J.A. Bayona's handsome, heart-wrenching debut owes as much to J.M. Barrie's *Peter Pan* as it does to its supernatural antecedents such as Henry James's *The Turn of the Screw*. Written in the mid-1990s by Sergio G. Sánchez, and executive produced by Guillermo Del Toro, who has a minor character named after him, it is a story wrapped in loss, full of people trying and failing to communicate with the past as crimes go unsolved, cries go unheard and trails go cold. Our heroine Laura (Belén Rueda) is even gifted a necklace dedicated to St Anthony, the god of lost things, by her husband Carlos (Fernando Cayo). The film's original title? *The Lost Boy*.

With their adopted son Simón (Roger Príncep) in tow, Laura and Carlos move back to the orphanage she grew up in with the intention of reopening it as a home for children with disabilities. While Simón, who is HIV-positive, plays with his invisible friends – including one he meets in a cave at the nearby beach – social-worker-with-a-secret Benigna (Montserrat Carulla) comes sniffing around. At the opening party Simón goes missing, and as the months pass Laura must learn to engage with those invisible friends, actually the ghosts of former residents, to find out what really happened. Rueda's Goya-nominated performance is even more remarkable when you learn that she lost a child in real life.

After 30 minutes of scene-setting and suggestion, the first time something supernatural occurs is at the party. Making her way through the crowds, Laura finds herself shadowed by a little boy in a sackcloth mask. He turns out to be Tomás, a disfigured child who died in the cave years ago. 'I wanted Tomás' disfigurement to provide pathos,' Bayona told *Indie London*, 'which is why the sackcloth features a wonky smile, sewn on by his doting mother with clear unconditional love.' Whatever the reason, it is creepy as hell, whether Tomás is standing at the end of the corridor, staring at Laura 😈, or rushing towards her 🕐 to lock her in the bathroom. Once she has freed herself, she cannot find Simón – or Tomás – anywhere, although she does glimpse a child standing forlornly in the mouth of the cave as the tide comes in.

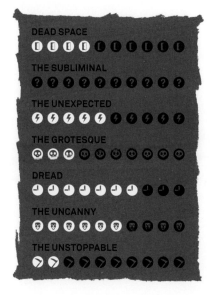

DEAD SPACE

THE SUBLIMINAL

THE UNEXPECTED

THE GROTESQUE

DREAD

THE UNCANNY

THE UNSTOPPABLE

> 'You hear, but don't listen. Seeing is not believing. It's the other way around. Believe, and you will see.'
> — Aurora

Six months pass, and with them all hope of finding Simón alive. But the film is not going where we expect it to. While Benigna knows more than she lets on – in fact, she used to work at the orphanage, Tomás was her son, and she poisoned the other children for letting him drown – she is swiftly dispensed with in a fantastic double jump scare that sees her hit by an ambulance then lurching – briefly – back to life 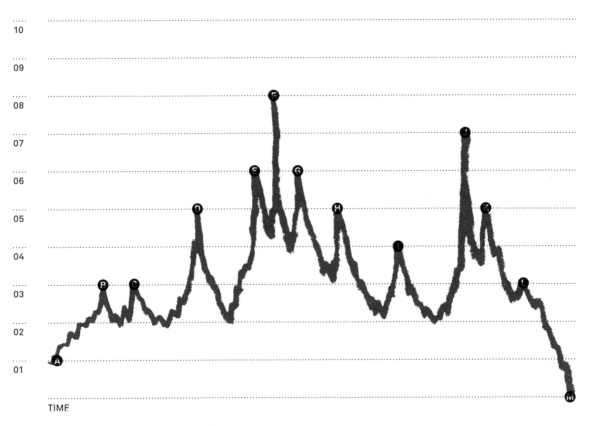, the bottom half of her face destroyed ☺.

For the most part, the set-pieces say more about the characters than they do about the supernatural. One wonderfully haunting moment has Laura confiding in Carlos as he gets into bed behind her, only for him to emerge from the bathroom, and whatever was lying there with her to disappear ◕. After a typically sober séance which reveals what Benigna did to the children, the film's most celebrated sequence sees Laura try to communicate with them through a game of One, Two, Three Knock on the Wall (also known as Grandma's Footsteps).

Shot with a rare handheld camera, and mixing trepidation with real pathos, it shows Laura counting, knocking on the wall, then pivoting to survey the empty room behind her ❶. The first time she turns there is nothing there; the next, an open door ◕; after that, the figure of a ghost-child; then more. For the final turn, the camera stays on her face as a hand touches her shoulder and the kids disappear off through the building, leading her, eventually, to Simón's final resting place.

SCARE RATING

10

09

08

07

06

05

04

03

02

01

TIME

Further viewing

WAKE WOOD 2009

After their young daughter Alice (Ella Connelly) dies in a savage dog attack, Patrick (Aidan Gillen) and his wife Louise (Eva Birthistle) move to the village of Wake Wood to recover in David Keating's Irish folk horror. Before you can say *Pet Sematary*, local leader Arthur (Timothy Spall) offers them the chance to bring Alice back to life for three days as part of an ancient ritual. This involves digging up her coffin to cut off her fingers 😊, then allowing her to be reborn through the body of another in an orgy of blood, mud and fire. But something is amiss. When Alice is questioned by locals, we see a flash of canine jaws ❓, while stepping over the town boundaries causes her to bleed profusely ⚡ as if dying all over again. The third act takes a turn into conventional killer-child territory before a coda of hard-to-credit cruelty.

I REMEMBER YOU 2017

Grief for a missing child casts a long shadow over this spooky Icelandic mystery, adapted by co-writer/director Óskar Thór Axelsson from a 2010 novel by Yrsa Sigurðardóttir. Two plots strands intertwine: the first concerns Freyr (Jóhannes Haukur Jóhannesson), a doctor mourning the disappearance of his son. The second follows Katrín (Anna Gunndís Guðmundsdóttir), her husband Garðar (Thor Kristjansson) and best friend Líf (Ágústa Eva Erlendsdóttir) as they renovate an old house in an island hamlet that has been abandoned for many years. While Katrín reaches into the stream to fetch cold beers, the figure of a hooded child appears behind her ⚡, continuing to haunt her whenever she is alone – including a claustrophobic sequence 🕐 in the cellar under the house. Freyr, meanwhile, sees his son's ghost leading him through the hospital to the morgue, where the body of an old woman might just prove to be the link between both cases.

THE DEVIL'S DOORWAY 2018

Despite sharing its basic premise with 2013's *The Borderlands*, Aislinn Clarke's found-footage chiller blazes trails in other ways. The first Northern Irish horror directed by a woman, it takes aim at the Catholic Church's Magdalene laundries, where pregnant girls were sent to work, and subjected to terrible state-sanctioned abuse. In 1960 Father Thomas (Lalor Roddy) and Father John (Ciaran Flynn) arrive at a laundry run by the fearsome Mother Superior (Helena Bereen) to document a reported miracle on film. Instead, they are woken in the night by children's laughter 😊, discover a pregnant girl (Lauren Coe) chained up in the basement, and follow a silent, dark-haired figure 🕐 to a secret room set up for a black mass. As well as making creepy use of the format, the film is unafraid to ask difficult questions about missing children and mass graves. As Father Thomas reminds us, 'The evil I've seen has always been the human kind.'

TIMELINE

Tragically, he has been in the house all along, locked in a concealed basement, where he fell and broke his neck the day of the party. Even worse, it is Laura's fault – while searching the cupboard under the stairs, she dislodged some building materials that sealed him in, and sealed his fate. Though we glimpse a figure in the darkness Ⓘ as she finds Simón's body, the denouement plays out more like fantasy than horror and is as bleak as it is beautiful. As Bayona said: 'I love the horror genre, but I want to transcend it too.'

Sitting alone with Simón's corpse, Laura overdoses on sleeping pills and 'wakes' to the glow of the long-defunct lighthouse. Here, Simón is alive, and the room is full of kids – including Tomás – who gather at her feet for a story. 'Once upon a time there was a house near the beach where the lost children lived,' she begins, the mother to her very own brood of boys and girls who never grew up.

[Rec]
Attack the block

RELEASED 2007

DIRECTOR JAUME BALAGUERÓ,
PACO PLAZA

SCREENPLAY JAUME BALAGUERÓ,
LUIS A. BERDEJO, PACO PLAZA

STARRING MANUELA VELASCO,
PABLO ROSSO, FERRÁN TERRAZA,
DAVID VERT, JORGE-YAMAN SERRANO

COUNTRY SPAIN

SUBGENRE FOUND FOOTAGE

Taking over a quarantined Barcelona apartment block from the ground floor to the penthouse, Jaume Balagueró and Paco Plaza's found-footage horror is an exercise in escalating tension ◔. The set-up is simple: Ángela Vidal (Manuela Velasco), host of the late-night TV show *While You're Asleep*, and her cameraman Pablo (Pablo Rosso) follow firefighters Manu (Ferrán Terraza) and Alex (David Vert) on a routine call-out, only to find themselves at the centre of what appears to be a zombie outbreak. Shot from the perspective of a single TV camera, the film thrusts the viewer into the action, with all the stress and barely suppressed panic that entails.

Upon arrival, Ángela and co. find the residents milling about in the lobby. A worried mother, who has a sick daughter, Jennifer (Claudia Silva), says she heard screaming coming from a first-floor flat. This, it turns out, belongs to an old woman called Conchita (Martha Carbonell), and the police are already at the scene. Having broken down the front door, the firefighters head into Conchita's apartment, the camera catching her blurry figure at the end of the corridor ◖, bloody, half-naked and confused. When they get nearer, she attacks the older policeman (Vicente Gil), ripping out his throat ☺, while the frame judders and distorts. Downstairs, the inhabitants learn that they have been locked in by the authorities. As they fight among themselves, Alex's body hits the ground with a splat ⚡.

Because the actors were not warned in advance, their shocked responses to Alex's death are genuine. Indeed, Balagueró and Plaza only showed them snatches of the script to keep them on edge and in the dark. Meanwhile the camerawork offers a visceral reaction to each new atrocity. 'We wanted the audience to come up closer to the horror,' Balagueró told *IGN*, 'to feel like they're a part of it all.'

In the hours that follow, we learn more about the origins of the outbreak from a health inspector (Ben Temple), who is allowed to enter in full hazmat suit. He explains that a dog with a rabies-like virus was traced back to the building. In fact, it belongs to Jennifer, who has also been showing some worrying symptoms. 'She only has tonsillitis!' claims her

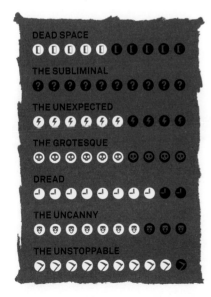

DEAD SPACE
◉◉◉◉◉◉◐◖◖◖◖

THE SUBLIMINAL
❓❓❓❓❓❓❓❓❓❓

THE GROTESQUE
☺☺☺☺☺☺☺◒☺◒☺

DREAD
◔◔◔◔◔◔◔◔◔◔◕

THE UNCANNY
☻☻☻☻☻☻☻☻◑☻◑☻

THE UNSTOPPABLE
⊘⊘⊘⊘⊘⊘⊘⊘⊘⊘⊘

'Tonight on "While You're Asleep" we'll accompany a team of firemen on their rounds through the city. Not only that, but we'll see things never revealed.'
— Ángela Vidal

mother as the residents turn nasty, but then Jennifer vomits blood on her 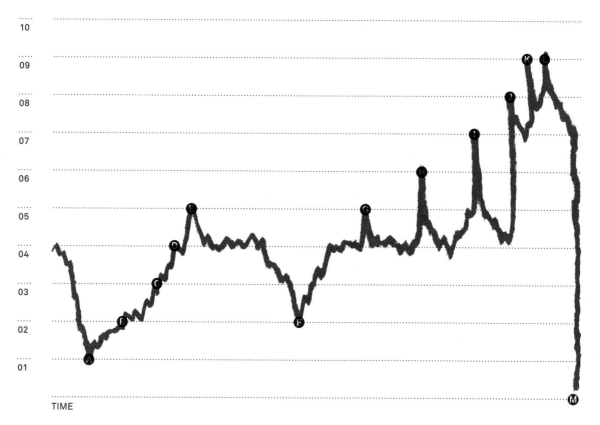 and runs off upstairs.

In Conchita's apartment, with the bodies missing and blood smears on the floor, Ángela and co. edge down the corridor ❹ to the lounge, where Jennifer stands in the darkness ❿, white-faced and black-eyed, before leaping on policeman Sergio (Jorge-Yaman Serrano) ❷. Our heroes flee, only to run into Conchita, who gets a mallet in the face from Manu. From here, the infection spreads like wildfire, causing resident after resident to fling themselves, roaring, at the camera ❯.

When the power goes out, Pablo's spotlight provides the only illumination. One minute it is flickering frantically across the apartment walls as he and Ángela search for the keys they need to escape ❿; the next it is shining into the stairwell revealing that *everyone* is infected – and coming for them. There is nowhere left to run but the penthouse, where they experience one of the genre's tensest sequences.

Having locked themselves in the darkened apartment, they find religious icons, newspaper cuttings and – never a good sign – a reel-to-reel tape player explaining the cause of the infection. The owner, it seems, works for the Vatican and has been trying to cure a possessed Portuguese girl named Tristana Medeiros. Instead, the enzyme she carries has mutated and become contagious, hence the outbreak, and she has been sealed in the penthouse to die. At this, a trapdoor in the ceiling suddenly swings open. When Pablo investigates, the camera

SCARE RATING

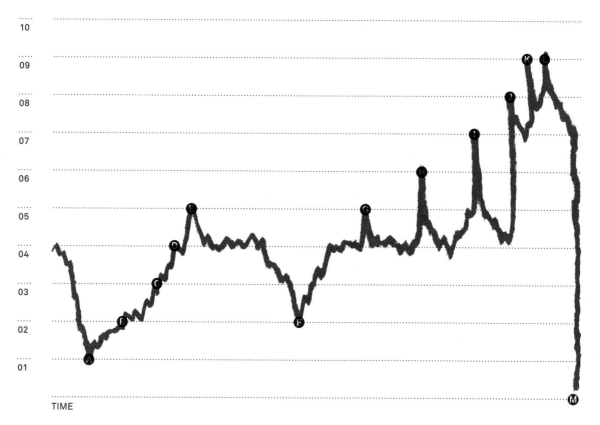

TIME

Further viewing

NIGHT OF THE LIVING DEAD 1968
Shot quickly and cheaply in already dated black and white, George A. Romero's landmark zombie film packs most of its scares into the first ten minutes. At an out-of-the-way cemetery, siblings Barbra (Judith O'Dea) and Johnny (Russell Streiner) put flowers on their father's grave, only to be attacked by an old man in a ripped suit who stumbles, stiff-legged, among the tombstones 💀. He kills Johnny, and Barbra flees to a nearby farmhouse where she finds a bloody corpse 😵 on the stairs, hordes of the undead gathering outside, and survivors hiding in the basement. While the pacing and the performances are patchy, what chills the most is the film's ceaseless nihilism. The zombies just keep on coming ⊘; children attack – and eat! – their parents; and the African-American hero Ben (Duane Johnson), the only sympathetic character who can also act, is gunned down by militia without a second thought.

V/H/S/2 2013
Amid sections on ghosts, zombies and aliens, the standout sequence in this found-footage anthology sequel is 'Safe Haven', another slice of adrenalised mayhem from Timo Tjahjanto and Gareth Huw Evans (*The Raid*). Having gained permission from sect leader 'The Father' (Epy Kusnandar), a film crew including Adam (Fachry Albar) and Lena (Hannah Al Rashid) is given the opportunity to explore Paradise Gates, a secret Indonesian cult, getting much more than they bargained for – especially Lena. When she calls the assembled school children beautiful, she is told, 'Not as beautiful as yours will be.' Then, at The Father's prompting, a mass suicide begins. To a soundtrack of distorted chanting 💀, Adam races through the compound, past rooms full of poisoned kids and followers blowing their brains out 😵, just in time to see his host explode in a shower of blood and gore. But when he discovers Lena in a birthing room, the madness really begins.

BASKIN 2015
Expanded from a short, Turkish director Can Everol's debut is a toxic cocktail of metaphysical dread 🕐 and gore so extreme 😵 it would give Clive Barker pause. While sharing some truly disgusting-looking barbecue at a roadside diner, a squadron of cops is called to an abandoned police station on the wrong side of town. Arriving after a nightmarish journey, they explore by torchlight, descending into a – perhaps literal – hellmouth in the bowels of the building. Here a severely deformed man (Mehmet Cerrahoglu) presides over scenes of derangement and degradation that would not look out of place in a Bosch painting. Eyes are gouged, intestines pulled out and live tarantulas scuttle from mouths as bag-faced demons screech and copulate 😵. The take-home? 'Hell is not a place you go to,' says the man. 'You carry hell with you at all times.'

TIMELINE

- **Ⓐ 5 MINS** FIRE STATION
- **Ⓑ 10 MINS** LOBBY
- **Ⓒ 14 MINS** OLD LADY ATTACKS
- **Ⓓ 18 MINS** FALLING FIREMAN
- **Ⓔ 20 MINS** OLD LADY ATTACKS AGAIN
- **Ⓕ 35 MINS** AUTHORITIES FAFF
- **Ⓖ 45 MINS** DAUGHTER ATTACKS
- **Ⓗ 53 MINS** EVERYONE ATTACKS
- **Ⓘ 60 MINS** PENTHOUSE
- **Ⓙ 65 MINS** ATTIC ATTACK
- **Ⓚ 67 MINS** TRISTANA!
- **Ⓛ 70 MINS** PABLO!
- **Ⓜ 75 MINS** ENDS

panning through 360 degrees, an infected child lunges into frame ⚡, and the spotlight goes out completely.

The final scene is captured in sickly green night-vision, with Ángela reaching out for Pablo like a drowning woman. But as the camera strafes the room, we catch an awful figure standing at the end of the corridor 🕐. As portrayed by Javier Botet, an extraordinary physical performer, Tristana is terrifying to behold – too tall, too skinny, all stretched and wrong 💀 – and when she lollops towards them, hammer raised, it is easy to imagine the fear in Ángela's eyes is real.

Pablo dies in a rain of blows, and Ángela is left alone with the camera, before being dragged off into the darkness to a fate unknown until 2009's excellent *[Rec]²*. 'Manuela kept asking, "Will I live or will I die?" and we said to her, "Try to survive, we don't know what's going to happen."' Plaza told *Tout Le Cinema*. 'It's something you can feel. She's really scared.' You certainly can. With its shaky camerawork, screechy performances and sudden violence, *[Rec]* is less like a fiction film than a frontline news report. And Ángela's desperate final line, repeated from earlier – 'We have to tape everything, Pablo. For fuck's sake!' – could be motto of the genre.

The Strangers

Faces of death

RELEASED 2008

DIRECTOR BRYAN BERTINO

SCREENPLAY BRYAN BERTINO

STARRING LIV TYLER, SCOTT
SPEEDMAN, KIP WEEKS,
GEMMA WARD, LAURA MARGOLIS

COUNTRY USA

SUBGENRE HOME INVASION

In a subgenre full of ugly, inexpensive shockers, Bryan Bertino's slick home-invasion movie is unusually sophisticated. Its intruders, three nameless 'strangers' (Kip Weeks, Gemma Ward and Laura Margolis) in impassive dime-store masks, slink from the shadows like ghosts – or *Halloween*'s Michael Myers – and their plan is to toy with rather than just torture their victims. In this case that means shaky couple Kristen McKay (Liv Tyler) and James Hoyt (Scott Speedman), who arrive in the middle of the night at his family's secluded summer house.

Inspired by the Manson family murders, and a series of break-ins that occurred in his neighbourhood as a child, Bertino keeps the story so personal that the events take place at the same address he grew up in. 'I wanted to ground the film in as much reality as possible,' he told comingsoon.net.

To begin, Bertino borrows a technique from *The Texas Chain Saw Massacre*, using introductory titles that are both written and read out to suggest the crime that follows is real, and so terrible the details 'are still not entirely known' ●. Next, we see drive-by shots of other houses in the area as the skies darken, an old Hitchcock trick that implies the story could take place in any of them. Finally, we watch two Mormon boys (Alex Fisher and Peter Clayton-Luce) discovering the crime scene and calling 911. 'There's blood everywhere,' says one. Just whose it is remains to be seen.

These first few minutes need to work hard, because the next half hour is more about grounding the main characters than scaring us. Kristen and James are on their way back from a wedding where he proposed and she turned him down. So when they turn up, in evening wear, at a house strewn with hopeful rose petals, the dynamic is tense but tender, our heroes occupying that shell-shocked limbo between being intimates and being exes. Indeed, as they prepare to have sex and thus become more typical horror film victims, there is a fateful knock at the door. 'Is Tamara here?' asks a girl, silhouetted in the darkness. 'That was weird,' decides James, having sent her on her way and screwed the porch light back in. But it is only the beginning. James goes for a drive to clear his head, and the girl returns asking

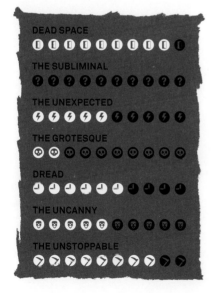

DEAD SPACE

THE SUBLIMINAL

THE UNEXPECTED

THE GROTESQUE

DREAD

THE UNCANNY

THE UNSTOPPABLE

'People don't just stand out there, staring at us like that. They want something.'
— James

the same question, and receiving even shorter shrift. After she has gone, Kristen locks the door, and a wide shot strands her alone in the empty house, suddenly vulnerable. Next comes the kind of startling dead-space scare upon which the film's reputation stands. As Kristen wanders to the kitchen, aimless, a little freaked out, a masked face (Weeks) seems to float into frame behind her 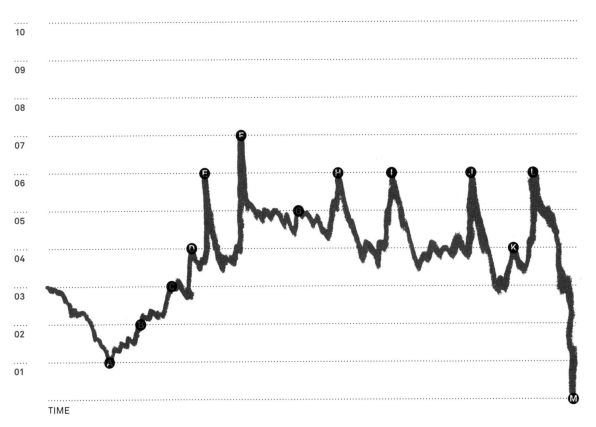, getting closer ● – and clearer – as she pours herself some water. It only disappears when, finally, Bertino cuts to another angle.

Later, when the man appears again in the window ●, the film kicks up a gear. Kristen screams, the record player sticks ● on a maddening loop, and the front door creaks open to reveal a masked woman (Ward) as well. While Kristen cowers in the bedroom, it seems things cannot get much worse. But as avowed fan Stephen King noted in *EW*: 'Horror is not spectacle, and never will be. Horror is an unknown actress, perhaps the girl next door, cowering in a cabin with a knife in her hands we know she'll never be able to use. Horror is the scene in *The Strangers* where Liv Tyler tries to hide beneath the bed . . . and discovers she can't fit there.'

With the home invasion in full swing, James returns and a pattern begins to asserts itself: the pair try to escape, one of the three strangers emerges from the darkness to stop them, and they are left even more vulnerable than before, increasing the sense that they are pawns in a particularly cruel game ●. There is a brutal example when

SCARE RATING

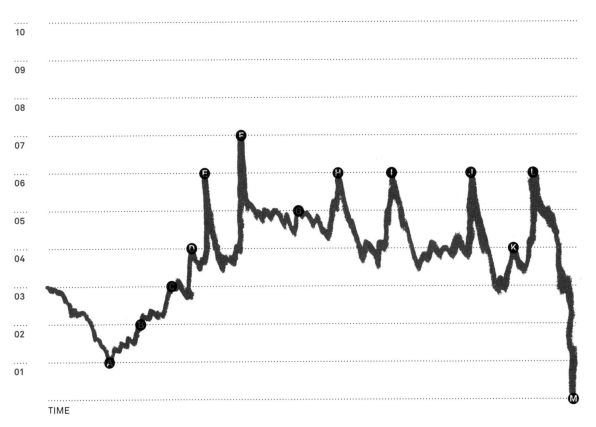

TIME

124

Further viewing

THEM 2006
Lasting barely 75 minutes and featuring a named cast of just three, David Moreau and Xavier Palud's French-Romanian home-invasion horror is as stark as its title. Based – or so they say – on real events, it takes half an hour before anything happens to the protagonists, French couple Clémentine (Olivia Bonamy) and Lucas (Michaël Cohen), who live in an isolated mansion on the outskirts of Bucharest. Mostly this means long, insinuating shots of empty corridors 🕐 in that pervasive grey-green colour palette beloved of New French Extremism. But when intruders in hoodies break in, steal their car and torment them, things really kick off. The middle section, which sees poor Clémentine chased across an antique-filled attic then back and forth through the house, is overwhelmingly tense, particularly the scene in the basement. Here, polythene sheets hang from the ceiling, allowing her assailants to conceal themselves ⚡ as she creeps past.

F 2010
A rare hoodie horror that actually manages to be frightening, writer/director Johannes Roberts' school-set slasher is lean, mean and full of tension. North London teacher Robert Anderson (the believably lived-in David Schofield) is a man on the brink. His wife has left him, his daughter Kate (Eliza Bennett) scorns him, and he's drinking on the job after a violent run-in with a pupil. One night while he takes detention, hooded intruders lay siege to the school. Not only is the setting convincing, the attack scenes are original and elegantly orchestrated. In the library, we see the intruders scurry up the shelves like free-runners behind doomed librarian Lucy (Emma Cleasby) 🅘. Later, they stalk towards young teacher Nicky (Roxanne McKee) slowly 🕐 like proteges of Michael Myers. Even up close we never really see their faces, and the cruelly curtailed ending is as harsh as any of the blood-letting.

US 2019
The second film from writer/director Jordan Peele (*Get Out*) combines a frightening home-invasion sequence with state-of-the-nation anxieties. The prologue, set in 1986, shows young Adelaide (Madison Curry) wandering off from her parents at Santa Cruz pleasure beach, only to stumble across her doppelganger in the hall of mirrors. 'My whole life I've felt like she's still coming for me,' says the grown-up Adelaide (Lupita Nyong'o), who brings her husband Gabe (Winston Duke) and kids (Shahadi Wright Joseph and Evan Alex) back to the area on vacation in the present day. One night, they see four figures standing, silently, in the driveway 🕐, and Adelaide's worst fears come true. 'It's us,' says young Jason (Evan Alex) of the intruders: boiler-suit-clad clones known as The Tethered who are looking to replace ordinary people across America. Cue much savagery 😨, strangeness ❓ and satirical sideswipes – note how the title could be either *Us* or *U.S.* depending on your point of view.

TIMELINE

James's friend Mike (Glenn Howerton) arrives to pick him up. As Mike walks through the carnage of the house, we see the male stranger, axe raised, looming behind him 🕐. Then, just as Mike is about to turn, James shoots and kills him ⚡, presuming he is a stranger too.

The message is clear, if nihilistic. In the face of real evil, the things that are meant to save us – the fire alarm that Kristen dismantles, the gun that goes off at the wrong time, the car that only drives in reverse, our loved ones – will fail us. The film's divisive showdown sees Kristen and James tied to chairs as the three strangers come in for the kill. Frankly, a better example of the banality of evil would be hard to find. As King wrote: '"Why are you doing this to us?" Kristen whispers. To which the woman in the doll-face mask responds, in a dead and affectless voice: "Because you were home." In the end, that is all the explanation a good horror film needs.'

Lake Mungo
Local girl in the photographs

RELEASED 2008

DIRECTOR JOEL ANDERSON

SCREENPLAY JOEL ANDERSON

STARRING ROSIE TRAYNOR, DAVID PLEDGER, MARTIN SHARPE, TALIA ZUCKER, TANIA LENTINI

COUNTRY AUSTRALIA

SUBGENRE GHOST STORY

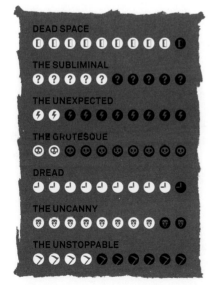

'In December 2005, a tragic accident began a series of extraordinary events that thrust a grieving family and the small Victorian town of Ararat into the media spotlight,' reads the title card opening Australian writer-director Joel Anderson's debut, a chillingly credible study of loss and how it warps us. 'This film is a record of those events.'

Utilising a variety of formats, from 33mm to camera-phone footage, the result is a faux-documentary mixing matter-of-fact interviews, home movies and TV news to build up a matrix of different viewpoints. Beginning with a series of vintage spirit photographs, and ending with some spirit photography of its own, the film suggests that, as psychic Ray Kemeny (Steve Jodrell) puts it, 'There are ghosts everywhere.'

When teenager Alice Palmer (Talia Zucker) drowns at the local lake, her family are distraught. Dad Russell (David Pledger) has to identify the body, which we see, blanched and bloated, in a series of police photographs ☻. But after the funeral the Palmers start hearing and seeing strange things around the house. Mother June (Rosie Traynor) has terrifying nightmares in which, 'Alice would come down the hall, still dripping from the dam, and just stand at the foot of our bed just staring at us. ◑' Russell, meanwhile, recalls seeing Alice in her own bedroom. 'She slowly turned around, looked me right in the eye, fully for what felt like forever, and then she just came at me,' he says, visibly shaken. 'Stood up and said: "Get out! Get out!"'

Soon, Alice starts appearing in photographs and videos shot by her brother, Matthew (Martin Sharpe), so they exhume her body to make sure it is really hers. DNA tests prove that it is, but further investigations reveal that, as her schoolfriend Kim (Chloe Armstrong) says, 'Alice kept secrets. She kept the fact she kept secrets a secret.' The biggest secret of all? That on a school trip to Lake Mungo, New South Wales, she foresaw her own death.

From the first few frames, Alice's anxieties cast a spooky pall over the entire film. 'I feel like something bad is going to happen to me,' she admits in voiceover. 'I feel like something bad *has* happened. It hasn't reached me yet, but it's on its way. ◑' The fact that Alice confesses a

'Death takes everything eventually. It's the meanest, dumbest machine there is and it doesn't care.'
— June Palmer

similar dream to June's – in which she stands, cold, wet and 'paralysed with fear', at the end of her parents' bed – only adds to the idea that there is a sinister dialogue between the past and the future that nobody can quite unpick.

'I like the idea of disquiet,' Anderson told journalist John Catana. 'I don't find jumping-out-of-the-closet moments scary.' To this end, the film makes highly effective use of after-the-fact pictures and video footage to create a slow-burn sense of unease. Matthew is an amateur photographer who has taken the same shot of the Palmers' back garden every three months for the past three years. In April 2006, he spots Alice in the latest image, and the camera zooms in until we can just make her out standing against the fence **G**. Next, a video camera he sets up in the house reveals a shadowy figure crossing the hallway to Alice's bedroom. Then, upon reviewing footage of a failed séance the family held with Ray, he sees Alice's face at the edge of the screen **I**. The power of these creepy, cumulative reveals is to make us fear what lurks in each corner and distrust everything we see. **J**

And so we should. Matthew's footage is proved to be fake, a misguided attempt to reassure his parents that Alice is still with them, and the mystery takes a mundane turn when one of the figures is revealed to be former neighbour Brett Toohey (Scott Terrill), sneaking into Alice's room to retrieve a sex tape they made. Although this line of enquiry leads, ultimately, nowhere – the Tooheys moved house and cannot be

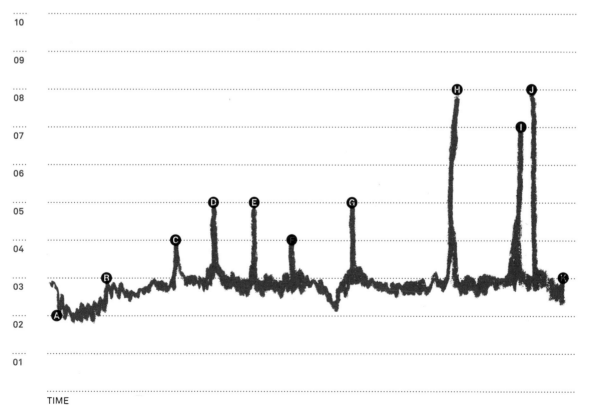

SCARE RATING

10
09
08
07
06
05
04
03
02
01

TIME

found – it makes explicit the film's debt to David Lynch's *Twin Peaks*, which revolves around the secrets of deceased teenager Laura Palmer (Sheryl Lee). It also leads Alice's family closer to the truth when they discover her diary, which contains Ray's business card, and references to that fateful school trip.

Lake Mungo is a dry lake where Aboriginal remains were discovered dating back some 20,000 years, but it is not just archaeologically rich, it is also metaphorically rich. As a dry lake it has no future – like Alice – and its barren sands are an extreme example of the atmospheric but empty landscape shots that pepper the film. Thanks to camera-phone footage, supplied by Kim, of Alice burying something in the darkness, the family travel to the site to discover a cache containing Alice's mobile, her bracelet and a necklace: a time capsule of her most precious things; insurance against the unnameable horrors to come.

On the phone, they find a shaky, badly shot video that makes the blood run cold Ⓘ, a far cry from the rest of the film's careful composure. Against the endless black of the outback night, a blur of white emerges, indistinct and far away. As we get closer, and that opening, 'I feel like something bad is going to happen to me,' voiceover replays, the blur becomes a face – *Alice's* face, blanched and bloated – the one we saw after her body was pulled from the water Ⓑ. 'I think Ali saw a ghost,' says Russell with grim finality, 'but she wasn't to know that it was her own.'

129

'Stuff started happening around the house. Noises in the roof, sounds coming from outside the window.'
— Russell Palmer

But not only is the film deeply unsettling, it is also deeply moving – even the spirit photographs seem sad. While most show faces materialising out of the background, one depicts hands clasping across the great divide. Another has ghostly fingers reaching out towards a man looking the other way, who, you feel, will never know. And, of course, when we look at regular photographs, we *are* seeing ghosts – of the past, of times gone by, of people as they were.

After the spirit photographs comes a picture of the Palmers in front of their house. Were they to look at this photograph, they would not see themselves, but the family member who is missing. 'Losing someone you love,' said Anderson, is 'a very human, very genuine fear. And I think that it's also great for drama in that respect, because it's a way of exploring a lot of things about what is important to people, how people deal with the unthinkable happening, how people deal with grief and things that are senseless. And you don't do it intellectually. I think you do it through grieving. I think you do it through struggling to make sense of your world.'

When quizzed about his reaction to Alice's death, Russell admits to leaving the porch light on 'just in case'. 'And why's that?' probes the interviewer. Russell takes a second to respond, half-smiling in embarrassment, eyes creasing as if he might cry – a really astute piece of acting that does not look like one. 'Just in case she comes home, I guess.' For his own reasons, Matthew walks around wearing Alice's jacket – which causes confusion when he is photographed from afar – and starts faking her image. Last, but not least, June slips into people's houses unnoticed at night. 'I guess I really just wanted to be inside someone else's life for a while,' she admits. 'Where I come from they block out the mirrors to stop the dead finding their way back,' says Ray, who is Hungarian by birth. Everyone, it seems, has their own rituals of grief, most relating to the idea that the dead are never fully gone. 'The idea that they might still exist, in a paranormal sense, that there might be something of them left behind – is incredibly strong and people have very strong affinity with that idea because it gives hope,' said Anderson. 'It's a strange kind of hope, but it's better than nothing.'

This hope pays off in the coda. Having excavated Alice's secrets, the Palmers begin the healing process, selling the house and preparing to move on. The film closes on the family photograph we first saw at the beginning. Matthew, Russell and June pose outside the house, the image given new context when we realise they are bidding farewell to their old lives. But there is a sting in the tail. In the dark of the window behind them, Alice's ghost is watching 🪦. And as the credits roll, there are more examples: her face in the shadows of some grainy VHS birthday footage, then standing in the distance at the lake. In Matthew's April 2006 garden image she appears twice – once as a fake ghost planted by her brother, then as a real ghost in the far corner 🔦. The message is clear, if unnerving: unquiet spirits surround us all the time, no matter if we can see them or not.

Further viewing

SINISTER 2012

Scott Derrickson's clever chiller begins with scratchy film footage of a family being lynched in their own back garden. Next thing we know, down-on-his-luck true-crime writer Ellison Oswalt (Ethan Hawke) has moved his wife and kids into the house without telling them what happened to the previous residents, the hanging tree still visible through the window 🌓. While researching the case, Ellison finds a box of films in the attic which contain innocent footage of different families intercut with their murders. Though it has plenty of spooky moments – not least when son Trevor (Michael Hall D'Addario), who suffers from night terrors, suddenly unfolds himself, screaming, from one of the packing boxes ⚡ – the standout scare comes when a family are tied to sun loungers then drowned in their own pool. In the murk, Ellison can just make out the face of a demon drifting impossibly through the water 🪦.

SAVAGELAND 2015

The area around the Arizona-Mexico border is nicknamed 'Savageland' because life there is so short and brutal. Written and directed by first-timers Phil Guidry, Simon Herbert and David Whelan with a clear political agenda, this faux-documentary uses talking heads and reconstructions to explore how the town of Sangre do Cristo, population 57, was wiped out overnight in a bizarre massacre. While some blame the cartels, the main suspect is illegal immigrant Francisco Salazar (Noe Montes), who is tried and executed for the killings. But Salazar also took a roll of – suppressed – photos that tell a different story, showing blurred, zombie-like shapes emerging from the desert 🪦 and demon faces just discernible in the background 🔦. The more we hear of the case, the more eerie details accumulate, such as the eight victims who jumped to their deaths off the water tower rather than face what was happening in the town below 🌓.

DEATH OF A VLOGGER 2020

Written, directed, produced, edited by and starring Graham Hughes, this low-budget Scottish effort skewers online fame while providing some surprisingly effective scares. Like *Lake Mungo*, it takes the form of a fake documentary investigating the death/disappearance of vlogger Graham (Hughes), whose online videos document a haunting in his flat. As he films himself talking straight to camera, Hughes makes great use of dead space 🔦, with the ghost – a J-horror-style, lank-haired wraith – appearing suddenly behind him. This technique reaches its apex during a séance with charlatan Steve (Paddy Kundracki) and best friend Erin (Annabel Logan). Inventively shot in 360 degrees, it sees the camera rotating from character to character as the suspense ratchets up 🌓 and a figure reveals itself ⚡. 'You don't really hear about stuff happening in places like this: newbuilds,' offers Graham. But Hughes' skill is in using everything to hand – from bed sheets to Street View – to make the ordinary ominous.

Martyrs

No pain no glory

RELEASED 2008

DIRECTOR PASCAL LAUGIER

SCREENPLAY PASCAL LAUGIER

STARRING MYLÈNE JAMPANOÏ,
MORJANA ALAOUI, CATHERINE BÉGIN,
ISABELLE CHASSE, ROBERT TOUPIN

COUNTRY FRANCE/CANADA

SUBGENRE NEW FRENCH EXTREMISM

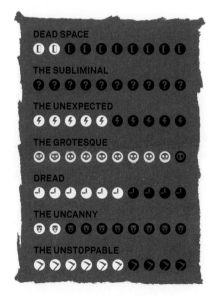

DEAD SPACE

THE SUBLIMINAL

THE UNEXPECTED

THE GROTESQUE

DREAD

THE UNCANNY

THE UNSTOPPABLE

Perhaps the most extreme work of the New French Extremism movement, *Martyrs* is a film the majority of people will only watch once – and never forget. But it is not just traumatising for its own sake, it is *about* trauma, containing so much violence it seems to have been cleaved in two. The first half is made up of a terrifying home invasion; the second, of extended torture scenes that push towards the profound.

As a child, Lucie (Jessie Pham) was kidnapped by persons unknown, before escaping, scarred and frightened. In a children's home she befriends Anna (Erika Scott) and the two grow up inseparable. Cut to fifteen years later. The Belfonds, an ordinary bourgeois family, are having breakfast when the now grown-up Lucie (Mylène Jampanoï) knocks at the door and shoots everyone ⚡ – the kids included. Soon Anna (Morjana Alaoui) arrives to help her clean up the bodies. But were the family really involved in her incarceration?

Frayed and frenetic like a nightmare, this section of the film keeps the viewer constantly on edge 🕐. The first thing we see of the Belfonds is daughter Marie (Juliette Gosselin) screaming as she is attacked, but it turns out she is actually play-fighting with her brother Antoine (future director Xavier Dolan-Tadros), just one of many nasty reversals. Later, when it seems like mother Gabrielle (Patricia Tulasne) may survive her injuries, Lucie caves her skull in with a hammer ☺. If our heroine is capable of such things, you think, what on earth are we going to see next? 'I liked the idea that, after a while, the audience would wonder, "What am I fucking watching?"' Laughier told *Eye for Film*.

But even in her cruellest moments, Lucie never completely loses our sympathy because her pain is so tangible, and the violence she metes out is scarcely worse than the violence done to her. The first inkling we have that Lucie is also being hunted is at the children's home when she wakes to see a feral figure (Isabelle Chasse) crouched on the edge of her bed 🧟, then lunging for her with a bestial roar ⚡.

The figure, a heavily scarred, naked woman who Lucie recalls from her years in captivity, next appears in the Belfond house, all pale, bent and bloody, flinging Lucie against the furniture and raking her back with a straight razor ☺. Though she returns with the regularity of a J-horror

'Martyrs are exceptional people. They survive pain, they survive total deprivation. They bear all the sins of the earth.'
— Mademoiselle

ghost ⟩, there is nothing spectral about these attacks, which seem to be born of fury rather than vengeance. It is only when we see through Anna's eyes that we realise the figure is not real, but a manifestation of trauma, and the only way to stop it is for Lucie to kill herself, which she does by cutting her own throat ⚡. For some, it seems, there is no escape from the long talons of abuse.

It is here that the film takes a sharp left-turn. At the house Anna discovers a ladder down to a secret basement, where a piteously skinny girl (Emilie Miskdjian) with metal straps riveted to her head cowers in the darkness. Anna tries to help her, but a clean-up squad arrives, shooting the girl and chaining Anna to a chair underground. The enigmatic Mademoiselle (Catherine Bégin) explains what is going on. They are part of a secret society whose mission is to create martyrs by torturing young girls until they achieve a state of transcendence.

Although there are many metaphorical levels to explore here – religious, racial (the captors are all Caucasian, the captives not), social (the bourgeois family above, the oppressed below) and historical (the film nods to the Second World War's shunned collaborators *les femmes tondues*) – Anna's fate is grimly mundane. She is beaten over and over again for days, weeks, months, until the violence becomes boring.

When she can take no more, she has her skin flayed and is hung on a rack ☺. This is where the film's reputation as torture porn comes from,

SCARE RATING

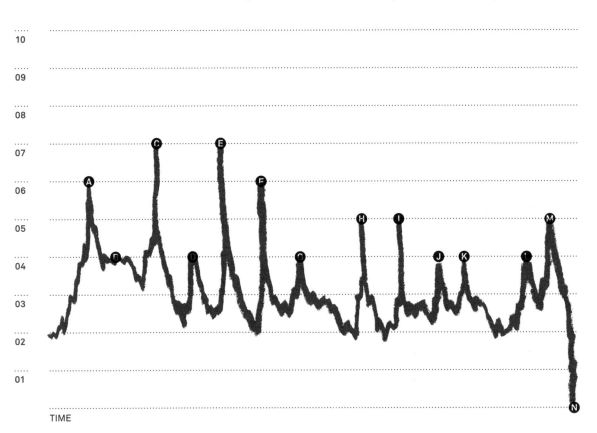

TIME

Further viewing

INSIDE 2007

Having lived through the car crash that killed her husband, young mother-to-be Sarah (Alysson Paradis) settles in to spend Christmas alone in Alexandre Bustillo and Julien Maury's vicious slice of New French Extremism. Or at least that is the plan. First, a strange woman (Béatrice Dalle) knocks on the door asking to use the phone. Then, once Sarah has refused, we see the woman outside the patio doors in silhouette 🕐, smashing the glass with a gloved hand ⚡. That night, after the police have been and gone, all hell breaks loose. In a series of primal, tooth-and-claw confrontations involving arterial spray, ocular trauma 💀 and inventive uses for household appliances, the pair square off so spectacularly that one cop describes the house as 'like a fucking war zone' 🔪. While some may object to Bustillo and Maury's penchant for casting beautiful women then disfiguring them, they do it very effectively.

KILL LIST 2011

Co-written with regular collaborator Amy Jump, then embellished with cast improvisations, Ben Wheatley's second feature concerns a powerful underground cult, beginning in socio-realist territory before segueing into horror. After a job gone wrong, hitman Jay (Neil Maskell) lives in domestic disharmony with his wife Shel (MyAnna Buring) and son Sam (Harry Simpson). But killing is in his bones, and partner Gal (Michael Smiley) soon persuades him to do more hits for a mysterious client (Struan Rodger), who prefers his deals signed in blood. With its discordant score and dissonant mood, the film casts a strange spell, especially when we see Fiona (Emma Fryer), Gal's witchy girlfriend, carving cult symbols into the back of Jay's mirror, or standing, waving like a ghost outside his hotel 💀. Stranger still, Jay's victims thank him for the honour of being killed by him, the sublimated violence exploding in scenes of sudden savagery ⚡ such as a pivotal hammer murder that will turn even the strongest of stomachs 💀.

THE INVITATION 2015

An altogether more genteel cult is at the centre of Karyn Kusama's sinister LA story. Still mourning the death of his son, Will (Logan Marshall Green) attends a dinner party hosted by his ex-wife Eden (Tammy Blanchard) and her new husband David (Michiel Huisman) at his old marital home in the Hollywood hills. It hardly bodes well that he runs over a coyote on the drive up, but once inside things quickly get more ominous 🕐. The guests are a mixture of glamorous old friends and odd new acquaintants, the atmosphere is strange and stilted, and Will suffers disorienting flashbacks to his former life 🕐. Eden and David, it transpires, have joined The Invitation, a collective with some unusual ideas about working through grief. While the guests listen in horror, Pruit (John Carroll Lynch) describes how he was saved, despite killing his wife with a single punch. Then they realise the front door is locked . . .

TIMELINE

something Laugier refutes. 'It's not a film about torture, it's a film about suffering, and what we do with the pain,' he said. In this case, Anna's pain takes her, and the film, into uncharted territory. The camera zooms in through her pupil to what seems like an elemental light at the centre of the universe. We hear heavenly music and whispers before we slowly pull back. Is this really transcendence?

What happens next is debatable. Having told Mademoiselle what she saw, Anna stops talking, and Mademoiselle calls the society together to share this rare success. But her mood is far from triumphant. 'Could you imagine what there is after death?' she asks her assistant. 'No Mademoiselle,' he admits. 'Keep doubting,' she tells him, before blowing her brains out. There are multiple readings of this moment, one of which is quite beautiful. Unlike poor Lucie, Anna's trauma has given her new powers of grace, and she has used them to vanquish their enemies. Perhaps Anna told Mademoiselle there was nothing waiting for us after death, that all the pain was worthless. Perhaps she told her that the next life was wonderful. Perhaps she lied. It is almost as if, as with surviving trauma, it is up to each person to choose.

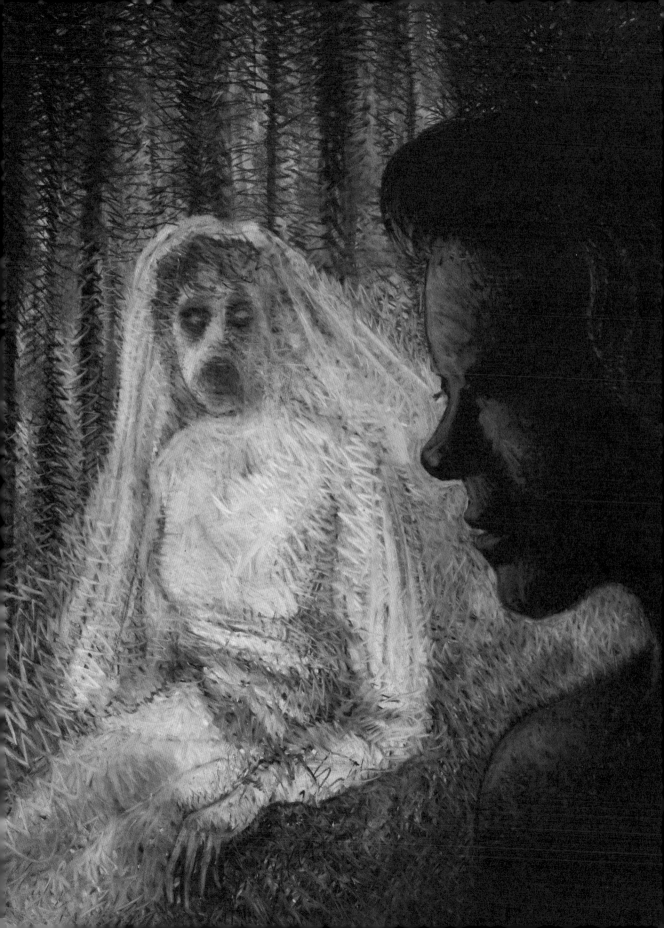

The Innkeepers

Corpse bride

RELEASED 2011

DIRECTOR TI WEST

SCREENPLAY TI WEST

STARRING SARA PAXTON, PAT HEALY, KELLY MCGILLIS, BRENDA COONEY, GEORGE RIDDLE

COUNTRY USA

SUBGENRE GHOST STORY

For writer/director Ti West (*The House of the Devil*), horror is less about the destination than the journey. Unhurried in pace, and conventional in their reveals, his films tease out the tension to breaking point, proving divisive among less patient audiences.

After years in decline, the Yankee Peddlar Inn, Connecticut, is closing down, and bored employees Claire (Sara Paxton) and Luke (Pat Healey) are the only staff on the rota for its last weekend. Besides dealing with the final guests – including actor-turned-medium Leanne Rease-Jones (Kelly McGillis) and an old man (George Riddle) who once spent his honeymoon there – they pass the time goofing around and ghost-hunting. The building is supposed to be haunted by Madeleine O'Malley, a jilted bride who hung herself in the 1800s. Her body was hidden in the basement, which Claire is warned to avoid by Leanne. 'I wanted to make a traditional, old-fashioned ghost story, but with modern characters that don't belong,' West told *IndieWire*. 'You could have no ghosts in it and it'd be OK, but when the ghosts show up it really raises the stakes.'

For the most part, indeed, there are no ghosts at all, and events seem to unfold in real time. When Claire goes out to get coffee, we watch the entire transaction – a longeur even Quentin Tarantino might have thought twice about including. Meanwhile, the internet video Luke shows her, which features an extended static shot of an empty chair suddenly interrupted by a spooky face, seems to parody West's deliberate pacing.

While you can see why casual viewers might tune out, the sense of cumulative dread leaves those who do stay the course vulnerable to the slightest provocation. Alone at the front desk, Claire hears a noise and – slowly, of course – walks the empty corridors, EVP (electronic voice phenomenon) recorder at the ready, to investigate ◕. The jump scare that follows, courtesy of Luke appearing behind her ⚡, is testament to the power of less-is-more.

As the film progresses, its ghosts become gradually more tangible, at least to Claire. After 40 minutes, she hears piano music through the

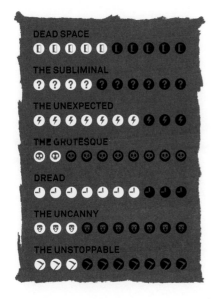

DEAD SPACE
◖◖◖◖◖●●●●●●

THE SUBLIMINAL
❓❓❓❓❓❓❓❓❓❓

THE UNEXPECTED
⚡⚡⚡⚡⚡⚡⚡⚡⚡⚡

THE GROTESQUE
☺☺☺☺☺☺☺☺☺☺

DREAD
◐◐◐◐◐◐◐◐●●

THE UNCANNY
😀😀😀😀😀😀😀😀😀😀

THE UNSTOPPABLE
➤➤➤➤➤➤➤➤➤➤

'There's a ghost
in this hotel and
I got it on tape, and
it's a big deal!'
— Claire

EVP earphones, which stops when she reaches the piano itself – until something presses down a single note and she almost leaps out of her skin ⚡. Later, as she lies in bed, we hear murmuring on the soundtrack, and stay in tight on her face as tries and fails to sleep. As a deeper chord comes through, she sits up, and the sheets slip off behind her ⬤. She rubs her eyes, still unaware of anything untoward, and the sheet slips off to reveal the rotting face of Madeleine O'Malley 😵, wedding gown and all.

Though Madeleine is fictional, the Yankee Pedlar is supposedly haunted in real life. During filming, the cast and crew stayed onsite and experienced all kinds of spooky goings-on. 'Sara Paxton would wake up in the middle of the night thinking someone was in the room with her,' recalled West. 'Everyone had stories, but I was too busy saying, "Let's shoot this! We have seventeen days!"' So much for slow horror.

In the basement, where most of the supernatural activity is centred, Claire and Luke hold a séance amid lots of ominous signs: creaking doors, blowing bulbs, the ticking of a far-off clock 🕐. As the EVP counter flickers, and whispers build on the soundtrack 😈, Claire tells Luke, 'She's right behind you!' and he runs away in fear.

It is when Claire is finally alone that the hotel's ghosts reveal themselves in a superbly staged climax. Having been told to leave by Leigh, Claire goes to warn the old man, who she finds dead in the bath,

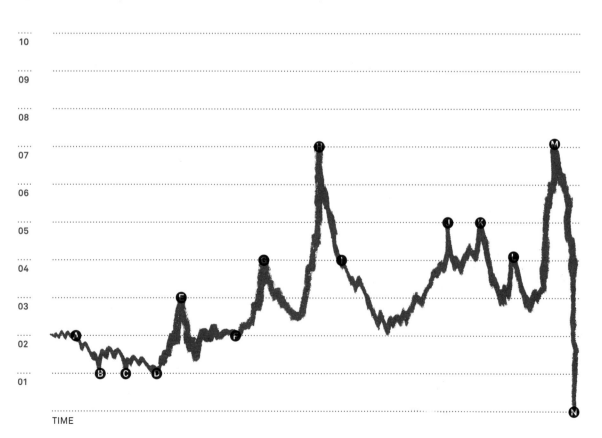

SCARE RATING

10

09

08

07

06

05

04

03

02

01

TIME

Further viewing

THE BORDERLANDS 2014
Set in deepest, darkest Devon where nothing happens very fast, Elliot Goldner's found-footage debut is largely a two-hander between Father Deacon (Gordon Kennedy) and tech expert Gray (Robin Hill) as they investigate a miracle supposed to have taken place in a remote church. Recording everything on head-cams for the Vatican – a clever device that allows them to keep filming whatever happens – the first hour is mostly boozy banter between the leads interspersed with tussles with the locals. 'Good luck with Edward Woodward!' Gray tells one. But after the priest (Luke Neil) commits suicide, things get progressively weirder. On a torchlit trip to the church, Deacon glimpses a figure in the darkness ⚡ and hears a baby crying 🎃. And when he calls in exorcist Father Calvino (Patrick Godfrey), they uncover the site's creepy pagan connections. The claustrophobic climax 🌓, in which Deacon and Gray venture into the labyrinth beneath, is a trippy tour de force 🎃.

HOUSEBOUND 2014
Written, directed and edited by Gerard Johnson in his feature debut, this tinder-dry Kiwi horror-comedy delivers on both fronts. After the failed robbery of an ATM, recovering addict Kylie Bucknall (Morgana O'Reilly) is sentenced to house arrest at the home of her mother Miriam (Rima Te Wiata), complete with an electronic ankle tag to stop her leaving. 'Aren't you lucky, Kylie, having all that fancy technology on your foot?' marvels Miriam, a spot-on comic creation. Trouble is, Miriam believes the house to be haunted – especially the basement, where she once saw a figure in a white sheet. 'White sheet? That's original,' grumbles Kylie. But soon she finds herself being surveilled in her sleep 🌓, hearing a vintage Motorola ringtone in the night 🎃 and having a spooky basement encounter of her own, when a hand reaches out and grabs her ⚡. Could the building's history as a halfway house have something to do with it?

THE WITCH IN THE WINDOW 2018
Though initially it plays more like a character piece than a horror film, writer/director Andy Mitton's slow-burner works incredibly hard for the sublest of scares. When divorced father Simon (Alex Draper) decides to spend a summer flipping a house with his soon-to-be teenaged son Finn (Charlie Tacker), they both start to feel the presence of Lydia (Carol Stanzione), the previous owner, who died watching over the property from her favourite vantage point. During a typical father-son exchange, a tiny camera movement makes you aware of her figure reflected in the corner of a picture frame ⓘ. Later, as Finn plays on his scooter and Simon fixes the roof, you realise she is standing, waiting, in the middle of the house 🌓. As Lydia's influence increases, Mitton favours blink-and-you'll-miss-them moments over big reveals. A case in point is when Finn's Magic Eye picture changes from spelling his name to spelling hers – talk about showing commitment to the cause.

TIMELINE

Ⓐ	**5 MINS**	GHOST VIDEO
Ⓑ	**10 MINS**	CHAT
Ⓒ	**15 MINS**	MORE CHAT
Ⓓ	**20 MINS**	EVEN MORE CHAT
Ⓔ	**25 MINS**	HE'S BEHIND YOU!
Ⓕ	**33 MINS**	BATS IN THE BASEMENT
Ⓖ	**40 MINS**	PIANO PLAYING
Ⓗ	**51 MINS**	HERE COMES THE BRIDE
Ⓘ	**56 MINS**	CREEPY OLD MAN
Ⓙ	**74 MINS**	SHE'S BEHIND YOU!
Ⓚ	**82 MINS**	DOUBLE SUICIDE
Ⓛ	**87 MINS**	BASEMENT CHASE
Ⓜ	**95 MINS**	STAYING PUT
Ⓝ	**100 MINS**	ENDS

his wrists cut 😵, his eyes blank and staring. As she backs away, her asthma flaring up, she sees Madeleine's body hanging from the ceiling too ⚡. Then, at the top of the basement stairs, the old man appears behind her, and she falls down into the darkness. Her last moments are a terrified, torch-strafed scramble through the basement, with Madeleine and the old man both coming for her 🌓 in the darkness, distorted voices seeming to call her name on the soundtrack 🎃, and Luke banging on the outside door, to no avail. She dies of an asthma attack, leaving no evidence of a haunting. But the inference that the ghosts were just in her head does not bear too much scrutiny – not least because of the times we, the viewer, glimpsed them first.

The final shot recalls that spoof internet video Luke showed Claire, and provides a witty précis of West's style. The camera tracks down an empty corridor to an empty room, where it rests, apparently showing nothing, for ages before the door slams shut ⚡.

But look carefully at the curtains and you can just see the outline of a figure – Claire? – looking out of the window ❓, with all the time in the world to make itself known.

139

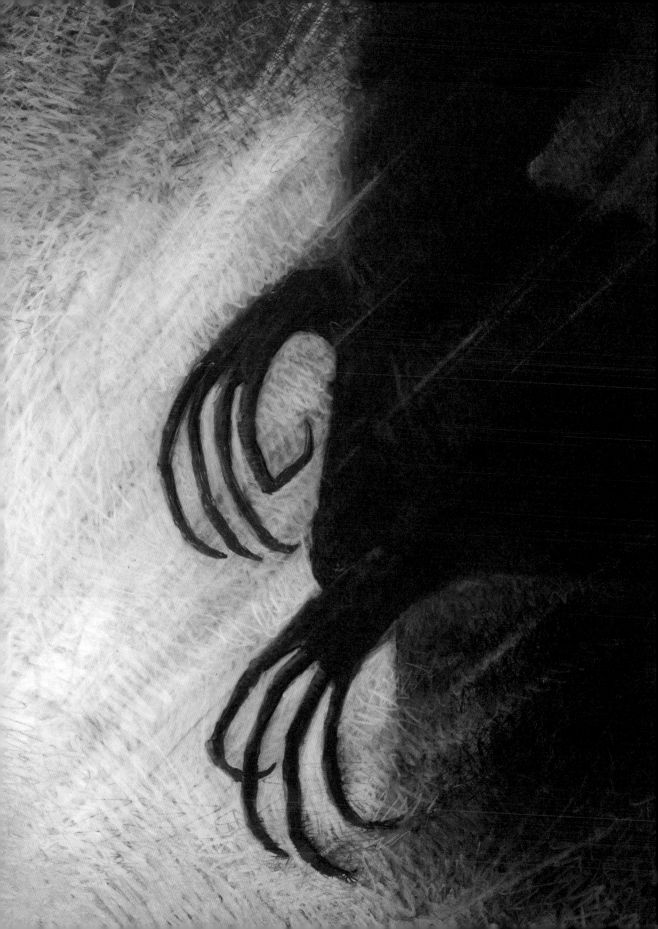

Banshee Chapter

Turn on, tune in, freak out

RELEASED 2013

DIRECTOR BLAIR ERICKSON

SCREENPLAY BLAIR ERICKSON,
DANIEL J. HEALEY

STARRING KATIA WINTER,
TED LEVINE, MICHAEL MCMILLIAN,
JENNIE GABRIELLE, COREY MOOSA

COUNTRY USA

SUBGENRE COSMIC HORROR

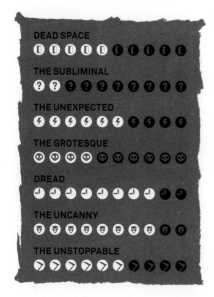

'In 1963 the US government began experimenting on unsuspecting Americans with chemical agents intended to induce mind control. The program was named "MK-Ultra". The results were horrifying.' So begins Blair Erickson's debut, a canny mixture of conspiracy theory and cosmic horror. Playing like *The X-Files* meets H.P. Lovecraft (upon whose story, *From Beyond*, it is loosely based), *Banshee Chapter* anchors its more outlandish ideas with down-to-earth execution. For example: when was the last time you saw a film using found footage but shot in 3D?

The opening sequence sets the creepy but convincing tone. Inspired by MK-Ultra, James Hirsch (Michael McMillian) ingests the hallucinogen DMT-19 while his friend Renny (Alex Gianopoulos) records the results on camera. 'Hey, I don't want to see myself doing some weird drug on YouTube,' jokes James, although the levity soon evaporates when he begins to hear eerie ice-cream van music and disembodied voices on the radio ⊗, sensing something coming towards the house ◑. Suddenly, a shadow passes outside the window ⚡, and the camera goes haywire. The last time we see James, he has dead black eyes, a pale, shapeless face and a bleeding mouth, and his guts are all over the floor ☺.

Journalist Anne Roland (Katia Winter) went to college with James and, as she investigates what happened to him, the film moves from found footage to a handheld cinema verité style, losing the awkwardness but keeping the urgency. The eerie music, she discovers, comes from a numbers station broadcast (a secret shortwave radio operation often used by spies) that can only be picked up in the desert at night. Sure enough, she drives out there and hears it ⊗, only to be interrupted by a figure looming out of the darkness ⚡.

Anne links the drug to Thomas Blackburn (Ted Levine), a Hunter S. Thompson-style gonzo author, and he tricks her into taking some at his house. 'Buy the ticket, take the ride!' he says, not expecting it to be quite such a bumpy one. During the trip, Anne finds his assistant Callie (Jenny Gabrielle) staring off into space, muttering, 'Something is coming. I don't like it. It can *see* me ◑.' Suddenly the eerie music

141

‘Can we go already? It's 2:45 in the morning and my eyes are bleeding.’
— Thomas Blackburn

starts, a creature appears in the window ⚡, and the house is under siege. 'It wants to wear us,' says Callie ominously 💀. As with James at the start of the film, the last we see of her she is black-eyed, blank-faced and vomiting blood 😵.

Just as Erickson never explains that evocative title, we are never explicitly told what is attacking them. 'You start to get the idea that it hollows people out and wears them,' he told comingsoon.net. 'That came from the real MK-Ultra program. They wanted to take a person and core them out like an apple so there wouldn't be any kind of conscience inside them and they would be able to completely manipulate them and turn them into puppets.'

What makes these scenes so effective is that they are repeatedly grounded in the real. As it unfolds, Anne's investigation is intercut with (fake) footage of the MK-Ultra experiments taking place in the mysterious Chamber 5. Shot in black and white on a fixed camera, it shows patients strapped into restraints, injected with DMT-19, then seeing and hearing terrifying beings around them 😵. The idea, as in the Lovecraft story, is that the drug turns our minds into receivers for creatures from a different plane of existence. We even discover where the drug comes from – the pineal gland of a human corpse (dubbed the 'primary source') – and question whether it was suggested by the beings themselves rather than the CIA.

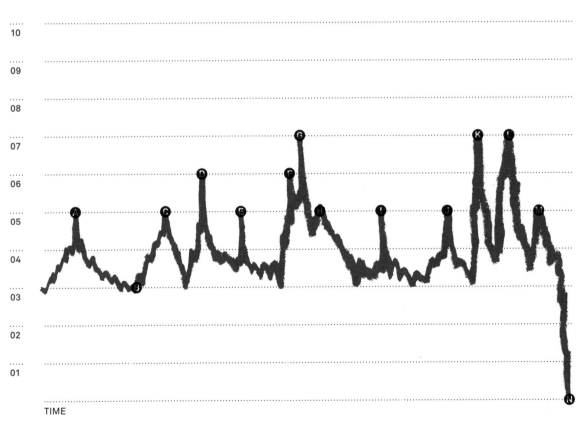

SCARE RATING

TIME

Further viewing

[Rec]² 2009

Beginning immediately after *[Rec]* finishes, this ferocious sequel is best thought of as *Aliens* to the original's *Alien*. Written and directed once again by Jaume Balagueró and Paco Plaza, it follows a Swat team into the infected Madrid apartment block from the first film. Their mission is to escort Dr Owen (Jonathan Mellor), a priest masquerading as a ministry of health worker, into the penthouse. Shot like a multiplayer video game from the team's head cams, the early scenes are full of foreboding 🕐, as they mount the blood-drenched stairs, the building creaking and complaining around them. When the infected residents attack, flinging themselves straight at us or dropping from the roof ⚡, the splatter is extreme 😊, the onslaught, relentless ▶. Even the camerawork feels violent, with sound cutting out, batteries dying and screens fading to black 🔘 as the team meet the messiest of ends.

ABSENTIA 2011

The feature debut of the prolific writer/director Mike Flanagan (*Oculus*), *Absentia* cloaks its outlandish premise in intimate drama. Pregnant Tricia (Courtney Bell) is about to declare her missing husband Daniel (Morgan Peter Brown) legally dead in absentia, so her troubled sister Callie (Katie Parker) moves in to help. But strange things keep happening in the underpass at the end of the street, and she starts to see Daniel in a series of waking nightmares. To begin with he is a barely glimpsed, black-eyed figure 🔘 in the distance. Then he starts to appear more often: standing behind the lawyer 🔘 as Tricia signs legal papers or, most shockingly, in the wardrobe as she prepares for a date ⚡. But it is when the real Daniel returns, bloodied and traumatised, that things turn unsettlingly Lovecraftian. His explanation of where he has been? 'I was underneath.'

THE POSSESSION OF MICHAEL KING 2014

'My resolution is to make a documentary about this family to show the world what a lucky guy I am,' says Michael King (Shane Johnson) straight to camera in David Jung's found-footage-adjacent horror. Next thing you know, his wife Samantha (Clare Pifko) is knocked down and killed by a car. Distraught, Michael begins a deep-dive into the dark arts to find out what actually happens when you die, filming everything along the way. Cue a series of increasingly freaky experiments. Under the guidance of a demonologist, he takes LSD and finds himself tied down in a basement with masked figures dancing around him 🔘. Next he ingests DMT in a graveyard, and a night-vision camera catches him cowering in a mausoleum pleading, 'I don't want to be dead.' Soon, he's hearing voices telling him to kill people 🕐 and seeing shadowy figures ⚡ appear in the windows of his house.

The climax sees Anne and Thomas tracing the signal to an abandoned fallout shelter in the desert, also the location of Chamber 5. Here they find a container with a porthole at which a blank face – the primary source? – appears ⚡, and they are stalked through the long, empty corridors by a figure that may or may not be James 🕐, or what is left of him. In true Hunter S. Thompson style, Thomas shoots himself rather than be taken over, and Anne torches the equipment with gasoline, before stumbling out into the dawn. But is the nightmare really over? The epilogue, set in a police interview room full of ironic anti-drugs posters, suggests not ▶.

The final scene sheds a little light on Thomas's history, and reminds us that the real villains are the ones we elected. 'What we ultimately ended up mining is the fear that the government would unleash something that would never go away and would follow you to the ends of the Earth and have these malicious intentions toward you,' Erickson told *Dread Central*. 'When you look at things like the NSA, is that really so far-fetched?'

Oculus

Mirror, mirror on the wall

RELEASED 2013

DIRECTOR MIKE FLANAGAN

SCREENPLAY MIKE FLANAGAN,
JEFF HOWARD, JEFF SEIDMAN (SHORT)

STARRING KAREN GILLAN, BRENTON
THWAITES, KATEE SACKHOFF,
RORY COCHRANE, ANNALISE BASSO

COUNTRY USA

SUBGENRE SUPERNATURAL

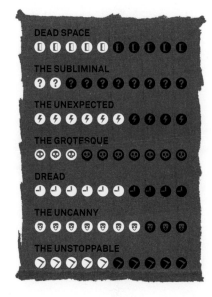

DEAD SPACE

THE SUBLIMINAL

THE UNEXPECTED

THE GROTESQUE

DREAD

THE UNCANNY

THE UNSTOPPABLE

The idea that we are not masters of our own fates is brought chillingly to life in the second offering from writer/director/editor Mike Flanagan (*Absentia*). Based on his 2006 short about a haunted mirror, and fully aware of the idea's potential ridiculousness, it is a film that creeps up on you and, like its subject, exerts a powerful hold.

Eleven years after their parents died in a bizarre double homicide, twenty-one-year-old Tim Russell (Brenton Thwaites) is released from psychiatric hospital into the care of his older sister Kaylie (Karen Gillan). But while he has spent the intervening time coming to terms with his part in the tragedy, she has concocted a plan to destroy the mirror she believes is to blame.

The early scenes are all about building up a sense of the mirror's hypnotic powers. Kaylie, it turns out, has acquired it for a client at the auction house where she works. Known as the Lasser Glass after its first recorded owner, the mirror certainly looks the part: all dark wood and ornate, reaching arms ❷. 'Hello again,' says Kaylie as it sits, awaiting delivery in a cluttered back room, 'you must be hungry.' Behind her, we see two figurines covered in sheets ❶. 'I hope this still hurts,' she says, examining a crack in the glass. Suddenly there are three figurines behind her, and one of them moves ❷, disappearing when she turns around.

Having set the mirror up in their childhood home, Kaylie talks Tim through its history, as an ominous bass vibrates on the soundtrack ❹. By her calculations, it is responsible for at least forty-five deaths over four centuries, persuading its custodians to hurt/kill themselves in inventively horrible ways. In 1943, for example, owner Alice Carden drowned her children in the cistern before breaking nearly every bone in her body – except the arm she needed to wield the hammer ❂.

The emphasis, though, is on effect rather than cause. 'Evil in the world doesn't have an answer,' Flanagan told *Den of Geek*. 'We try, as a culture, to create one in so many different ways that I think in our fiction, when we don't give it that kind of explanation, it's just scarier.'

Kaylie's plan to prove that the mirror has supernatural powers is almost as scary – and outlandish – as its alleged crimes. As Tim puts it:

'Because there's no scientific term equivalent to the word haunted, we'll just say this object is responsible for at least forty-five deaths.'
— Kaylie Russell

'What's more likely? That you're misremembering events from eleven years ago, or that the mirror eats dogs?' She intends to record how it manipulates them using video cameras to capture what *really* happens; alarms to make sure she and Tim eat and stay hydrated; a (potentially sacrificial) dog and several house plants; plus a 'kill-switch' in the form of a ceiling-mounted anchor, which is set to smash the mirror if they become incapacitated. Meanwhile, Flanagan cuts from past to present so frequently it is hard to tell where we are anymore – another part of the mirror's dastardly MO. The idea, he told *Movies Online*, was to 'create a sense of distortion and disorientation that would be similar for the viewer as it was for Tim and Kaylie in the room'.

As children, Kaylie (Annalise Basso) and Tim (Garrett Ryan Ewald) keep seeing a woman (Kate Siegel, the future Mrs Flanagan) with shards of glass over her eyes 💀, just one of many previous owners. 'This comes from a tradition in the Jewish faith where they'll cover a mirror at a funeral to prevent souls from coming back through,' said Flanagan. 'I thought that was terrifying.'

Even more alarming for the kids is watching their mother (Katee Sackhoff) go insane and their father (Rory Cochrane) turn murderous. He starts hearing things moving around in his office – where the mirror is hung – at night, and begins pulling his fingernails off 💀. She sees her own reflection, but grotesquely aged 💀. 'Each mirror is slightly distorted,' said Flanagan. 'The imperfections of the glass presents us with what we assume

SCARE RATING

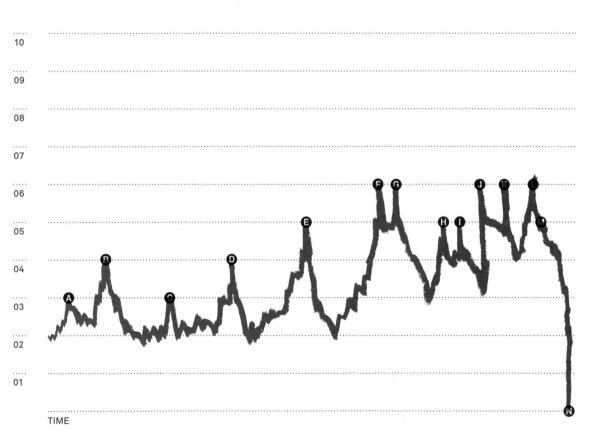

TIME

Further viewing

CANDYMAN 1992

Remembered as a slasher, but far more resonant and intelligent, Bernard Rose's Clive Barker adaptation is so classy it boasts high production values and a Philip Glass score. As graduate student Helen Lyle (Virginia Madsen) investigates urban legends in Chicago, she comes across the story of Ruthie Jean, a woman from the Cabrini Green projects who was supposedly killed by Candyman (Tony Todd), a murdered slave with a hook for a hand. Candyman appears if you say his name five times in a mirror ●, but not like a common-or-garden supernatural killer. In the film's most shocking scene, Helen wakes in the bathroom of one of the project flats with no idea how she got there. Outside she finds a severed dog's head on the floor ● as a young mother (Vanessa A. Williams) screams for her missing baby. Candyman, it transpires, does not crave blood so much as belief.

THE PACT 2012

A thoroughly modern, frequently terrifying spin on the ghost story, writer/director Nicholas McCarthy's debut centres on a nondescript house with a secret in the endless LA sprawl. After the death of their mother, sisters Annie (Caity Kotz) and Nicole (Agnes Brucker) reluctantly come home for the funeral, only for Nicole to disappear while Skyping her daughter Eva (Dakota Bright). 'Mummy what's that behind you?' asks the little girl ● innocently. With the help of detective Bill Creek (Casper Van Dien) and psychic Stevie (Haley Hudson), Annie sets out to solve the – ingenious – mystery, which has its roots in a decades-old series of murders. McCarthy makes great use of the oppressive, old-fashioned setting with creeping camerawork and, at one point, a startling silhouette to suggest an evil presence ●. But he is not above using dream sequences or internet phantoms to secure more scares.

THE LIGHTHOUSE 2019

Another history lesson from Robert Eggers (*The Witch*), *The Lighthouse* was co-written with his brother, Max. Ephraim Winslow (Robert Pattinson) and Thomas Wake (Willem Dafoe) are two keepers going slowly, boozily bonkers on a rock off the coast of New England. Even the old-fashioned aspect ratio and sepia cinematography feel claustrophobic ●. While Wake jealously tends the light, Winslow guards a dark secret, dreaming of tentacled sea beasts ● and sensuous mermaids, the latter wrapped in seaweed and squawking like a gull ●. The combination of isolation and total immersion in each other's company starts to fray their sanity. Winslow's imaginings intrude into his daily life, while Wake takes an axe to the safety boat like a nineteenth-century Jack Torrance. Soon, neither can tell which threats are real and which imaginary, time is spilling through their fingers like sand, and – even worse – they are running out of grog.

is reality, but it isn't. So we took that idea that we take for granted that this is an objective reality, but it's not.' These distortions continue into the present, so neither we, nor the characters, can ever trust what we are seeing. Grown-up Kaylie eats an apple while replacing the house's spent lightbulbs, a side effect of the mirror's evil powers. Without warning, the next shot shows her biting into the glass and spitting out bloody shards ●, but it is just an hallucination.

Having briefly left the mirror's influence, the siblings step back into the room to find that the house plants have died – another side effect – and the cameras have been turned away. Indeed, the tape shows them moving the cameras, although they have no memory of doing so. When they finally make it outside, resolving to wait until the kill-switch trips, they look back into the house to see themselves ● standing in the path of the anchor, ready to die. But which version of them is real?

As their story ends, once again, in tragedy, the film seems to be suggesting that we are cursed to repeat our histories ● no matter how hard we try. But even more alarming is the idea that one day we will look into the mirror and, through age or illness, madness or malign influence, not recognise what we see.

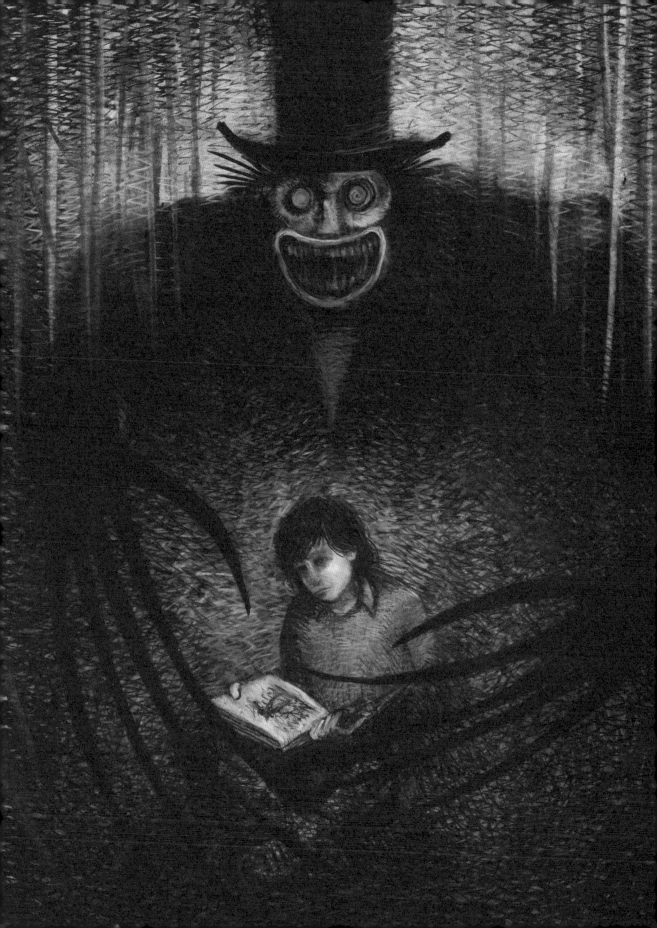

The Babadook

Grim fairy tale

RELEASED 2014

DIRECTOR JENNIFER KENT

SCREENPLAY JENNIFER KENT

STARRING ESSIE DAVIES, NOAH WISEMAN, HAYLEY MCELHINNEY, DANIEL HENSHALL, BARBARA WEST

COUNTRY AUSTRALIA

SUBGENRE PSYCHOLOGICAL HORROR

There are not many films that can scare us by their titles alone, but Australian writer/director Jennifer Kent's singular debut is one. Inspired by the Serbian word for boogeyman, *babaroga*, Babadook is an unsettling construction: childish, mysterious, vaguely threatening; and both the character and the film more than live up to their billing.

In a suburban Adelaide house decked out in suffocating blue-greys, widow Amelia (Essie Davies) is struggling to bring up her behaviourally challenged six-year-old son Samuel (Noah Wiseman), while battling loneliness, depression and sleep deprivation. Samuel is a troubled child with an overactive imagination, building Rube Goldberg contraptions to kill the monsters he is afraid will take his mother too. At night we watch the pair check under the bed and in the closet ❶ to root them out.

Clearly they love each other but, equally clearly, they are not coping. Samuel's determination to protect this mother is stifling – witness the scene where he interrupts her masturbating – and his eccentricities scare her, hence the shots of him, alien and asleep, in her bed. 'It's the great unspoken thing,' Kent told *The Guardian*. 'We're all, as women, educated and conditioned to think that motherhood is an easy thing that just happens. But it's not always the case. I wanted to show a real woman who was drowning in that environment.'

Though horror offers slightly more opportunity for female film-makers than other genres, Kent still found herself out on a limb. 'I may as well have said I was directing a porno,' she told *Den of Geek*. 'People were like, "Oh, that's not a real film. It's disgusting. And also, why would a woman want to direct that kind of stuff?"' Having trained under controversial Danish director Lars Von Trier (*Antichrist*), and road-tested the concept with the 2005 short *Monster*, Kent took it all in her stride, something Amelia is unable to do.

One night, Samuel chooses a bedtime story that his mother has not seen before: *Mister Babadook*, a petrifying pop-up book about a monster that, once invited in, will not leave. Not only does this give Samuel's fears a shape – the Babadook is an amorphous, black-clad figure with a top hat and talons, based on the 'Man in the Beaver Hat'

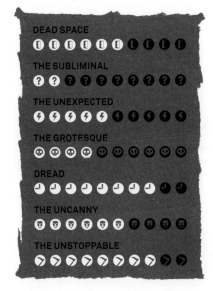

DEAD SPACE
◐◐◐◐◐◐◑◑◑◑◑

THE SUBLIMINAL
❓❓❓❓❓❓❓❓❓❓

THE UNEXPECTED
⚡⚡⚡⚡⚡⚡⚡⚡⚡⚡

THE GROTESQUE
☺☺☺☺☺☺☺☺☺☺

DREAD
◔◔◔◔◔◔◔◔◑◕◑

THE UNCANNY
☻☻☻☻☻☻☻☻☻☻

THE UNSTOPPABLE
➤➤➤➤➤➤➤➤➤➤

from Tod Browning's 1927 film *London After Midnight* – it gives them an MO. 'A rumbling sound, then three sharp knocks: BA-BA DOOK! DOOK! DOOK! That's when you'll know that he's around, you'll see him if you look,' reads one page. 'This is what he wears on top. He's funny, don't you think? See him in your room at night and you won't sleep a wink,' threatens another 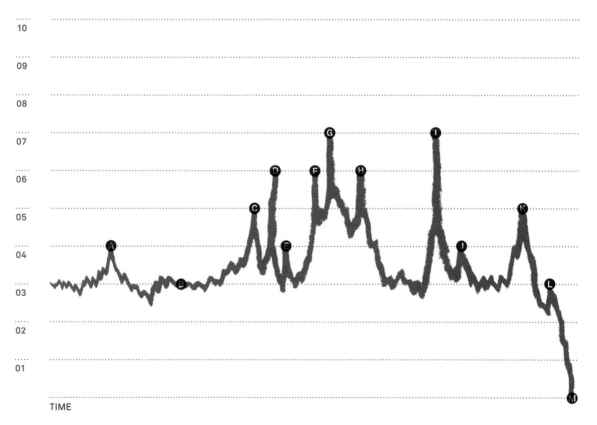.

Over the next few days, Samuel starts acting up and blaming it on the Babadook. When Amelia goes down to the basement, her late husband Oscar's belongings have been rifled through. Frantically, she gathers them up, only stopping when she thinks she sees the Babadook out of the corner of her eye. In fact, it is one of Oscar's suits hanging on the wall ⦿, although the implication – that grief is the real monster here – is hard to miss.

Soon, Amelia and Samuel discover that, as the story says, 'If it's in a word, or it's in a look, you can't get rid of the Babadook.' To begin with, Amelia hides the book on top of the wardrobe. Next, she rips it up. But after a quiet knock at the door, followed by a loud, ominous banging ⦿, she opens it to find the book sitting there, pieced back together, with new pages showing the main character killing her dog, throttling her child, then cutting her own throat. Wisely, she burns it on the barbecue, which makes the eerie voices ⦿ on the soundtrack subside – for a while.

SCARE RATING

10

09

08

07

06

05

04

03

02

01

TIME

'It wasn't me, Mum, the Babadook did it!' — Samuel

Out of options, Amelia phones her sister, Claire (Hayley McElhinney), who has been reluctant to help since Samuel accidentally hurt her daughter, Ruby (Chloe Hurn). 'Go to the police,' is Claire's advice, before hanging up. The phone rings again. 'Claire?' asks Amelia, haltingly. Nothing. 'Hello?' Still nothing. And then comes the noise, guttural and obscene, the last syllable stretched out like a scream: 'BA-BA DOOK! DOOK! DOOOOOOOOOK! ♪'

Soon, Amelia starts seeing traces of the Babadook everywhere she goes. At the police station, where she attempts to report being stalked, she gets short shrift from the duty sergeant (Adam Morgan). 'Someone sent me a children's book,' she says, weakly, before admitting that she burnt the evidence. When the sergeant leans in, she sees the Babadook's hat, cape and talons hanging up on the wall behind him ⊕, before running off in fear and shame.

Later, as she glances across at Mrs Roach (Barbara West), the nice old lady who lives next door, the Babadook looms out of the darkness ⬤. That night, while Samuel sleeps and Amelia lies awake beside him, she hears creaking noises from outside the door, which turn out to be the dog, Bugsy. She lets him in, but the door opens once again, and something else scuttles into the room with a horrible insectile sound ⬤. Amelia hides under the covers as a now-familiar cry comes: 'BA-BA DOOK! DOOK! DOOOOOOOOOK! ♪' When she looks up again the Babadook is slithering across the ceiling with ragged breaths, hanging on to the light fitting like a bat ⬤, then falling towards her face as she lies paralysed.

She grabs Samuel and they go downstairs to watch late-night TV, but as her eyelids close, soothing music-box sounds begin and black-and-white George Méliès fantasies flicker on the box, the Babadook appears on-screen ⬤. While day breaks on her pale, shattered face, what was implicit can no longer be ignored: the Babadook is not a real monster, but a manifestation of the monstrous within.

From here, things begin to deteriorate quickly, the film subtly shifting its viewpoint from hers – concerned parent – to his – terrified child. One night she serves them soup with traces of glass in it. Later, she sees cockroaches coming from the wall ⬤. It is not long before her behaviour becomes truly unhinged. 'Why do you have to keep talk-talk-talking?' she shouts at Samuel, her repetition echoing the Babadook's signature cry ⬤. 'If you're that hungry, why don't you go and eat shit?'

These scenes, of course, did not involve Wiseman, whose performance is powerful enough without requiring actual trauma. 'During the reverse shots where Amelia was abusing Sam verbally, we had Essie yell at an adult stand-in on his knees,' Kent told *Film Journal*. 'I didn't want to destroy a childhood to make this film.'

TIMELINE

'I'll wager with you, I'll make you a bet. The more you deny me, the stronger I get.'
— Mister Babadook

For Samuel, however, a destroyed childhood is about the best that can be hoped for. As Amelia watches a news item about a mother who stabbed her son with a kitchen knife, her own grinning face appears in the window on-screen ➊. In the basement, the ghost of her late husband Oskar (Benjamin Winspear) assures her, 'We're going to be together. You just need to bring me the boy.' Having killed Bugsy the dog, she attacks Samuel, until he cries out: 'I know you don't love me. The Babadook won't let you. But I love you, Mum. And I always will. You let it in, you have to get it out!' An extended climax sees her, finally, casting the Babadook out.

This, Kent seems to be saying, is the real truth; the unnameable fears that are scarier than any monster. Sometimes those who are meant to protect us are the ones that hurt us most; sometimes they hate us, or leave us, or die; sometimes unwelcome intruders – grief, fear, madness – creep into our lives and cannot be exorcised no matter what.

'I think where horror excels is when it becomes emotional and visceral,' Kent admitted in *The Guardian*. 'It was never about, "Oh,

Further viewing

UNDER THE SHADOW 2016
'A woman should be scared of exposing herself more than anything else,' Shideh (Nardes Rashidi) is told in Babak Anvari's subtext-heavy, Persian-language chiller. The setting is war-torn Tehran during the Iran-Iraq conflict of the late 1980s, and our heroine has been left alone to look after her daughter, Dorsa (Avin Manshadi), while her husband does military service. Shideh is a bad Muslim – she disobeys sharia law by driving, doing aerobics videos and studying medicine – but she is also, she fears, a bad mother. As these anxieties play out against a backdrop of suspicious neighbours and sudden bombing raids, the pair find themselves menaced by a *djinn*, or malevolent spirit. Of its many iterations, the spookiest is, simply, a sheet ➑ that whips around the edges of the frame ➊. But that sheet carries metaphorical weight too. Shideh, we realise, is living under more than one shadow – she even jumps at her reflection in the mirror; her veil, a mantle of fear.

STILL/BORN 2017
Equal parts creepy and crass, Canadian writer/director Brandon Christensen's feature debut stars his niece Grace as Adam, a new-born baby belonging to Mary (Christie Burke) and Jack (Jesse Moss). Adam's twin died at birth, and when Jack heads back to work, Mary struggles to cope with her grief and the demands of being a new mother. First, she hears a voice screaming into the baby monitor ➑. Then, when they buy a video model, she sees a figure running into Adam's room to pick him up ⚡. Next, when she soothes Adam during the night, she hears crying coming from the other – empty – cot ◀, and turns to see a baby covered in blood ☻. Could something more sinister than post-partum depression be to blame? On the other hand, if Mary is really losing her mind, how is visiting a therapist played by perma-villain Michael Ironside going to help?

VERONICA 2017
Paco Plaza's classy possession movie begins with a panicked police call and a camera following them on to the scene. Not only does this recall his earlier *[Rec]*, it emphasises the film's (flimsy) true-story credentials. It hardly needs them. Verónica (the excellent Sandra Escacena) is a put-upon Madrid schoolgirl bringing up her younger siblings for her busy mum. At school during a solar eclipse she and her friends perform a seance to contact her late father, but it goes horribly wrong. On the way home, Sister 'Death' (Consuelo Trujillo), a blind nun, stares at her ➑. At dinner, her hands start to shake and meatballs dribble from her mouth like blood ☻. Soon she starts seeing things around the flat: a demon reflected in the dark of the TV screen ➊; her father standing naked in the corner of her room ⚡; and she wonders who – or what – has really been conjured.

I want to scare people." Not at all. I wanted to talk about the need to face the darkness in ourselves and in our lives. That was the core idea for me, to take a woman who'd really run away from a terrible situation for many years and have to face it. The horror is really just a by-product.'

Amelia and Samuel survive, and an epilogue shows them in happier times preparing to celebrate Samuel's birthday for the first time. In the garden, a suggestive camera move rises up from the soil to show Amelia tending a rose so dark it might as well be black. Together they collect worms in a bowl which she takes to the basement door. 'Am I ever going to see it?' Samuel asks. 'One day, when you're bigger,' is her response. Down in the darkness, something – the Babadook, we presume – roars towards her, but she shushes it and it calms down, taking the bowl and scuttling off under the stairs again.

'How was it?' asks Samuel when she emerges. 'Quiet today,' is her answer, her acceptance speaking volumes. Afterall, as Kent told *The Dissolve*. 'You can't kill the monster, you can only integrate it.'

It Follows

Coming to a cinema near you

RELEASED 2015

DIRECTOR DAVID ROBERT MITCHELL

SCREENPLAY DAVID ROBERT MITCHELL

STARRING MAIKA MONROE, LILI SEPE,
KEIR GILCHRIST, OLIVIA LUCCARDI,
DANIEL ZOVATTO

COUNTRY USA

SUBGENRE SUPERNATURAL

Inspired by a recurring nightmare he had as a child, David Thomas Mitchell's second film has the slow, stoned timbre of a dream.

Its young protagonists spend endless hours hanging out with no adults in sight; seasons change from scene to scene; and the technology, clothes and cars cannot be ascribed to a particular decade. 'It's about placing the film outside of time,' Mitchell told *Dread Central*, 'making it feel like a dream – or a nightmare.'

The opening sequence firmly suggests the latter. Tottering out of a suburban house on high heels as if she has been surprised while getting dressed, a young woman (Bailey Spry) looks about her in terror. As the camera pans through 360 degrees and Disasterpiece's electronic score throbs with awful certainty ⏰, she drives off. Stopping at the lake shore, she phones her dad to say she loves him, but the morning finds her dead, her leg snapped back on itself ☻.

We meet teenager Jay (Maika Monroe), her younger sister Kelly (Lili Sepe) and their friends Yara (Olivia Luccardi) and Paul (Keir Gilchrist), who has a crush on Jay. Jay and Kelly's dad (Ele Bardha) is missing, presumed dead; their mum (Deborah Williams) drinks the days away; and they spend their time swimming in their backyard pool, playing cards and watching old movies.

While out on a date, Jay has sex with Hugh (Jake Weary), who chloroforms her and ties her to a wheelchair in a derelict building. He has passed on a curse, he tells her. Something is coming to kill her, and the only way to get rid of it is by sleeping with someone else.

Sure enough, 'it' soon appears in the form of a naked woman (Ruby Harris) walking inexorably towards them. Though they manage to get away, It is clear that, on a long enough timeline, they will not be so lucky. 'My basic idea was of a horror film where the fear came from something that is so slow, that you can somehow escape from it,' Mitchell told *IndieWire*. 'But the fact that it's relentless and eternal – the fear comes from that.'

From that stark, insinuating title onwards, the film pulses with a palpable sense of dread ⏰, because 'it' could be anyone, anywhere.

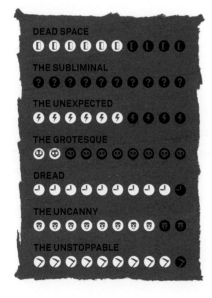

DEAD SPACE
◉◉◉◉◉◉◉●◉◉◉◉

THE SUBLIMINAL
❓❓❓❓❓❓❓❓❓❓

THE UNEXPECTED
⚡⚡⚡⚡⚡⚡⚡⚡⚡⚡

THE GROTESQUE
☺☺☺☺☺☺☺☺☺☺

DREAD
⏰⏰⏰⏰⏰⏰⏰⏰⏰⏰

THE UNCANNY
☻☻☻☻☻☻☻☻☻☻

THE UNSTOPPABLE
➤➤➤➤➤➤➤➤➤➤

'It can look like people
you know, or it can be
a stranger in a crowd.
Whatever helps it
get close to you.'
— Hugh

At school, another 360-degree pan shows Jay sitting by the window, as an old woman in a hospital gown strides towards her from the far distance ⬤.

'It' even tries to get her at home in the film's petrifying centrepiece. One night, while her friends stay over, a bruised, half-dressed girl waits in the kitchen, peeing on the floor ⬤. As they hide in Jay's bedroom, Yara knocks at the door and a huge, black-eyed man bursts in behind her ⬤. Jay escapes, but there is no changing the fact that, as Hugh says, 'Wherever you are, it is somewhere walking towards you.'

The form 'it' takes may appear random, but it is clearly designed to unsettle the target. When Jay passes the curse on to her (willing) neighbour Greg (Daniel Zovatto), it is his mother (Leisa Pulido) who comes for him in a state of undress. Later, once Greg has died and the curse returns to Jay, she sees 'it' as her grandfather standing naked on the roof ⬤.

With such a heady cocktail of sex, death and incest, it is hard to pin down an exact reading, but Mitchell has described his film as being 'about the anxiety of waiting' – waiting for 'it', waiting to be a grown-up, waiting to die.

As teenagers, Jay, Kelly and their friends are stuck in the no man's land between childhood and adulthood, symbolised here by the derelict housing estates of Detroit's urban sprawl. Part of the

SCARE RATING

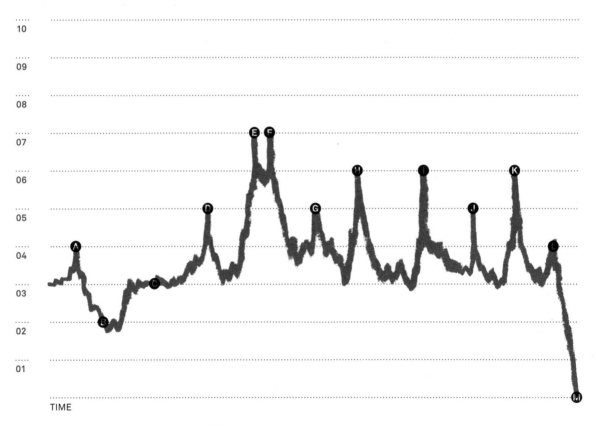

TIME

Further viewing

CARNIVAL OF SOULS 1962
This American curio was shot guerrilla-style by industrial film-maker Herk Hervey, who produced, directed, co-wrote and appears as the chief antagonist. Emerging unscathed after her car crashes into a river, church organist Mary (Candace Hilligoss) leaves town for a new job. She soon finds herself adrift in an eerie, *Twilight Zone* world and menaced by a white-faced figure (Hervey) at all turns 🕑. From its canted-angle credits to its amateur-hour performances, the film has a strange, stilted quality that feels genuinely dream-like and anticipates the work of David Lynch. As Hervey and his white-faced crowds dance in sped-up motion 🔵 in a deserted pavilion, or emerge from the water, their make-up running, the artifice only adds to the sense that nothing is quite as it seems. Horror stalwarts will see the plot signposts a mile off, but it is still a powerful exercise in unease 🕑.

THE FOG 1980
John Carpenter's *Halloween* follow-up is an old-fashioned treat. On the eve of Antonio Bay's 100th anniversary, a cast of familiar faces – including hitcher Elizabeth (Jamie Lee Curtis), priest-with-a-secret Father Malone (Hal Holbrook) and radio announcer Stevie Wayne (Adrienne Barbeau) – find themselves at the mercy of a crew of spooky drowned sailors who arrive swathed in dry ice. Despite the odd jump scare ⚡, such as when Elizabeth is menaced by a moving corpse in a hospital room (a virtual reprise of one of *Halloween*'s iconic scenes), the film's strongest suit is shuffling dread 🕑. Its most effective moments play up the siege mentality, such as when Dan O'Bannon (Charles Cyphers) is attacked in his house while Carpenter's synth score tolls like a warning bell; or Elizabeth and Nick (Tom Atkins) try to escape by truck, as the sailors' squelching footsteps get closer and closer.

TRIANGLE 2009
This metaphysical chiller from British writer/director Christopher Smith (*Creep*) has the quality of a half-remembered dream. The fact it is full of Australians playing Americans and Queensland stands in for Florida only adds to the sense of dislocation 🔵. Despite a series of bad omens 🕑, harrassed single mother Jess (Melissa George) leaves her autistic son Tommy (Joshua McIvor) behind to go on a pleasure cruise with Greg (Michael Dorman) and crew. But when the boat overturns in a storm they are rescued by the Aeolus, a huge, deserted ocean liner with a killer onboard. Aeolus was the father of Sisyphus and, sure enough, Jess soon finds herself pursued around its long, empty corridors trying and failing to escape her fate. George is great as the woman in the centre of her own awful hall of mirrors and the sense of déjà vu 🔵 is painfully palpable throughout.

TIMELINE

- Ⓐ **4 MINS** BEACH ATTACK I
- Ⓑ **10 MINS** LOSING IT AT THE MOVIES
- Ⓒ **19 MINS** 'THIS THING IS GONNA FOLLOW YOU'
- Ⓓ **29 MINS** OLD WOMAN AT THE SCHOOL
- Ⓔ **38 MINS** PEEING GIRL IN THE KITCHEN
- Ⓕ **41 MINS** TALL GUY IN THE BEDROOM
- Ⓖ **50 MINS** GIRL AT THE SCHOOL
- Ⓗ **58 MINS** BEACH ATTACK II
- Ⓘ **71 MINS** IT FOLLOWS GREG
- Ⓙ **80 MINS** ON THE ROOF
- Ⓚ **87 MINS** RUBBISH POOL PLAN
- Ⓛ **95 MINS** STILL FOLLOWED?
- Ⓜ **100 MINS** ENDS

reason the attacks are so scary is that Mitchell perfectly captures the anxieties of these years, that feeling of being simultaneously free and vulnerable – hence the significance of large, unknowable bodies of water like the lake or the pool. Before Hugh chloroforms her, Jay talks of childhood dreams of escape. 'It was never about going anywhere,' she says, 'just having some kind of freedom I guess. Now we're old enough, but where the hell do we go, right?'

With this terrible new knowledge, there is nowhere to run. 'Jay opens herself up to danger through sex, yet sex is the one way in which she can free herself from that danger,' Mitchell told *The Guardian*. 'We're all here for a limited amount of time, and we can't escape our mortality, but love and sex are two ways in which we can – at least temporarily – push death away.'

Just how temporarily becomes apparent in the final scenes after the gang seem to kill 'it' at the local pool. Now lovers, Jay and Paul walk the waking suburbs, holding hands and dressed in matching black and white. Far behind them, someone – Greg? – still follows, but they are looking to the future, and facing it together.

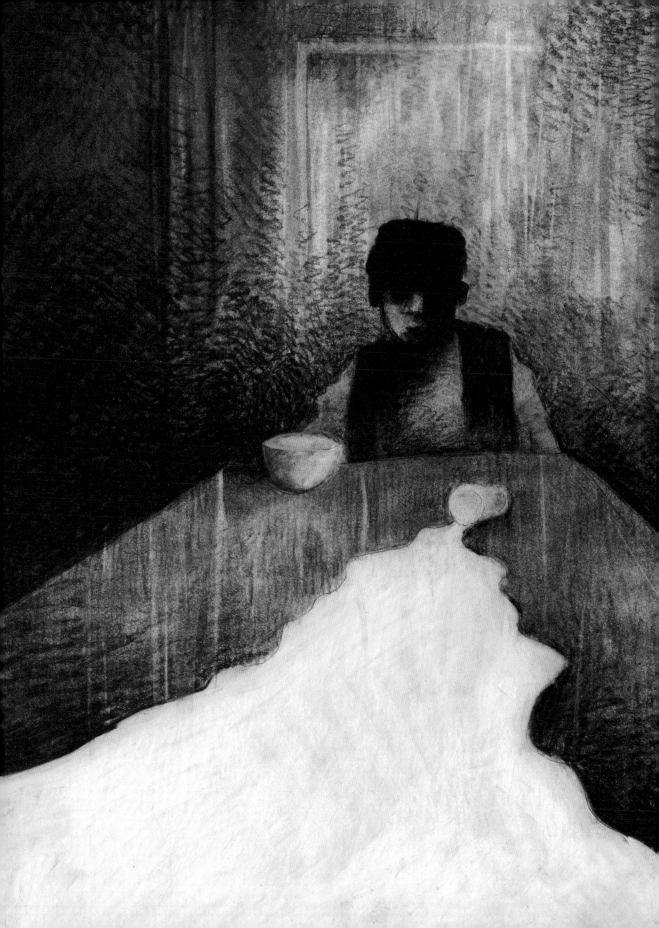

Terrified

Something strange in the neighbourhood

RELEASED 2017

DIRECTOR DEMIÁN RUGNA

SCREENPLAY DEMIÁN RUGNA

STARRING MAXIMILIANO GHIONE, NORBERTO GONZALO, ELVIRA ONETTO, GEORGE L. LEWIS, AGUSTÍN RITTANO

COUNTRY ARGENTINA

SUBGENRE COSMIC HORROR

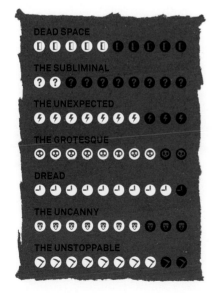

DEAD SPACE

THE SUBLIMINAL

THE UNEXPECTED

THE GROTESQUE

DREAD

THE UNCANNY

THE UNSTOPPABLE

Very few horror films are so scary that, upon facing the enemy, the hero has an actual heart attack. But that is what happens to Detective Funes (Maximiliano Ghione) near the end of Demián Rugna's extraordinary Argentine shocker. Playing like a J-horror film directed by James Wan, it concerns a series of H.P. Lovecraft-style interdimensional beings invading three neighbouring properties in an ordinary Buenos Aires suburb. But such a synopsis hardly does credit to the film's demented vibe.

In house number one, Clara (Natalia Señorales) hears voices from the plughole saying they are going to kill her 🕐. At night, her husband Juan (Agustín Rittano) is woken by banging sounds that he blames on their neighbour at house number two, Walter (Demián Salomón). But when Juan comes back in from complaining, he realises, 'That's not Walter.' Instead, it is Clara, suspended in mid-air by forces unseen 💀, being smashed repeatedly into the bathroom walls like Annie (Toni Collette) in *Hereditary*.

At Walter's things are scarcely any better, not least because something keeps moving his bed. When he looks underneath, the sheet tassels trailing like strands of matted hair, he sees nothing. But when he lies down again, we do: a huge, white figure curled up on the floor, its legs bent back on themselves 💀. Training a camera on the bed only makes things worse – the footage shows the figure standing over him as he sleeps, then hiding in the closet 🕐. Determined, Walter grabs his gun and looks inside, but it is empty. Then, as he checks the camera, a white face emerges from the darkness behind him 🌓, and we see the figure, reaching, reflected in the gun-metal. What is so scary is that the figure has no plan, it just seems to have taken up residence in Walter's room. 'That's what I wanted,' said Rugna. 'The beings do not have our moral codes, our language. Maybe they are like astronauts discovering our world; maybe they need to push a chair to see what happens or destroy a human body to see if it survives.'

In the third house, a ten-year-old boy Pucho (Matias Rascovschi) sits at the kitchen table, having returned, charcoal-skinned and rotting 👁, from the grave. Funes and his friend, the paranormal

> '‎You shouldn't have
> blood on your hands,
> not here. These
> beings like blood.'
> — Dr Albreck

researcher Jano Mario (Norberto Gonzalo), step out to discuss what to do with the body. When they come back it has moved 🕐, spilling milk across the table.

The wraparound story takes place at the police station where Juan is being held upon suspicion of murdering Clara. Here, Jano and his colleagues Dr Albreck (Elvira Onetto) and Dr Rosenstok (George L. Lewis) assemble, deciding to spend the night in the three houses to establish what has happened. Little do they know what they are letting themselves in for.

Throughout the film, as events spiral out of control, Rugna mixes bone-deep dread with uncanny visuals and some viciously timed jump scares. When Funes phones Jano in the adjacent house to say he is leaving, Jano looks across the street and replies, 'There's a guy by the window. That's not you, is it? 🕐' In fact, it is the white figure from Walter's closet, who appears and disappears depending on Jano's viewpoint 🩸. But before Jano can process what he is seeing, the figure is suddenly standing outside his window ⚡.

The outlandish tone is helped immeasurably by Marcos Berta's extraordinary creature design – a mixture of prosthetics, CGI and stunt-casting. At one point Rosenstok gets his hand pinned to the kitchen cabinet with a knife, as something inside starts to suck his blood 🩸. Later, as Funes is about to drive off in terror, an impossible

SCARE RATING

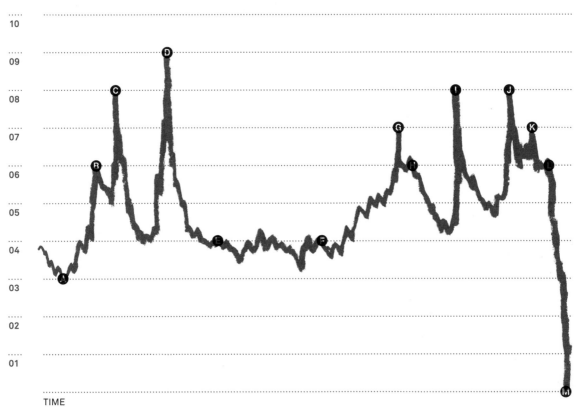

TIME

Further viewing

INSIDIOUS 2010

For its first 40 minutes, this influential horror from *Saw* director James Wan and writer Leigh Whannell is scary as hell. When the Lambert family move house, bad things start to happen. Son Dalton (Ty Simpkins) falls into a coma, mum Renai (Rose Byrne) hears voices coming through the baby monitor 🎃, and weird faces appear at the window in the night ⚡. Brilliantly, Renai and her husband Josh (Patrick Wilson) break genre protocol by moving again, but the apparitions only get worse – 'It's not the house that's haunted,' Josh's mum (Barbara Hershey) is told, 'it's your son.' A spooky sequence sees Renai hunting a strange little figure from room to room to the tune of 'Tiptoe Through the Tulips' 🕐, and there is a superb jump scare ⚡ when a red demon's face appears all of a sudden behind Josh 🔆. Unfortunately the second half is a disappointingly sub-Elm Street trip to the other side.

HELL HOUSE LLC 2015

Centring on an undisclosed disaster that killed revellers in a haunted house attraction, writer/director Stephen Cognetti's debut offers a smart take on the found-footage genre. Beginning as a documentary, complete with talking heads, news footage and panicky 911 calls, it switches gear when survivor Sarah Havel (Ryan Jennifer) turns up with behind-the-scenes film showing her boyfriend Alex (Danny Bellini) and the Hell House team setting up shop. As they ready an abandoned hotel for Halloween, the location proves doubly effective, with handheld cameras catching their own spooky props in the half-light as they encounter the former occupants – a Satanist and his black-cloaked followers. A mannequin that seems to move around the house provides some memorable jump scares ⚡, which build into dread 🕐 when the characters realise they cannot be sure who – or what – is doing the moving.

LIGHTS OUT 2016

Expanded from his short, David F. Sandberg's daft but effective feature debut borrows its start-stop tempo from J-horror and its villain's MO from *Doctor Who*'s Weeping Angels. A no-nonsense opening sequence introduces Diana (Alicia Vela-Bailey), a silhouetted she-demon with glowing eyes 🎃 who can only be seen in the darkness but teleports towards her victims when the lights go out 🕐. Diana has been shadowing Sophie (Maria Bello), since they met in mental hospital years ago, and begins to threaten Sophie's children Rebecca (Teresa Palmer) and Martin (Gabriel Bateman). Though Diana's backstory feels hastily grafted on, her sudden appearances in the flash of a gun or the wave of a torch are inventive and unnerving. Ultimately the film works because it takes the basic notion that underpins all horror – that there is something awful waiting in the darkness – and pushes it to the next level.

being that looks like Dr Albreck's head on the end of a lolling, distended neck, races towards the car 🎃.

Rugna's own deafening score only intensifies the fear, switching from skin-pricking violins to orchestral crescendos punctuated with thunderous bangs as if the foundations of the buildings themselves were crumbling around the characters.

Although Dr Albreck provides some kind of context – the creatures are, she says, from a dimension that shares the same space as ours, and use water to move between the two – the film is much more interested in scaring us than explaining itself. 'I feel if I add more information, the tension, the latent horror, is going vanish,' said Rugna. 'So the rhythm of the film is: don't waste your time on explanations. It's a nightmare – there's no time to relax. ▶'

Just seconds after Albreck's explanation we see exactly what he means. 'Is there a way to stop this?' asks Funes, nearing the end of his rope. Albreck smiles, as if speaking to child. 'No,' she says, as a huge talon shoots out of the wall and grabs her ⚡. It is at this point, while the creature comes crawling through the wall, all bleeding skin and squelching special effects 🎃, that Funes's heart finally gives out. And, frankly, who can blame him?

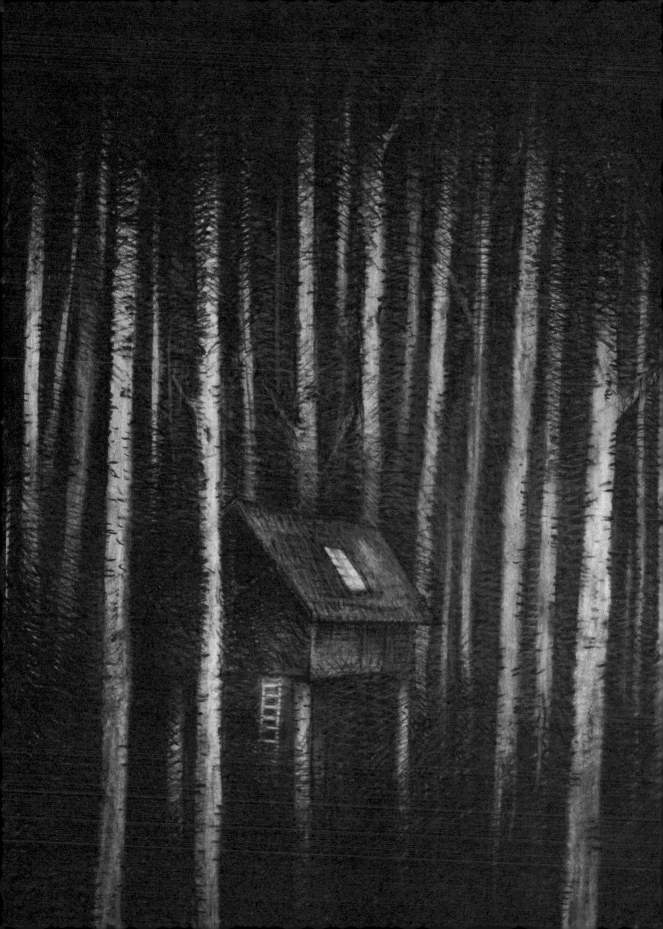

Hereditary

Uneasy lies the head

RELEASED 2018

DIRECTOR ARI ASTER

SCREENPLAY ARI ASTER

STARRING TONI COLLETTE, GABRIEL BYRNE, ALEX WOLFF, MILLY SHAPIRO, ANN DOWD

COUNTRY USA

SUBGENRE OCCULT

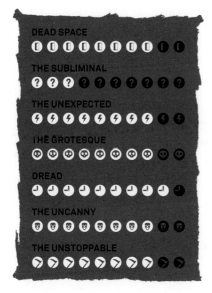

DEAD SPACE
◉◉◉◉◉◉◉◉◉◉◉◉

THE SUBLIMINAL
❓❓❓❓❓❓❓❓❓❓

THE UNEXPECTED
⚡⚡⚡⚡⚡⚡⚡⚡⚡⚡

THE GROTESQUE
◉◉◉◉◉◉◉◉◉◉◉

DREAD
◔◔◔◔◔◔◔◔◔◔◔

THE UNCANNY
☻☻☻☻☻☻☻☻☻☻

THE UNSTOPPABLE
◉◉◉◉◉◉◉◉◉◉

Horror, so they say, knows everything about killing and nothing about death. But Ari Aster's devastating debut is an exception. 'I really wanted to make a film about the corrosive effects of trauma on a family unit,' he told *Vox*. 'A film that had sort of an ouroboros quality about a family that's basically eating itself in its grief.'

While studying at the American Film Institute, Aster explored dark home truths in his short dramas, *The Strange Thing About the Johnsons*, which deals with incest, and *Munchausen*, which centres on a dangerously overprotective mother. For his debut feature, he made the crew watch Mike Leigh and Ingmar Bergman movies and, before it erupts into outright horror, *Hereditary* pitches itself about halfway between the two.

Beginning with a funeral notice, and ending with a monstrous rebirth, it introduces the Grahams, a dysfunctional clan made up of Annie (Toni Collette), Steve (Gabriel Byrne) and their children Peter (Alex Wolff) and Charlie (Milly Shapiro). It opens with the burial of Annie's mother Ellen (Kathleen Chalfant), a difficult, secretive woman, whose passing affects the family in different ways. Annie sees her ghost standing in the corner of the room ☻, but young Charlie seems more actively disturbed, making a strange clucking sound and cutting the head off a pigeon ◉ that flies into the school window.

When death comes calling again, everything starts to fracture. As Aster told Mick Garris, 'I wanted it to feel like the film was coming apart at the seams because it couldn't contain the feelings.' The result is so relentlessly distressing it should carry a trigger warning.

It is also relentlessly terrifying, with a keen sense of the uncanny. Annie is a miniaturist, making tiny models of her life for a forthcoming exhibition. Starting with a view of the treehouse outside, the opening shot moves slowly through her workshop to an exact replica of the Graham house, built by make-up supervisor Steve Newburn. To the sound of a distorted heartbeat, the kind a baby might hear in the womb, we close in on Peter's bedroom. Suddenly it has become

the real thing ☠, and we see Steve entering to wake his son for the funeral. Not only is this an elegant special effect, its artificiality makes us question the truth of what we are seeing, and suggests there is a higher power manipulating the characters to its own agenda ◑. In a literal sense, there is: the real house was created entirely on a soundstage, and Aster came prepared with a seventy-five-page shot list.

At school, Peter sits through a lesson on Sophocles, with the words 'escaping fate' written on the board (as in *Halloween*) and a pupil explaining how the characters are 'just like pawns in this horrible, hopeless machine'. Meanwhile, we are shown odd words carved into the walls, and a strange pendant worn by both Ellen and Annie – actually the symbol of Paimon, god of mischief – scratched into a telegraph pole that plays a pivotal role in the film's most shocking scene.

Under sufferance from his mother, Peter takes Charlie to a party, where he disappears to smoke weed, while she heads straight for the chocolate cake. Charlie, it has been established, has a nut allergy, and we know there are nuts in the cake ◑. As Colin Stetson's soundtrack churns and drones like that horrible, hopeless machine, she bursts into the stoners' room unable to breathe. Peter grabs her, runs to car and speeds off towards the hospital while she sits in the back, her throat constricting. But when she leans out of the window

SCARE RATING

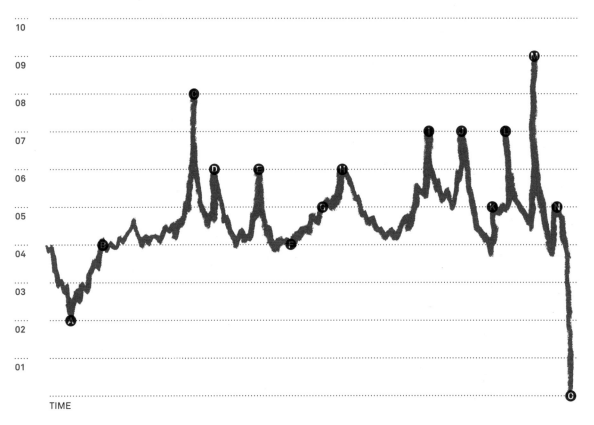

TIME

> 'I didn't let her near me when I had my first – my son – which is why I gave her my daughter, who she immediately stabbed her hooks into.'
> — Annie Graham

for air, Peter swerves to avoid a dead deer, decapitating his sister on that very telegraph pole ☺. Incredibly, something similar happened in 2005 in Marietta, Georgia, to drunk driver John Kemper Hutcherson and his friend/passenger Frankie Brohm.

The shell-shocked sequence that follows must rank among the most acute depictions of trauma in cinema. Unable to go back, even to look back, Peter drives home like a zombie, climbs into bed, then lies completely still, as the dawn breaks and, off-screen, we hear Annie find the body.

The next time someone speaks it feels like hours have passed. Lying prostrate on the bedroom floor like she is in too much pain to ever stand again, Annie screams, 'I just wanna die!' as Steve holds her. Slowly, as if exploring one of Annie's room sets, the camera turns to where Peter stands, frozen, in the corridor, a broken man.

Chances are, viewers will know exactly how he feels. Having watched a major character – a thirteen-year-old child no less – killed off in such a horrible way, we fear the worst ◐ because there are no limits as to what the film might do next ⬎.

At a grief support group, Annie meets the sympathetic Joan (Ann Dowd), and recounts her traumatic family history. Her mother suffered from dissociative identity disorder, her father starved himself to death, and her older brother, a schizophrenic, hung himself blaming their mother for 'putting people inside him' ☺. No wonder Annie feels like everything is 'ruined'. But there are clues in her confession, too. Along with Annie's – increasingly disturbing – models and the preponderance of arcane symbols, the sense is that the Grahams' tragedies are all part of some devilish design.

Annie tells Joan that she once woke from sleep-walking to find herself standing over Peter and Charlie, the three of them covered in paint thinner and her about to strike a match. Later, she replays the incident in a nightmare spiked with home truths. 'I never wanted to be your mother,' she admits to Peter, 'but *she* pressured me.'

During a lesson on Greek mythology, as the teacher claims, 'Agamemnon had no choice,' Peter hears Charlie's clucking sound ☺, and looks around alarmed. Next, his hand rises, held in place by an unseen force, and the camera zooms in on his face, swollen as if from anaphylactic shock ☺. Without warning, he bangs his head full force on the desk ⚡ – twice – then backs away screaming at what just happened. It is an incredible bit of acting and, while Collette deserves all the plaudits for her volcanic performance, Wolff is just as good as the spirit-broken victim around whom evil plans are coalescing.

'It's a story about a long-lived possession ritual told from the perspective of the sacrificial lamb,' Aster told *Variety*. 'Ultimately we are with the family in their ignorance of what's really happening. But I also wanted to imbue the film with this sinister, more knowing

> '**You don't ever raise your voice at me! I'm your mother, you understand? I've given everything to you!**'
> — Annie Graham

perspective ⬤. The movie itself knows exactly where the story is going, and everything is inevitable ⬤.'

It may be inevitable, but it is not necessarily clear. The salient facts are these: Ellen, Joan and their cronies are occultists. Having failed with Annie's older brother and Charlie, they intend to turn Peter into Paimon's vessel on Earth. Annie tries to stop them, but only succeeds in killing Steve, who goes up in flames and dies, then being turned into a puppet herself.

After witnessing such pain and suffering, the climax is almost too much to take ⬤. Peter wakes in the darkness as a white-clad figure scurries across the wall behind him ⬤. He finds his father's blackened corpse ⬤ on the lounge floor, as the figure – Annie – comes into awful focus on the ceiling above ⬤. Looking around, he sees a naked man (David Stanley, who we also saw at Ellen's funeral) in the hall, smiling ⬤, then runs for the attic as his mother bangs on the trapdoor. But it is not her fists hammering on the wood, it is her head ⬤; the woman inside long gone.

Alone – or so he thinks – in the darkness, Peter finds candles, the outline of his grandmother's body, and a photo of himself with the eyes poked out. Then he hears it: a wet, ripping sound ⬤. He looks up in horror ⬤, before we see what he does: Annie suspended in mid-air, severing her own head with piano wire in quick, robotic jerks ⬤: the blood spurting, her eyes staring, the pace quickening . . .

More naked followers appear and Peter, left with no option, hurls himself out of the window. It is only then that we hear Annie's head fall. Apparently this and Charlie's decapitation were the first images Aster thought of. 'The concept of a mother so destroyed by what happened to her child that she has to do it to herself. I built the movie around that,' he told *Bloody Disgusting*.

The final sequence shows Peter at the centre of his own grim tableaux. In the treehouse, surrounded by the decapitated corpses of his mother and grandmother ⬤, with Charlie's head mounted on a mannequin and a congregation of naked followers bowing down to him, he is crowned King Paimon by Joan. The last image we see is of the same scene recreated with miniatures, though who actually made it is anyone's guess.

While critics have complained about ending with Joan's explain-all speech, there is an overwhelming amount of information to process and, in a sense, it does not matter. The true power of the film is not in its preordained plot or petrifying imagery, but the sense of real people pulverised by pain. Indeed, given the horrors they have witnessed, the audience would be forgiven for stumbling from the cinema a little broken too.

Further viewing

A DARK SONG 2017
Sombre and engrossing, with a core of genuine sorrow at its centre, writer/director Liam Gavin's slow-burn debut concerns grieving mum Sophia (Catherine Walker) who hires occultist Joseph (Steve Oram) and holes up in a big country house to perform a rite that will enable her to speak to her murdered son. If the pair's interactions are intense, the labyrinthine preparations are even more so, with Sophia fasting, eating toadstools and drinking blood to help 'unshackle the house from the world'. It also unshackles the drama from everyday reality. As Sophia gets more and more out of her depth, dark figures appear behind her in the dead space , she senses a presence, sitting, smoking in Joseph's chair , and talks to her son – or something pretending to be him – through a closed door. The climax, which sees her reliving his last moments harried by angels and demons, is both supremely moving and creepy as hell.

HOUSEWIFE 2018
The second film from Turkish auteur Can Everol (*Baskin*) borrows from the best (Dario Argento, Mario Bava, H.P. Lovecraft) to create something wholly original and – in places – completely unhinged. A feverishly Freudian prologue sees young Holly (Zuri Sen) and her sister Hazel (Elif Gülalp) attacked by their mother (Defne Halman) who has visions of 'visitors'. Years later, the adult Holly (Clémentine Poidatz) makes dolls' furniture while her husband Timucin (Ali Aksöz) writes books on occultism. Amid an atmosphere of dread , she is persuaded to check out a cult lead by the charismatic Bruce O'Hara (David Sakurai), who plunges her back into her family's awful past. Cue plenty of uncanny imagery , some great jump scares (including one that nods directly to Bava's *Shock*), and all kinds of inescapable narrative loops. As Bruce warns, 'You might forever be trapped in a maze of dreams.' And how.

SAINT MAUD 2020
British writer/director Rose Glass's austere debut sees Maud (Morfydd Clark), a pious young nurse, employed to look after Amanda (Jennifer Ehle), a dying dancer, in a grim seaside town. Against the odds, they start to form a bond, with Amanda calling Maud her 'little saviour'. Yet there are hints that Maud is not quite right. She hears voices whispering in the ether around her, goes into dead faints, and burns her hand – on purpose – on the Aga. When Amanda sacks her, Maud really starts to unravel. Across an awful inebriated night, she sees vortexes appear in pints of beer, has violent sex with a stranger and imagines her hands breaking through his ribcage . Beyond the exceptional performances, the film's real genius is in keeping us guessing whether Maud's religious fervour is due to saintliness or insanity right up to the shocking climax.

It Chapter Two
Fears of a clown

RELEASED 2019

DIRECTOR ANDY MUSCHIETTI

SCREENPLAY GARY DAUBERMAN,
STEPHEN KING (NOVEL)

STARRING JESSICA CHASTAIN,
JAMES McAVOY, BILL HADER,
ISAIAH MUSTAFA, JAY RYAN,
JAMES RANSONE

COUNTRY USA

SUBGENRE COSMIC HORROR

In 2017, Stephen King's 1986 masterpiece was adapted into a movie by Andy Muschietti (*Mama*). That first part became the highest-grossing horror of all time, but this second chapter, based on the book's modern-day strand, is scarier: a fun-house frightener with real fangs.

Every twenty-seven years, an ancient shape-shifting evil terrorises the town of Derry, Maine, mostly taking the form of Pennywise the Dancing Clown (Bill Skarsgård), and playing on its victims' weaknesses. In 1989, the Losers' Club, a group of seven outsider school kids lead by Bill Denborough (Jaeden Lieberher), almost killed It. But when It reappears in 2016, they are drawn back to face their fears, even though they can barely remember them.

Two scenes show the gloves are really off this time. In a shocking opening sequence, inspired by the murder of Charlie Howard in 1984, a homophobic attack sees local man Adrian Mellon (Xavier Dolan from *Martyrs*) beaten half-to-death then thrown into the river, before Pennywise pulls him out and eats his heart ☻.

Later, we see Pennywise actually kill a child – something even Freddy Krueger avoided doing on-screen. During a baseball game, little Victoria (Ryan Kiera Armstrong) follows a firefly, that classic symbol of American innocence, under the bleachers. Here, Pennywise waits in the darkness, promising to blow away her birthmark if she gets close enough. 'One, two . . .' he begins, his face huge, his lips wet, his make-up bisecting wild, staring eyes ☻. 'You're supposed to say three,' she prompts ◕, but instead his jaws clamp around her head ⚡.

'Pennywise appears in many forms and, many times, he is completely out of control,' Muschietti told *Hot Press*. 'Bill [Skarsgård] did not hold back, ever. He always had this terrifying unpredictability. Sometimes, he would even be unpredictable to me – and to himself.'

Once reassembled, Bill (James McAvoy) and the rest of the Losers find they have collective amnesia regarding what happened to them as kids. So Mike Hanlon (Isaiah Mustafa), the only Loser who stayed in Derry, sends them off to recover artefacts from their youths in an attempt to jog their memories.

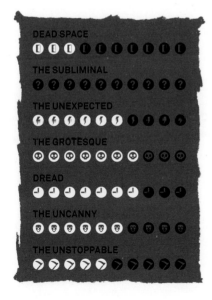

DEAD SPACE
◑ ◑ ◑ ● ◑ ◑ ◑ ◑ ◑ ◑ ●

THE SUBLIMINAL
❓ ❓ ❓ ❓ ❓ ❓ ❓ ❓

THE UNEXPECTED
◑ ◑ ◑ ◑ ◑ ◑ ◑ ◑ ◑ ◑ ⟳

THE GROTESQUE
☺ ☺ ☺ ☺ ☺ ☺ ☺ ☻ ☺ ☺

DREAD
◕ ◕ ◕ ◕ ◕ ◕ ◕ ◕ ◑ ◕

THE UNCANNY
☺ ☺ ☺ ☺ ☺ ☺ ◉ ◉ ◉ ◉

THE UNSTOPPABLE
⚡ ⚡ ⚡ ⚡ ⚡ ⚡ ⚡ ⚡ ⚡ ⚡

'For twenty-seven years, I've dreamt of you. I craved you. Oh, I've missed you!'
— Pennywise

Bev Marshall (Jessica Chastain) heads back to the apartment she shared with her abusive father (Stephen Bogaert). She is let in by Mrs Kersh (Joan Gregson), a kindly old lady who has lived there since his passing. What follows is deeply, deliciously uncanny 🌑. Over tea and cookies, Mrs Kersh tells Bev, 'No one who dies here ever really dies,' with a mad glint in her eyes. Next, as Bev examines photos of Mrs Kersh's father, a – strangely familiar – circus performer, we see the old lady dancing, naked, in the dead space behind her 🌑. Finally, Mrs Kersh/Pennywise comes roaring into view as a huge, cackling hag ⚡, and Bev flees the scene, but not before she sees Pennywise/Mrs Kersh's father at the end of a long, dark corridor. 'Run, run, run!' he tells her, smearing on white greasepaint, then raking his fingernails down his cheeks to produce those trademark red gashes 🌑.

Before the Losers tackle It in its lair in the sewers, they each have experiences like Bev's. The most memorable is an incident that happened to Eddie (James Ransone) as a sickly child. In the basement of the town pharmacy, young Eddie (Jack Dylan Grazer) finds his mother (Molly Atkinson, the same actor who will later play his wife) strapped to a gurney and murmuring, 'He's coming, he's going to infect me!' 🌑. Next, a figure wrapped in a sheet trundles towards them, growling and gibbering, and finally revealing itself as a nightmarish leper, before plunging its tongue into her mouth 🌑. God knows what Freud would make of that, but this is what the film does so well: turning amorphous childhood fears into moments of visceral terror.

SCARE RATING

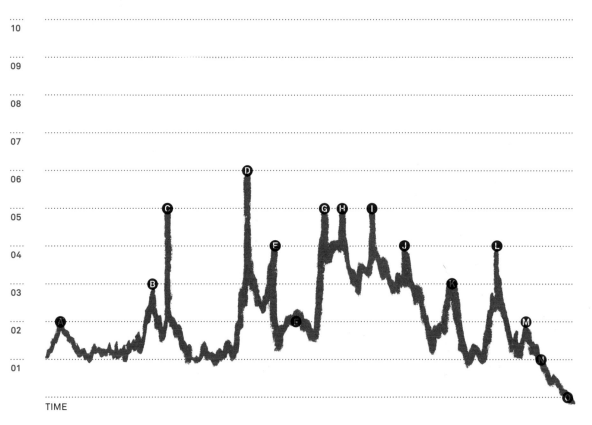

TIME

Further viewing

IN THE MOUTH OF MADNESS 1995
'Every paranoid schizophrenic has one: a "them", a "they", an "it",' says recently sectioned insurance investigator John Trent (Sam Neill) at the start of John Carpenter's H.P. Lovecraft homage. Trent has lost his mind, and more besides, on the trail of missing author Sutter Cane (Jurgen Prochnow), a clear stand-in for Stephen King. Not only are Cane's apocalyptic writings causing his readers to go insane – witness the axe-wielding maniac who attacks Trent at lunch (actually Cane's agent) 🗲 – they are also coming true, with disturbing results. En route to the (supposedly fictional) town of Hobbs End, Trent passes a boy on a bike, who minutes later, has become an old man with a shock of white hair 🙂 as if he has seen *It Chapter Two*'s Deadlights. Soon Cane is ripping holes in reality for all kinds of monstrous beings 😵 to pass through.

TRICK 'R TREAT 2008
Inspired, like King, by the EC Comics of the 1950s, Michael Dougherty's gateway horror pulls off the rare feat of being both funny and scary. Set during the Halloween celebrations of a small Ohio town with some dark secrets, it is made up of overlapping vignettes that subvert expectations at every turn. The most substantial is about a school bus full of 'disturbed' children drowned in a quarry, who come back to wreak revenge on those who killed them, creepy home-made masks 😵 and all. But it is the asides that really delight: grumpy school principal Steven Wilkins (Dylan Baker) teaching his son to carve a *real* pumpkin head 😵; or Little Red Riding Hood-alike Laurie (Anna Paquin) turning the tables on a predator. Indeed, often it is the 'innocents' who prove most deadly. Watch out for Sam, a little boy with a burlap sack over his face, who embodies/enforces Halloween's real spirit with gusto.

DRAG ME TO HELL 2009
Sam Raimi's credit-crunch horror is a triumphant return to the genre for *The Evil Dead* director. When ambitious bank worker Christine (Alison Lohman) refuses to help Mrs Ganush, an elderly Eastern European lady, she finds herself menaced by a Lamia, an ancient demon that torments her for three days before, well, you can probably guess the rest. With her long, dirty fingernails, evil eye and disgusting dentures 😵, Mrs Ganush is the ultimate movie crone. After a furious, funny-sick fight in Christine's car, involving staples in the eye and sputum on the face, Ganush steals a button to perform the curse, and Christine's fate is sealed unless she can pass it on. Soon she finds herself attacked in her home by howling winds and monstrous shadows 🌙, leading to a great dead-space reveal 🚪 when she wakes to find Ganush lying in bed beside her. Sleep tight now.

TIMELINE

Ⓐ	5 MINS	HOMOPHOBIC ATTACK
Ⓑ	36 MINS	FORTUNE COOKIES
Ⓒ	40 MINS	UNDER THE BLEACHERS
Ⓓ	64 MINS	BEV MEETS MRS KERSH
Ⓔ	75 MINS	JOHN BUNYAN ATTACKS
Ⓕ	77 MINS	STEPHEN KING CAMEO
Ⓖ	89 MINS	'KISS ME FAT BOY'
Ⓗ	96 MINS	EDDIE AND THE LEPER
Ⓘ	105 MINS	HALL OF MIRRORS
Ⓙ	115 MINS	HOUSE ON NEIBOLT ST.
Ⓚ	130 MINS	INCY WINCY SPIDER
Ⓛ	145 MINS	EDDIE'S SPAGHETTI
Ⓜ	153 MINS	UNDERWHELMING CLIMAX
Ⓝ	160 MINS	MANY ENDINGS
Ⓞ	169 MINS	ENDS

Unlike the Losers, Muschietti cannot quite finish what he has started: an accusation that could also be levelled at King himself, who cameos as a shopkeeper. But there is something in the transitions – between then and now, real and imaginary, happy and sad – that captures how memories can suddenly whisk us back, unbidden, to our youths, no matter how much time has passed.

Where the film falls down is by including too many references to other works rather than relying on the book's exhaustive mythology. When lovers Bev and Ben Hanscom (Jay Ryan) are separated from the Losers in the sewers, she sees her father wielding an axe and crying, 'Here's Johnny!' like Jack Torrance in *The Shining*. There is also a homage to John Carpenter's *The Thing*, as the severed head of deceased Loser Stan Uris (Wyatt Oleff) sprouts arachnid legs and scuttles towards the gang. Richie Tozier (Bill Hader) even says, 'You've gotta be fucking kidding!' – a direct quote.

But perhaps Muschietti is just heeding King's advice. 'I recognise terror as the finest emotion and so I will try to terrorise the reader,' King wrote in *Danse Macabre*. 'But if I find that I cannot terrify, I will try to horrify, and if I find that I cannot horrify, I'll go for the gross-out. I'm not proud.' Maybe that is the real secret to scaring people after all.

Index

For Elliott and James

The author would like to thank:
Alice Graham, Glenn Howard, Michael Brunström,
Philip Cooper, Paileen Currie, Ruth Ellis and the team
at White Lion Publishing.

My very own Losers' Club:
Ali Catterall, Anton Bitel, Imogen Harris, Josh
Winning, Matt Dykzeul, Nick Kiss, Rafe D'Aquino,
Rosie Fletcher and Veronique De Sutter.

John and Vivienne Glasby for their love and support.

And, most of all, Vari Innes, who keeps me safe
in the dark.

The Book of Horror
First published in 2020 by
White Lion Publishing,
an imprint of The Quarto Group,
The Old Brewery, 6 Blundell Street,
London N7 9BH, United Kingdom
T (0)20 7700 6700 F (0)20 7700 8066
www.QuartoKnows.com

A catalogue record for this book is
available from the British Library.

ISBN 978-0-7112-5178-6

10 9 8 7 6 5 4 3 2 1

Typeset in Akkurat and Exquise

Design by Glenn Howard

Printed in China

MIX
Paper from
responsible sources
FSC® C008047